"It's enough to wear out several
pairs of blue suede shoes."

— *The New York Times*

THE FIELD GUIDE
TO
ELVIS
SHRINES

THE FIELD GUIDE TO
ELVIS SHRINES

BILL YENNE

LAST GASP

SAN FRANCISCO

For book orders, contact:
Last Gasp of San Francisco
777 Florida Street
San Francisco, California 94110
gasp@lastgasp.com

ISBN 0-86719-591-6

Table of Contents

Acknowledgments

The author would like to thank Azia Yenne for her help in putting this book together, and Joni Mabe, George Booth II, and Harriet Karlin for supplying photographs for this book. He would also like to extend a special thank-you to Joe Watkins for tracking down and photographing all the Memphis, Tennessee, Elvis-related sites.

Dedication

The author dedicates this guide book to all the Elvis fans that he has known through the years and to all those who have helped with suggestions, leads, and bits of information that have made this book what it is. A special nod of thanks is due to Joe Watkins for the work he did in Memphis, and to Jim Parish, who edited the manuscript and provided numerous helpful suggestions and encouragement.

List of Maps

Introduction

It is a hot and sticky summer day, the kind that makes your shirt stick to your back against the car seat. That must be why they call it "sticky." It is a hot and sticky southern summer day in 1957, the kind where you can smell the fragrance of the ponds and hear the incessant hissing of the bugs. The road is marked with the stark, old-fashioned black-on-white U.S. highway signs. They read "U.S. Tennessee 51." You pass a sign that says "Welcome to Mississippi" and something about "the Magnolia State." The road is now marked with signs that read "U.S. Mississippi 51."

You have been driving for hours when you decide to stop at one of those little roadside cafés for a glass of iced tea. It feels good to get out of the car. You lift the straw hat from your head and sweep your cloth handkerchief across your brow before going in. My, but it's cool inside. The shade of the big, old oak trees and the whirring fans have kept the heat of Highway 51 locked outside.

They have a glass case next to the cash register with all their pies displayed, and—my goodness—doesn't the banana cream look good!

As you push through the squeaky screen door to leave, a big pink Cadillac with a bunch of boys in it pulls up. You chat with them a bit. They tell you that they're musicians, and you can see that they've got the neck of their old stand-up bass sticking out the back window of the Caddie. It seems that these boys are from up in Memphis and they're heading down to Shreveport to play on the *Louisiana* (they call it "LOO-zee-anna") *Hayride* radio show.

You wish them well and promise to tune in.

★

It is a hot and sticky summer day, the kind that makes your shirt stick to your back against the car seat. It is a hot and sticky southern summer day in 1977, and it occurs to you that it's time to turn on the air-conditioning.

You are making your way east from downtown Memphis, Tennessee, on Union Avenue, when suddenly you hear the wail of an ambulance. You glance in your rearview mirror, but see nothing. Then you spot it ca-

reening toward you. Union Avenue is four lanes wide, so there is no need to pull over. You watch the ambulance driver swerve into the right lane and make a tight turn into the emergency entrance at Baptist Memorial Hospital.

The light is red, so you stop and casually watch as they take a man on a stretcher out of the ambulance and rush him into the emergency room. He is a big, dark-haired man. There is something about him that seems familiar, like he's somebody you've known all your life. The light changes. Time to roll up the window, turn on the air-conditioning, and move on down the road.

★

This book is about a boy who grew up to be a big, dark-haired man, but more than that, it is about the places he went and the places people still go to feel like they are near his special spirit.

He was just an average southern boy—or below average, if you believe in the class system that prevailed in the South when he was growing up there. However, he became special. He rose "above his raising," as they used to say down South, to describe "white trash" who aspire to become middle class or better. He became special to people regardless of class, and he became special to people who never had, and never would, set foot in the South.

The boy grew up to become familiar to millions of people, and he went from radio's *Louisiana Hayride* to a televised concert where a billion people tuned in. He touched something in people, and he became like somebody that we had known all our lives. In short, the boy who grew into a man is Elvis Presley, who became the King.

When, at the age of forty-two, the King died on that hot August day in 1977, the world gasped and the world mourned.

On a hot August day in 1987, the media of the world noticed something strange: the King's millions of subjects had never stopped mourning him. Nearly half a million people came to carry candles in a silent procession past his grave site in Memphis, Tennessee, to mark the tenth anniversary of his passing. In life, a boy had become special. In death, the man who became the people's king achieved a kind of immortality beyond the special status that has been achieved by few, if any, hereditary kings.

Today the August candlelight procession past his grave site is an annual affair, but processions occur daily, as millions come to pay their continuing and, it would seem, everlasting respects. In Paris there are fresh flowers on the grave of rock star Jim Morrison every morning, and in Renton, Washington, people come to the headstone of rock legend Jimi Hendrix nearly every day. In Memphis, they come in busload after busload.

Just as August is not the only time the faithful pay their respects, Elvis Presley's grave site in Memphis is not the only place. While graves evoke that notion of a "final resting place," most of us would rather remember our loved ones in places that were made unique by their presence, and in places where the memories of their life are celebrated. These locations become "shrines."

Webster's Dictionary defines a *shrine* as "a site hallowed by a venerated object or its association." With this fully in mind, we have compiled this special collection of sites which are "hallowed" by their association with that southern boy who became the people's "King."

—Bill Yenne

Notes on Organization

This book is organized geographically. We start with Tupelo, Mississippi, (because Elvis started here), then move to the region in which Tupelo is located, then to Memphis—eighty-eight miles to the northwest of Tupelo, where Elvis grew up and spent much of his adult life—and then, in turn, to the region in which Memphis is located. Having reviewed the South, we move next to the North, and then gradually to the West, and on to Hawaii, where there are numerous important Elvis sites. Finally, we touch down briefly in Canada, Germany, France, and, of all places, Kazakhstan, to finish our journey. An appendix following the geographical text follows Elvis into cyberspace.

In tracing the cherished history of Elvis's life and times—the archaeology of Elvis, if you will—one finds that the passage of time has wrought many changes. Some sites—such as those in Tupelo—have remained unaltered, while in other instances, the original building still exists, but now it is hardly recognizable. Then, too, there are many important sites that simply no longer exist. We have listed such locations only when they are extremely important to the chronicle of Elvis and his career, or when they happen to be conveniently close to an existing site.

Except for the cities of Tupelo (Mississippi), Memphis (Tennessee), Los Angeles (California), Las Vegas (Nevada), and Honolulu (Hawaii), we have grouped the venues of Elvis concerts by state, with the entries arranged in chronological order by the date of the first concert given in a particular place. This is done to give readers the cities in the order that Elvis himself first experienced them. Because he performed in more venues in Texas than anywhere else, the locales in the expansive Lone Star State are listed alphabetically by city. It should be noted that this is the first directory of Elvis concert sites to list addresses and phone numbers. When two or more phone numbers are listed for a venue, they are listed in the order we consider to be most important for the reader.

Many of the concert venues, especially the smaller ones for the 1950s tours, were not found listed under the name they had at the time, nor were they found to be listed under another name. We would appreciate hearing from readers with additional information about these sites, so that we can update the second edition of this book. And, of course, al-

though our research is current, changes do occur constantly. Again, we would greatly appreciate hearing from readers with any changes they have encountered since the publication of this book, so we can update this guide.

Finally, when visiting the sites referenced in this book, especially in Memphis and other large cities, we suggest that you obtain a local street map of the city and use it along with our locator maps to help you plot the locations of the sites that you wish to see.

The following icons have been used throughout this book to alert the reader to the type of site being detailed and its link to Elvis Presley.

Homes and hotel suites occupied by Elvis, his friends, and/or his family

Museums, memorial sites, or sites where memorabilia may be viewed

Sites related to Elvis's films

Sites related to Elvis's music and/or concerts

Aviation sites related to Elvis

Automobile or motorcycle sites related to Elvis

Churches and other religious sites

Sites related to Elvis's finances

Restaurants where Elvis ate or where his memory is invoked

Military sites associated with Elvis

Sites associated with legal issues and/or the criminal justice system

Schools attended by Elvis, his friends, and/or his family

Chapter 1

Tupelo (and East Tupelo), Mississippi

In a two-room shack at 306 Old Saltillo ("Saltville") Road in East Tupelo, Mississippi, at approximately four o'clock on the morning of January 8, 1935, Gladys Love Smith Presley gave birth to a stillborn baby boy. At 4:35 A.M., the deceased child's twin brother was born, alive and healthy. Gladys and her husband, Vernon Elvis Presley, named the twin who died "Jesse Garon Presley" after Vernon's father, Jessie (with an "i") D. McClowell Presley. According to his birth certificate, the surviving boy was named "Elvis Aron Presley," although it is generally believed that they intended his middle name to be "Aaron" and that the clerk made a mistake when the birth certificate was prepared.

Another discrepancy on the birth certificate is the spelling of "Saltillo" Road as "Saltville" Road. This may have been an error made by a courthouse clerk, or it may have been that the latter spelling was that which was generally used at the time by folks living there.

Gladys Love Smith Presley (1912–1958) was born in Pontotoc County, Mississippi, the daughter of Robert Lee Smith (?–1932) and his first cousin, Octavia Lavenia "Doll" Mansell Smith (1876–1935). Her siblings were John, Clettes, Travis, Levalle, Rhetha, Lillian, and Tracy Smith. Vernon Elvis Presley (1916–1979) was born in Fulton, Mississippi, the son of Jessie D. McClowell Presley (1896–1973) and Minnie Mae Hood Presley (1893–1980). His siblings were Delta Mae, Nasval, Lorene, Vester, and Gladys Earline Presley.

At the time of the birth of Elvis Aron Presley, East Tupelo was a poor and unincorporated residential suburb of Tupelo, Mississippi. It would be incorporated into the Tupelo city limits in 1948, but, for years afterward, the area would be referred to as "East Tupelo." In 1935 Tupelo had a population of 6,000; today it has over 30,000 people.

The county seat of Lee County and the first city illuminated by electricity from the Tennessee Valley Authority, Tupelo is located in northeastern Mississippi, about ninety minutes southeast of Memphis on U.S. Highway 78 and about three hours northeast of the state capital at

The map image shows "Tupelo★" label.

Tupelo, Mississippi

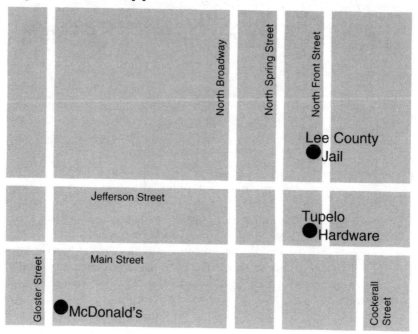

Jackson on the scenic Natchez Trace Parkway. For information in planning a visit to Tupelo and its Elvis Presley sites, you are encouraged to contact the helpful folks at the Tupelo Convention and Visitors Bureau: (601) 841-6521.

The Elvis Presley sites in Tupelo are clustered in three general areas. Most are in the section previously known as East Tupelo, which is located east of downtown Tupelo on Mississippi Route 6. In the center of town, the important sites are Tupelo Hardware, the Lee County Jail, and the Tupelo Fairgrounds. About a half mile west of the center of Tupelo, there are two important Elvis sites: Milam Intermediate School and the McDonald's fast-food restaurant that features the memorabilia collection of Robert L. Hudson.

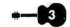
Elvis Presley Birthplace 🏠

306 Elvis Presley Drive
(formerly 306 Old Saltillo Road)
Tupelo, Mississippi 38801
(601) 841-1245

The centerpiece of the Elvis Presley Birthplace complex—which now contains a museum and a meditation chapel—is the original, two-room building in which Elvis was born. Vernon Presley built this home himself (with the help of his brother Vester) in 1934, using funds he borrowed from his employer, dairy farmer Orville Bean. It is said that the house was constructed with lumber purchased for $180. The floor was raised about eighteen inches from the surface of the ground because this part of East Tupelo was prone to flooding. Behind the structure, the Presleys kept a cow and several chickens.

Given that two-room shacks are frequently torn down to make way for more substantial dwellings, it is amazing that the tiny house survived four decades of development to become a state historical site. However, survive it has!

Tupelo, Mississippi (eastern part)

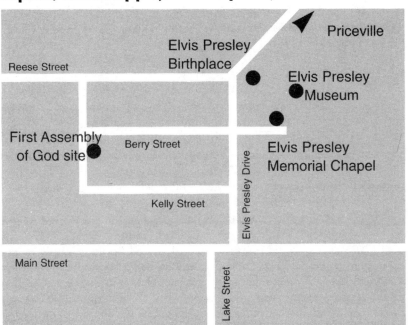

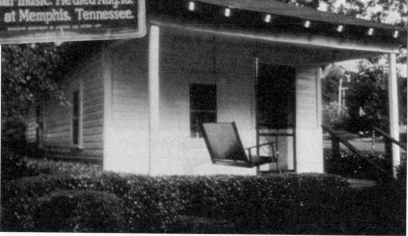

BIRTHPLACE OF
ELVIS PRESLEY
—*—
Elvis Aaron Presley was born
Jan. 8, 1935, in this house,
built by his father. Presley's
career as a singer and enter-
tainer redefined American
popular music. He died Aug. 16,
1977, at Memphis. Tennessee.

The marker at the Elvis Presley Birthplace.
(Photo courtesy of Tupelo Convention and Visitors
Bureau, used by permission.)

*The original, two-room Tupelo, Mississippi house in which Elvis was
born. (Photo courtesy of Tupelo Convention and Visitors Bureau, used by permission.)*

◆

Elvis and his parents had lived here at 306 Old Saltillo Road for al-
most three years when Vernon Presley was arrested in November 1937 for
altering a check for four dollars and thirty cents given to him by Orville
Bean. Vernon was sentenced in May 1938 to three years in the
Mississippi State Penitentiary at Parchman. Orville Bean, who held a note
on the house because Vernon Presley had borrowed the money from him
to build it, foreclosed and threw Elvis and Gladys out on the street.

The building at 306 Old Saltillo Road went through a variety of
ownership over the years, but it has been open to the public as a tourist
attraction since 1971. On October 1, 1977, about a month and a half
after Elvis's death, the house was at last earmarked for preservation by the
state of Mississippi. With money raised by the Elvis Presley Memorial
Foundation, it was repainted, rewired, reroofed, and redecorated to a con-
dition approximating that of the late 1930s. By this time only Vernon
Presley remained alive to know how it had actually appeared, but he ap-
parently had little input on the restoration project. On January 8, 1978,

which would have been Elvis Presley's forty-third birthday, the house was designated a state historical site by the Mississippi Department of Archives and History. A plaque denoting the site as the birthplace of Elvis "Aaron" Presley was erected next to the building.

The house is now open to the public from 9:00 A.M. to 5:30 P.M., Monday through Saturday between May and September, and from 9:00 A.M. to 5:00 P.M., Monday through Saturday between October and April. It is open from 1:00 P.M. to 5:00 P.M. on Sundays all year round. The admission charge is $1.00 for adults and $.50 for children under twelve. Since times and fees are always subject to change, it is good to call ahead.

Elvis Presley Memorial Chapel 🏠

306 Elvis Presley Drive
(formerly 306 Old Saltillo Road)
Tupelo, Mississippi 38801
(601) 841-1245

Located adjacent to the two-room building in which Elvis Presley was born, the Elvis Presley Memorial Chapel is an important part of the Elvis Presley Birthplace complex. The chapel was dedicated on August 17, 1979, the second anniversary of Elvis's death. Costing 1,389 times as much as the actual birthplace, the chapel was constructed for $250,000, with funds donated from friends and fans. With a reasonably tasteful ambiance—lit by the diffuse light from stained-glass windows—the chapel provides a space for quiet meditation and reflection.

The chapel is open to the public from 9:00 A.M. to 5:30 P.M., Monday through Saturday between May and September, and from 9:00 A.M. to 5:00 P.M., Monday through Saturday between October and April. It is open from 1:00 P.M. to 5:00 P.M. on Sundays all year round. There is no admission charge. Because opening and closing times are subject to change, it is always wise to call ahead.

Elvis Presley Museum 🏛

306 Elvis Presley Drive
(formerly 306 Old Saltillo Road)
Tupelo, Mississippi 38801
(601) 841-1245

The third important part of the Elvis Presley Birthplace complex, the Elvis Presley Museum, features "Times and Things Remembered," an exhibit based on the memorabilia collection amassed by Janelle McComb, a

longtime Tupelo-area resident who was well acquainted with Elvis and the Presley family. Opened in 1992, the museum contains records, statuary, promotional items, and Presley family personal effects.

The museum is open to the public from 9:00 A.M. to 5:30 P.M., Monday through Saturday between May and September, and from 9:00 A.M. to 5:00 P.M., Monday through Saturday between October and April. It is open from 1:00 P.M. to 5:00 P.M. on Sundays all year round. The admission charge is $4.00 for adults and $2.00 for children between the ages of four and twelve. Since opening and closing times and fees are subject to change, it is always best to call ahead.

Elvis's Last House in Tupelo 🏠

1010 North Green Street
Tupelo, Mississippi 38801

Located in what was then known as the Shakerag section of Tupelo, this modest home was the last house in which the Presley family lived prior to moving to Memphis, Tennessee, in November 1948. There was once a slaughterhouse nearby, so the rent was probably low and in keeping with the family's very modest means. It is not open to the public, so when you go, view it from a distance and let your mind slip back in time to the last day that an eleven-year-old Elvis walked across this threshold. However, please do not disturb the people living there now. When the Presleys moved out, Gladys's eldest sister Lillian Mann, Lillian's husband Bobby, and her family moved into the 1010 North Green Street house.

Elvis's Maple Street House 🏠

510 ½ Maple Street
Tupelo, Mississippi 38801

This house on the south side of Tupelo was actually the home of Gladys's cousin Frank Richards, his wife, Leona, and their children. The Presleys are said to have lived with them at this location briefly, but it is believed that only Elvis and Gladys resided here, and that was probably during the time that Vernon Presley was in prison in Parchman, Mississippi, from 1938 to 1941.

Other Elvis Home Sites in Tupelo 🏠

Tupelo, Mississippi 38801

During the eleven years that Elvis Presley resided in Tupelo, he and his family moved, on the average, once a year. Elvis and Gladys probably moved several times while Vernon Presley was incarcerated at the Mississippi State Prison in Parchman in the late 1930s. It is known that they lived longest (three years) at the house on Old Saltillo Road where Elvis was born, and that they lived last at the house on North Green Street. In the interim, they lived in a number of houses that are believed to no longer exist, although there is a record of the street names. Since there is little or nothing Elvis-related remaining at any of these sites, the following list is offered for only very serious Elvis archaeologists.

Berry Street is probably the most interesting. It is a short, two-block thoroughfare, the center of which is located one block south of the Elvis Presley Birthplace at 306 Old Saltillo Road. Berry Street was the site of two homes, including the first house occupied by Gladys and Vernon Presley after their June 17, 1933, wedding, which took place in Verona, Mississippi. The second was owned by Orville Bean, the dairy farmer for whom Vernon Presley worked, and whose check Vernon altered in 1937. Apparently there were no hard feelings, as Bean sold the house to Vernon in August 1945 for a $200 down payment on a $2,000 note. When Vernon fell behind on his payments, he was forced to sell the home to his friend Aaron Kennedy for $3,000 in July 1946. It has been said that Kennedy let the Presleys continue to live there, although they did move sometime in mid-1946 to North Commerce Street. The North Commerce Street house was one block east and two blocks north of Tupelo Hardware on Main Street in the Downtown area. Trivia buffs will note that it was while they were living in this home that Vernon's mother, Minnie Mae Presley—known to the family as "Dodger"—began living with the family. She was still living with Elvis at the time of his death in 1977, and with Vernon at the time of his death in 1979. She passed away in 1980.

Kelly Street, in what was then East Tupelo, was the Presley family home in 1942, about a year after Vernon Presley was released from state prison. Kelly is a one-block street, a block south, and parallel to, Berry Street. One end of Kelly Street is at Elvis Presley Drive (then Old Saltillo Road), and the other is at Adams Street. The First Assembly of God Church at the corner of Kelly and Adams Streets was the Presley family's church during most of their years in Tupelo.

A house in the 200-block of North Commerce Street was the Presley's home after they moved from Berry Street in mid-1946. The site where the residence was located now contains a shopping mall.

Other home sites in Tupelo include Mulberry Alley, near the city dump and the fairgrounds, and Reese Street, where the family lived with Vernon's brother Vester, who was married to Gladys's younger sister Clettes.

Priceville Cemetery

Feemster Lake Road
(located in an unincorporated area three miles from Tupelo, Mississippi)

This is the cemetery where, on January 8, 1935, Jesse Garon Presley, the deceased twin brother of Elvis, was buried in an unmarked grave. To reach the Priceville Cemetery from Tupelo, begin at the Elvis Presley Birthplace and drive northeast on Elvis Presley Drive (formerly Old Saltillo Road) until it intersects with Feemster Lake Road. As noted above, the cemetery is approximately three miles from Tupelo. While the cemetery may be visited, with proper respect, of course, Jesse Garon's grave is unmarked, and its exact location is a secret known only to a few.

Lawhon Elementary School

(formerly East Tupelo Elementary School)
140 Lake Street
Tupelo, Mississippi 38801
(601) 841-8910

Known at the time as East Tupelo Elementary School, this was where Elvis attended grades one through five, beginning in September 1941. It is located approximately a half mile south of his birthplace and of the Berry Street–Kelly Street area where he lived during much of the period that he was in the early grades. The school's name was changed to Lawhon (pronounced "Law-horn") several years after he left to attend Milam Junior High School across town.

Today, the Lawhon Elementary School has been substantially altered from its 1940s appearance, but the school auditorium, where Elvis sang on a number of occasions, remains unchanged. The stage where he once stood is still in place.

A glass case in the foyer contains a great deal of Elvis memorabilia, including scrapbooks, letters from early girlfriends, and snapshots of Elvis taken during the years that he attended the school. There are also album covers and memorabilia that relate to his life after he left the school. There are no known desks still preserved in which Elvis once carved his famous initials.

As Lawhon Elementary School is an operating facility, it may be visited only during regular school hours, with the permission of the school administration, and in such a way as to not disrupt classes that are in session. The administration is, however, used to visits from Elvis Presley fans and the staff is generally accommodating. Phone ahead to schedule a visit and note that the building is closed when school is not in session.

First Assembly of God Church 🏠

206 Adams Street (original site)
909 Berry Street (present location of the original building)
Tupelo, Mississippi 38801
(601) 844-5841

During their years in Tupelo, the Presley family attended this church, and Elvis sang in the choir. These were probably his first public performances as a singer, and apparently they began at a very early age. It was also here that Elvis Presley was baptized in 1944, at the age of nine, by Reverend W. Frank Smith. Vernon Presley is listed as having been a deacon at the church.

The original site of the church was at the corner of Adams and Kelly Streets, one block west and two blocks south of the house where Elvis was born. When a new church was built, the original building was moved a block north to Berry Street.

It is theorized by some fans, though not proved, that Elvis was influenced by pastors at the First Assembly of God Church who played guitar during services. These men included Reverend Smith (after 1944), as well as Reverend Edward D. Parks and Reverend James F. Ballard.

Tupelo Hardware Company 🎵

114 West Main Street
P.O. Box 1040
Tupelo, Mississippi 38802
(601) 842-4637

Perhaps the second-most-important Elvis Presley site in Tupelo after his birthplace is the Tupelo Hardware Company. This is where Gladys Presley bought her son his first guitar. The business was purchased by George H. Booth in 1926, and is still owned by his son, George H. Booth II. Specializing in industrial and mill supplies as well as hardware, Tupelo Hardware also has been one of those types of emporiums found in

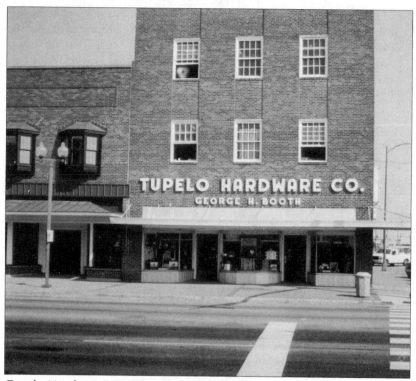

Tupelo Hardware Company on West Main Street, where Gladys Presley bought her son his first guitar in 1946. A guitar case painted on the floor now marks the place where the famous transaction occurred. (Photo courtesy of Tupelo Hardware Company, used by permission.)

◆

small towns that sells a lot more than just hardware. In 1946 this included musical instruments.

As the story goes, Elvis frequently came into the store after school with his eyes gravitating to a .22-caliber rifle. Then, as now, many preteen and teenage boys in the South were avid hunters, and Elvis wanted to be part of the sport. Forrest L. Bobo, who was married to one of Gladys's relatives, worked at Tupelo Hardware, and he let Elvis play with the rifle—throwing the bolt and so forth—but it was store policy not to sell a gun to a child. One day, Elvis came in with his mother, who had promised to buy him a present. He showed her the gun, but she said no.

As legend has it, Elvis threw a tantrum when told he couldn't have the rifle. However, when his mother said that he could pick out something else, he chose a guitar. Forrest Bobo recalled having told Elvis that if he had a guitar he might become famous someday. Bobo had no idea

how prophetic that statement was. Gladys paid $7.75 for the instrument, and the rest is history. A guitar case painted on the floor now marks the spot where the famous transaction occurred.

Although the Presleys moved to Memphis two years later in 1948, Elvis performed in Tupelo twice as an adult, in 1956 and 1957, and is re-called to have stopped into Tupelo Hardware to purchase guitar picks.

Today, Tupelo Hardware offers a variety of memorabilia items to commemorate the historic January 1946 event. These include T-shirts, yardsticks, lighters, and guitar-shaped key chains, all of which are marked with the store's logo and the legend, "Where Gladys bought her son his first guitar."

Tupelo Hardware is open during regular business hours, and the staff are very friendly to, albeit a bit amused by, the many Elvis Presley fans who come to visit. Since hours are subject to change, call or write ahead for specifics.

Lee County Jail ⚖

301 North Front Street
Tupelo, Mississippi 38801
(601) 841-9040

In November 1937, when Vernon Presley was arrested for altering a check given to him by Orville Bean, he did time in the Lee County Jail. As the story goes, Vernon sold Bean a calf for $4.30 and then altered the check to read $40. In May 1938, Vernon Presley was sentenced to three years at the Mississippi State Prison at Parchman—known as Parchman Farm—in Sunflower County, Mississippi. Vernon was released from prison on January 4, 1941.

Tupelo Fairgrounds ♫

East Main Street at Cockerall Street
Tupelo, Mississippi 38801

The Tupelo Fairgrounds were the venue for what was probably the first Elvis Presley performance before an audience outside of events at his church and school. It was also his first performance to be broadcast on the radio. The occasion was the Mississippi-Alabama Fair and Dairy Show, held at the Tupelo Fairgrounds on October 3, 1945. J. D. Cole, the principal at East Tupelo (now Lawhon) Elementary School, entered Elvis and several of his other students in a singing contest sponsored and broadcast by WELO radio in Tupelo.

Elvis sang the song "Old Shep" and was awarded second prize, which netted him $5 and free admission to the amusement rides all day. It was long reported that first place went to Becky Harris, who claimed on many occasions as an adult that it was she who beat Elvis. However, she did not. Becky Harris did win first place in 1946, but the 1945 winner was Elvis's schoolmate Shirley Jones Gallentine, who sang "My Dreams Are Getting Better All the Time." Shirley took home a $25 war bond, but her singing career did not rise nearly so meteorically as that of the second-place winner. Previous to their legendary Mississippi-Alabama Fair and Dairy Show duel, Shirley had sung with Elvis in a number of school productions.

When Elvis made his second appearance at the Tupelo Fairgrounds, he did so on the way from being a star to becoming a major celebrity. On September 26, 1956, he was being honored as a hometown-boy-made-good. The occasion was being celebrated as "Elvis Presley Day," with a parade and two concerts in which Elvis was backed by the singing group the Jordanaires. The performances were recorded and eventually released by RCA in the 1984 Golden Celebration boxed set.

The third and last Elvis Presley appearance came on September 27, 1957, and is remembered locally for his having donated his $10,000 fee to the city of Tupelo. Elvis musicologists recall this as being his first concert without his backup musicians Scotty Moore and Bill Black.

Today the Tupelo Fairgrounds is no longer used for its original purpose, having been replaced by the Northern Mississippi Agri-Center in neighboring Verona, Mississippi. In recent years the original fairgrounds has been used by Tupelo city maintenance crews for storage, but there has been talk of a major development on the site. As late as 1998, the original 1945 grandstands still stood, but the stage where Elvis performed in 1945, 1956, and 1957 was already gone.

Milam Intermediate School 🎓

720 West Jefferson Street
Tupelo, Mississippi 38801
(601) 841-8920

Known as Milam Junior High School at the time, this was the school where Elvis Presley attended the sixth, seventh, and part of the eighth grade, entering there in September 1946. He left in November 1948 when the Presley family made the move to Memphis. It is recalled that two of his teachers at Milam were Mrs. Quay Web Camp and Virginia Plumb. Unlike Lawhon Elementary School in the former East Tupelo, where a memorabilia-filled glass case is on display, there is nothing at Milam Intermediate School to commemorate his years here. There has been some discussion about whether there should be, but to date, noth-

ing has been done. Much of the school was remodeled in 1981. However, a substantial part of the original 1927 school wing remained as it was in Elvis's time.

Milam Intermediate School is an operating school, and, as such, it may be visited only during regular school hours, with the permission of the school administration, and in such a way as to not disrupt classes that are in session. As with Lawhon Elementary School, the administration is used to visits from Elvis Presley fans and the staff is generally accommodating. Phone ahead to schedule a visit and note that the building is closed when school is not in session.

McDonald's Restaurant ✕

372 South Gloster Street
Tupelo, Mississippi 38801
(601) 844-5505

A favorite stop for Elvis Presley fans visiting Tupelo, this McDonald's features a large cut-glass panel commemorating the King, as well as hundreds of items of Elvis memorabilia from the collection of Robert L. Hudson. In addition to photographs and albums covers, the collection is noted for its many dining-related items, including plates, glasses, cups, and mugs. This site is approximately one half-mile south of Milam Intermediate School. Please note the address, because this is one of several McDonald's restaurants in the Tupelo area, and one of two on South Gloster Street. It is open during regular business hours and is filled with the kind of conversation pieces that make it easy to meet kindred spirits.

Chapter 2

The Deep South beyond Tupelo

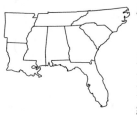

This chapter includes sites that are located in Louisiana, Alabama, Florida, Georgia, and the Carolinas, as well as in Mississippi outside of Tupelo. With the exception of the Municipal Auditorium in Shreveport, Louisiana, the concert venues for each state are grouped together, with the entries being in chronological order by the date of the first Elvis concert given in a particular place.

As with all the other parts of the United States, many of the important sites associated with the life and times of Elvis Presley are gone. These include the Captain Shreve Hotel in Shreveport, where the singer stayed with Scotty Moore and Bill Black on their visits to that city for appearances on radio's *Louisiana Hayride*. Some sites were probably fictitious, such as the Vieux Carré Saloon in New Orleans that was used in a scene from the movie *King Creole* (1958).

However, many important sites still remain, including the Municipal Auditorium in Shreveport, where the actual performances broadcast on *Louisiana Hayride* took place, and the Charlotte Motor Speedway, where *Speedway* (1968) was filmed.

It should also be noted that certain southern venues were used for background scenes in various Elvis feature films. For *King Creole*, shooting was done in and around the French Quarter of New Orleans, and at nearby Lake Pontchartrain in early 1958. Fort Lauderdale, Florida, was the setting for *Girl Happy* (1965), a movie shot in June and July 1964. While most of the production was shot at Metro-Goldwyn-Mayer's Culver City, California lot, exteriors—including Elvis, as Rusty Wells, arriving in his red convertible—were filmed in Fort Lauderdale. That city got another "plug" as Elvis sang the song "Fort Lauderdale Chamber of Commerce" to costar Shelley Fabares and others at poolside.

The Elvis movie that involved the most expansive location-shooting in the South was *Follow That Dream* (1962). Exterior filming for this pro-

ject was done during August 1961 in Tampa, Florida, as well as in several cities in the northern part of the state, specifically Crystal River, Ocala, Yankeetown, and Inverness (where the courthouse was used extensively). While *Clambake* (1967) features exterior scenes filmed in and around Miami, Elvis was not there. United Artists flew an Elvis impersonator to Miami, and Elvis stayed in Los Angeles.

In this chapter, travel directions for visiting an individual site are given only when such a site is located some distance away from a city with a major airport.

Municipal Auditorium ♫

705 Grand Avenue
Shreveport, Louisiana 71101
(318) 673-7727

KWKH Radio ♫

6341 Westport Avenue
Shreveport, Louisiana 71129
(318) 688-1130

A major milestone in Elvis's career came in 1954, when he was invited to appear on *Louisiana Hayride*, a country-music radio program broadcast by station KWKH from the 3,500-seat Municipal Auditorium in Shreveport. Second only in importance to the *Grand Ole Opry*—broadcast from Nashville, Tennessee, by WSM Radio—*Louisiana Hayride* was carried by nearly two hundred CBS network affiliate stations from El Paso, Texas, to Miami, Florida, and Richmond, Virginia. The show provided important exposure for country acts. Indeed, stars from Hank Williams to Gene Autry had used *Louisiana Hayride* as a stepping stone to national prominence.

With Scotty Moore and Bill Black as his backup musicians, Elvis made his first *Hayride* appearance on October 16, 1954. Elvis was paid $18 per show, and Bill and Scotty each earned $12. (Elvis's stipend on the radio program was increased to $200 in November 1955.) By the time of his last regular appearance on *Louisiana Hayride* in April 1956, he was getting paid much more at other venues. He had clearly outgrown the medium that first brought his sound to a wide audience throughout the South and beyond. He was heard one last time on *Louisiana Hayride,* broadcast live from the Louisiana Fairgrounds, on December 15, 1956.

All of Elvis's *Louisiana Hayride* shows were broadcast by radio, but the March 5, 1955, show was also televised in the Shreveport area. This would be the first-ever appearance of Elvis on television. All of Elvis's

Louisiana Hayride appearances originated at the Municipal Auditorium in Shreveport, except as noted below.

Elvis Appearances on *Louisiana Hayride*:

October 16, 1954
October 23, 1954
November 6, 13, 20, 27, 1954
December 4, 11, 18*, 1954
January 8, 15, 22, 1955
February 5, 19, 1955
January 8, 15, 22, 1955
March 5, 12, 26, 1955
April 2, 9, 23**, 30*, 1955
May 14, 21, 1955
June 4, 11, 25, 1955

July 2, 1955
August 6, 27, 1955
September 10, 24, 1955
October 1, 8, 29, 1955
November 5, 12, 19*, 26, 1955
December 10, 17, 31, 1955
January 7, 14, 21, 1956
February 25, 1956
March 3, 10, 1956
April 7, 1956
December 15, 1956***

* Remote broadcast from Gladewater, Texas.
** Remote broadcast from Waco, Texas.
*** Remote broadcast from Louisiana Fairgrounds, Shreveport, Louisiana.

..

Louisiana Fairgrounds/ Louisiana State Fair ♫

3701 Huston Street
Shreveport, Louisiana 71109
(318) 631-0038

As noted above, the Louisiana Fairgrounds were the site of Elvis's last performance broadcast on the *Louisiana Hayride* radio program. The concert took place on December 15, 1956, eight months after Elvis's last regular *Louisiana Hayride* appearance downtown at the Shreveport Municipal Auditorium. It was a remote broadcast by KWKH Radio of a benefit performance for the YMCA, at which the crowd was estimated to have numbered 10,000.

Fairmont Hotel

(formerly the Roosevelt Hotel)
123 Baronne Street
New Orleans, Louisiana 70112

In 1958, when Elvis came to the Crescent City for the *King Creole* (1958) movie location work, he stayed on the tenth floor of the Roosevelt Hotel. The hotel was not featured in any of the scenes in *King Creole,* and it has been substantially remodeled since 1958.

Citrus County Courthouse

110 North Apopka Avenue
Inverness, Florida 34450
(352) 637-9410 (Citrus County Clerk of the Court)
(352) 637-9400 (Florida Circuit Court)

The county seat of Citrus County, Inverness is presently a town of 5,900 people in northern Florida. In 1961 its courthouse was a featured setting for Elvis when he came to town to film *Follow That Dream* (1962). The courthouse is still present, and is located near the center of town on Apopka Avenue.

To reach Inverness from the Tampa/St. Petersburg area, take Interstate 75 north to Exit 65 near the town of Bushnell. Instead of going toward Bushnell, take County Road 48 northwest eleven miles to Floral City. From Floral City, take U.S. Highway 41 north for six miles to Inverness. To reach Inverness from the Orlando area, take the Florida Turnpike toll road northwest to Wildwood, near Interstate 75. At Wildwood, look for signs directing you to Florida Route 44, which will take you the last eighteen miles into Inverness.

Additional shooting for *Follow That Dream* took place in Ocala, Yankeetown, and Crystal River, Florida, all of which are near Inverness. While Crystal River is in Citrus County, Ocala is the county seat of neighboring Marion County, and Yankeetown is just across the line in Levy County. Yankeetown got its name—an improbable one for a place in the South—from the Northerners who came here to watch the birds and to fish for largemouth bass.

To reach Crystal River from Inverness, drive west on Florida Route 44 for seventeen miles. Ocala is a major city about twenty miles north on Interstate 75. To reach Yankeetown from Inverness, drive north for seventeen miles on U.S. Highway 41 to the town of Dunnellon, which is located on the north shore of the winding Withlacoochee River. At

Dunnellon, turn west on Florida Route 40 and drive for about twenty miles. The sleepy little fishing town of Yankeetown is located on a point of land overlooking Withlacoochee Bay. The drives from Inverness to Crystal River or to Yankeetown are like stepping back into another time, a far cry from the fast-paced beach life of places such as Miami and Fort Lauderdale, and it is this sort of atmosphere that made *Follow That Dream* such a special Elvis film for his fans.

Fontainbleau Hilton Resort and Towers

4441 Collins Avenue
Miami, Florida 33140
(305) 538-2000

When Elvis returned to civilian life after his two-year hitch in the U.S. Army in 1960, his first television appearance was as an invited guest on a Frank Sinatra ABC-TV special filmed at the Fontainbleau Hotel and broadcast on May 12, 1960. Although it was entitled *Welcome Home Elvis*, it was really Frank Sinatra's show. Elvis sang two solos and did a duet with Old Blue Eyes on "Witchcraft," which was, at the time, one of Sinatra's hits. Other guests on the TV program included Nancy Sinatra— Elvis's official greeter when he returned from his army duty—as well as her father's Rat Pack buddies Peter Lawford, Joey Bishop, and Sammy Davis Jr. The special was taped on March 26, 1960.

The hotel was not used in the filming of any of Elvis's pictures, but during the 1960s it was a movie backdrop for Jerry Lewis in *The Bellboy* (1960) and for Sean Connery (as James Bond) in *Goldfinger* (1964). The refurbished 1,206-room beachfront property is now the Fontainbleau Hilton Resort & Towers.

The Karl E. Lindroos Collection 🏛

201 East Ocean Avenue, Suite 7
Lantana, Florida 33462
(561) 588-0095

One of the largest private collections of Elvis memorabilia in the world, the Lindroos Collection represents more than two decades of collecting by Karl Lindroos, a Palm Beach, Florida, real-estate developer. He spent a tremendous amount of time, money, and traveling to obtain the items, and then to prove their authenticity, before accepting them into the collection. All items have been obtained only from people closely associated with Elvis, such as Billy Smith, his first cousin; Lamar Fike, who

lived with Elvis in Germany and at Graceland and was with him from the early Sun Records years to the end; Marty Lacker, a close friend and employee for twenty-two years; and Sonny West, a very close pal to Presley for many years. Also included are items from the Elvis Presley Museum previously owned by singer Jimmy Velvet, another good friend of Elvis. In this collection, the documents are notarized and the motor vehicles come with title searches and copies of titles of ownership from motor vehicle authorities in Tennessee.

The collection was on display at Grenada Studio in Manchester, England, for eighteen months and had over one million visitors during that time. A major part of the collection was on display at High Chaparral, a steakhouse and theme park near Varnamo, Sweden, for three years, where it drew hundreds of thousands of visitors. (High Chaparral is part of a chain of Western America–themed restaurants in Europe and Australia.)

Among the vehicles is Elvis's 1962 Dodge motor home, which was used on movie locations as a dressing room. It was made to Elvis's specifications, with leather truckers' seats and specially ordered mattresses. Also in the collection are Elvis's last Harley-Davidson motorcycle, bought in Marina Del Rey, California, and used at Graceland for entertaining friends; his 1977 Chevrolet Silverado pickup truck; and his 1974 Mercedes 450 SLC, which was also used by Elvis's personal physician, Dr. George Nichopolous.

The guns in the collection include Elvis's Smith & Wesson .38 and the .22-caliber Derringer that he kept in his boot while performing on stage. The jewelry in the collection encompasses gold and diamond-studded TCB ("Taking Care of Business") and TLC ("Tender Loving Care") rings and necklaces, and a topaz ring once given to Malessa Blackwood, who dated Elvis in 1976.

Graceland Too 🏛

200 East Gholson Avenue
Holly Springs, Mississippi 38636
(601) 252-1918
(601) 252-7954

Paul MacLeod is the world's greatest Elvis Presley fan. Nobody else even comes close! Paul transformed his own home into a replica of Elvis's home; he named his son Elvis Aron Presley MacLeod; and when his obsession with Elvis and Elvis memorabilia became too much for Selena MacLeod, Paul's wife of twenty-two years, he told her, "'Bye."

Known officially as Graceland Too, Paul MacLeod's 1854 house, with its twin chimneys, is located only thirty miles south of the real—or

should we say "other"—Graceland in Memphis. The house is more of an approximation than a replica, but it comes close, with a portico and matched concrete lions that are essentially direct copies. Inside, there are even remnants of the original carpet roll and rubber backing that were used in the legendary jungle den at the other Graceland. Graceland Too displays more Elvis memorabilia per square foot than Graceland, with pictures, posters, and publications everywhere! Indeed, Paul MacLeod has an estimated ten million items in his collection, and as many as wall space allows are on display. His video and record collection rivals the RCA vaults, and MacLeod continuously monitors numerous television sets for any mention of the King. A special place is set aside for a dried flower, the first flower that was placed on Elvis's grave in 1977.

The most astonishing item in Paul MacLeod's Graceland Too is Elvis himself—Elvis Aron Presley MacLeod. Paul's twenty-something son is a working Elvis impersonator with an uncanny resemblance to the man whom he and his father idolize. The two live together at Graceland Too, with Paul's mother residing upstairs, out of sight, paralleling the role of Minnie Mae Presley in Elvis's life.

Graceland Too has been open to the public since 1990, with the current admission price being $5. It is conveniently located on U.S. Highway 78, nearly halfway between Memphis and Tupelo. Both of the MacLeod men act as tour guides and sleep in the living room so that they can be ready to give the tour anytime, day or night. Give them a break, though—call ahead and come at a decent hour.

Circle G Ranch 🏠

Mississippi Highway 301 at Goodman Road
Walls, Mississippi 38680

Located in De Soto County, less than five miles south of the Tennessee state line and the Memphis city limits, the 163-acre Circle G Ranch was a working cattle ranch that Elvis acquired primarily as a recreational getaway and a place to keep his horses. The ranch was known as Twinkletown Farm when Elvis acquired it from Jack Adams on February 9, 1967. The purchase price has been variously reported as $300,000, $437,000, or $500,000. Elvis renamed the spread the Circle G, with the "G" suggesting Graceland or Gladys or both. Later the name was officially changed to Flying Circle G to avoid confusion with a previous Circle G Ranch in Texas, although it has always been referred to simply as the Circle G.

Though Elvis did run eighteen head of Santa Gertrudis cattle on the ranch, he used the ranch primarily for recreation. He put up a ten-foot-high fence around the property to conceal it from the public road, and

stocked the ranch's small lake with fish for fishing. He bought a fleet of twenty-five Ford Ranchero trucks for his friends to drive while on the property, and had several mobile homes moved in for sleeping accommodations—rather than using the existing ranch house. It was in one of these trailers that Elvis and Priscilla spent their honeymoon when their trip to the Bahamas did not live up to Elvis's expectations. Elvis kept his horse, Rising Sun, on the Circle G, along with Domino, the horse that he bought for Priscilla.

However, the cost of upkeep on the ranch was such that Elvis decided to sell it two years after he bought it. Reportedly he sold it to a gun club in May 1969, but he took it back when they could not obtain a shooting permit. He finally sold it in May 1973 to the Boyle Investment Company. After his death, the ranch went through several incarnations as a tourist attraction, and during the late 1980s the ranch house was McLemore's Ranch House Restaurant.

To visit the ranch, drive south from Graceland in Memphis on Interstate 55 to the Tennessee-Mississippi state line and continue for another two miles to Goodman Road in Southaven. Turn right on Goodman Road for four miles to Mississippi Route 301. Turn left and the ranch house will be on the left, about a tenth of a mile from the intersection.

Mississippi State Penitentiary ⚖

Parchman, Mississippi 38738
(601) 745-6611

In May 1938 Vernon Presley was sentenced to three years in prison for altering a four-dollar check given to him by dairy farmer Orville Bean, for whom he worked. In November 1937 Vernon had sold Bean a calf for $4.30 and then altered the check to read $40.

Vernon Presley did his prison time at the Mississippi State Penitentiary at Parchman—known as Parchman Farm or Parchment Farm—in Sunflower County, Mississippi. This prison was, and still is, one of the toughest and most-feared maximum security prisons in the United States. The rich literature of American folk music contains many fearful references to "The Parchment Farm," and several songs that tell of the horrors of doing time in such a terrible place.

Vernon was said to have been released from prison on January 4, 1941, but because exact dates differ from source to source, it is unknown whether this is accurate, and whether he spent only nine months, or the full three-year sentence, or had the last five months of his sentence commuted for good behavior. Some stories say that while at Parchman, Vernon was bull-whipped, and carried the scars for the rest of his life. This is suggested as an

explanation for his never being seen without his shirt, even when lounging about the swimming pool at Graceland or when in Las Vegas.

Joni Mabe's Traveling Panoramic Encyclopedia of Everything Elvis 🏛

The Historic Loudermilk Boarding House Museum
271 Foreacre Street
Cornelia, Georgia 30531
(706) 778-2001

There are many categories of Elvis shrines. On the one hand, there are those which relate to places where he lived, appeared, or visited in his lifetime, and many of these contain museums, commemorations, and tributes. On the other hand, there are those that have been assembled since his death to pay tribute to him. Of the latter, Joni Mabe's Traveling Museum of Obsessions, Personalities, and Oddities, and Joni Mabe's Traveling Panoramic Encyclopedia of Everything Elvis, are among the most notable. This is partly because of their size and scope, but primarily it is because of Joni Mabe's own tireless efforts to promote her unusual collection and the memory of Elvis.

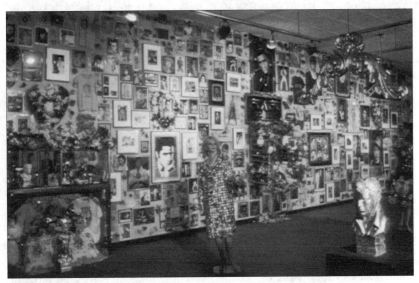

Joni Mabe's Traveling Panoramic Encyclopedia of Everything Elvis.
(Photo courtesy of Gerald Jones, via Joni Mabe, used by permission.)

Joni Mabe's collection contains thousands of items that are anything and everything Elvis, and include actual Elvis artifacts as well as artwork that she has created to pay tribute to Elvis and various aspects of his life. In her installations she creates a whole environment, with Elvis's music and image covering the entire walls of a given space. Joni describes her collection as "the ultimate Elvis world."

The most prized items in Joni's collection are the "Elvis Wart"—removed in 1957 and preserved in formaldehyde—and the "Maybe Elvis Toenail." She also has Elvis sweat, a lock of Elvis's hair, dirt from the grounds of Graceland, and a small bottle of water from the swimming pool at Graceland.

Joni Mabe began collecting in 1977, the year that Elvis died, because she fell in love with Elvis and saw his face everywhere she went. When Elvis died, she was outside waxing a 1965 International Scout in Mt. Airy, Georgia, and heard the news of Elvis's death on the vehicle's radio. Joni has been installing her huge collection in museums and other spaces since 1983. Among her notable installations was one for the opening of the Rock and Roll Hall of Fame in Cleveland, Ohio, in 1996.

Joni Mabe's Traveling Museum of Obsessions, Personalities, and Oddities and Joni Mabe's Traveling Panoramic Encyclopedia of Everything Elvis recently found a permanent home at the 1908 Loudermilk Boarding House Museum, Joni's grandparents' boarding house, which has been on the national register of historic places since 1994.

Cornelia, Georgia, is located eighty-five miles northeast of Atlanta. From Atlanta, take Interstate 85 to Exit 45, and then travel northwest on Interstate 985 to Exit 7. Finally, take U.S. Highway 23 for twenty miles to Cornelia.

Joni Mabe's Southern Icons of the Twentieth Century 🏛

Concourse E, Gate 30
Hartsfield Atlanta International Airport
6000 North Terminal Parkway
Atlanta, Georgia 30320
(404) 530-6600
(404) 530-6830

Among Joni Mabe's other installations is her Southern Icons of the Twentieth Century, which is on permanent display at Hartsfield Atlanta International Airport. The eclectic installation features memorabilia of Elvis, along with that of Patsy Cline, Ty Cobb, William Faulkner, Oliver

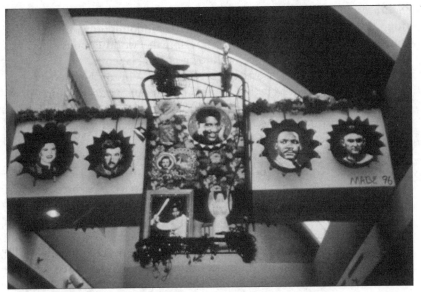

Joni Mabe's Southern Icons of the Twentieth Century is on permanent display at Hartsfield Atlanta (Georgia) International Airport. In addition to Elvis, it pays tribute to Patsy Cline and Martin Luther King Jr. (Photo by Joni Mabe, used by permission.)

◆

Hardy, Mahalia Jackson, Martin Luther King Jr., Flannery O'Conner, Otis Redding, Jackie Robinson, Hank Williams, and Tennessee Williams.

Charlotte Motor Speedway

P.O. Box 600
Concord, North Carolina 28026
(704) 455-3216

On June 12, 1967, filming began on the most ambitious of Elvis's race-car movies. The exterior scenes for *Speedway* were all shot at the Charlotte Motor Speedway, with ten cameras used to shoot the Charlotte 500 race sequences. *Speedway* starred Elvis as Steve Grayson, opposite Nancy Sinatra as Susan Jacks and Bill Bixby as Kenny Donford. It was Elvis's only film appearance with the older daughter of Frank Sinatra, the singing idol of the generation that preceded Elvis.

The Charlotte Motor Speedway was built by businessman O. Bruton Smith in 1960, and it hosted its first event, the World 600 race, on June 19, 1960. The speedway is still the largest sports stadium in the

Southeast. The 2,000-acre complex includes the 1.5-mile oval track surrounded by 115,000 permanent seats, 52 condominium units, 76 VIP suites, and a 7-story office tower housing the world-famous Speedway Club. In the movie, the club was known as the Hangout.

The speedway now hosts three NASCAR Winston Cup events each year, including two in May. The Winston Select All-Star race features previous Winston Cup winners in a special "Saturday Night Shootout" format. The Coca-Cola 600 is the third-largest single-day, paid sporting event in the United States, and the October running of the UAW-GM Quality 500 is usually pivotal in the season-long battle for the Winston Cup championship. In September 1996, Indy Racing League driver John Paul Jr. drove the first Indy-style race car around the Charlotte track in a three-hour test session. The Team Menard Lola chassis was powered by a Menard V6 engine and Paul recorded a quick lap of 26.01 seconds (207.61 mph), which unofficially broke the speedway's all-time track record.

The Charlotte Motor Speedway is located on U.S. Highway 29 North, between Charlotte and Concord. It is not to be confused with the smaller Concord Motor Speedway, which is located on U.S. Highway 601, south of Concord.

Elvis Concert Venues in Alabama 🎵

Within this state the venues of Elvis concerts are arranged in chronological order by the date of the first concert given in a particular place, then followed, chronologically, by the rest of the concerts given in that place. This is done to give readers the cities in the order that Elvis first experienced them.

Community Center
2901 East 19th Avenue
Sheffield, Alabama 35660
(205) 386-5615
(January 19, 1955; August 2, 1955; November 15, 1955)

★

Ernest F. Ladd Stadium
1621 Virginia Street
Mobile, Alabama 36604
(334) 478-3344
(May 4–5, 1955)

Radio Ranch Club
Mobile, Alabama 36601
(This venue was not found to be listed under this name, and is believed to have been torn down.)
(June 29–30, 1955)

★

Alabama State Coliseum
(formerly Garrett Coliseum)
1555 Federal Drive
Montgomery, Alabama 36107
(334) 242-5597
(December 3, 1955; March 6, 1974; February 16, 1977)

★

Chickasaw Municipal Auditorium
300 Thompson Boulevard
Chickasaw, Alabama 36611
(334) 452-6466
(September 14, 1970; June 20, 1973; June 2, 1975; August 29, 1976; June 2, 1977)

U of Alabama Field House
323 Paul Bryant Drive
Tuscaloosa, Alabama 35486
(205) 348-3600 (Field House)
(November 14, 1971)

University of Alabama Coliseum
323 Paul Bryant Drive
Tuscaloosa, Alabama 35486
(205) 348-5984 (Coliseum)
(June 3, 1975 and August 30, 1976)

University Memorial Coliseum
Auburn University
Auburn, Alabama 36830
(334) 844-4000
(March 5, 1974)

★

Von Braun Civic Center
700 Monroe Street Southwest
Huntsville, Alabama 35801
(205) 533-1953
(May 30-June 1, 1975 and September 6, 1976)

★

Birmingham Jefferson Civic Center
One Civic Center Plaza
Birmingham, Alabama 35203
(205) 458-8400
(December 29, 1976)

★

Elvis Concert Venues in Arkansas

The venues are arranged in chronological order by the date of the first concert. One of our Arkansas readers, Bill Bowden of Fayetteville, recalls Elvis having also performed at high school gyms in Marianna and Wester.

Catholic Club (St. Mary's Catholic Church)
123 Columbia
Helena, Arkansas 72342
(870) 338-3744
(December 2, 1954; January 13, 1955; March 8, 1955)
Charles Roskopf, a reader from Helena, wrote to tell us of the widely circulated anecdote that the priest in charge of renting the hall stopped one of Elvis's shows "because of his sensuous movements."

Municipal Auditorium
Texarkana, Arkansas 75502
(870) 772-8021
(December 3, 1954 and February 25, 1955)

Arkansas Municipal Stadium
Texarkana, Arkansas
(April 22, 1955 and September 2, 1955)

Arkansas Municipal Auditorium (later **Hut Club**)
Texarkana, Arkansas
(November 17, 1955)

Robinson HS Auditorium
21501 Highway 10
Little Rock, Arkansas 72212
(February 20, 1955; August 3,
1955; May 16, 1956)

T.H. Barton Coliseum
2600 Howard Street
Little Rock, Arkansas 72206
(501) 372-8341
(April 17, 1972)

★

**Camden City Municipal
Auditorium**
Camden, Arkansas 71701
(February 21, 1955, August 4,
1955 and November 16, 1955)

According to one of our read-
ers, Thomas Edison Bensberg, the
former owner of Bensberg's Music
Store in Camden, the "Muny Hall"
was used for basketball games
and banquets as well as concerts.
The ground floor housed city
offices, such as the police depart-
ment. During the winter of 1964,
a transient who had broken into
the hall, started a fire on the stage
that damaged the building to the
point where it had to be demol-
ished. Mr. Bensberg recalls that
the first time Elvis came, it was by
Greyhound bus. The last visit was
by Cadillac. "By the time Colonel
Parker took him over," Mr.
Bensberg adds, "Camden was not
big enough." Indeed, Elvis never
returned.

★

City Hall
200 West Avenue at A Street
Hope, Arkansas 71801
(870) 777-6701
(February 22, 1955)

★

Coliseum in Fair Park
Hope, Arkansas 71801
(June 5, 1955)

Watson Chapel High School
4000 Camden Road
Pine Bluff, Arkansas 71603
(870) 879-3230
(February 23, 1955)

Pine Bluff Convention Center
One Convention Center Plaza
Pine Bluff, Arkansas 71601
(870) 536-7600
(September 7 and 8, 1976)

National Guard Armory
2000 Fairgrounds Road
Newport, Arkansas 72112
(870) 523-8980
(March 2, 1955)

Porky's Rooftop Club
Highway 67
Newport, Arkansas 72112
(March 2, 1955)

According to Ida Lacy, librarian
and director of the Jackson Coun-
ty Library in Newport, Porky's
burned down long ago, and
owner Porky Sellers passed away
in 1998. Another reader, Peggy
Olsen, told us that she remembers
paying 50 cents to see Elvis at
Porky's. She also recalls that Porky
was an avid collector of Elvis
memorabilia. The current where-
abouts of this unique collection is
unknown.

★

Silver Moon Club
Newport, Arkansas
(July 21, 1955 and October 24,
1955)

**St. Francis County Fair
and Livestock Show**
Forrest City, Arkansas 72336
(870) 261-1730
(September 5, 1955)

★

High School Auditorium
467 Victoria Street
Forrest City, Arkansas 72336
(870) 633-1464
(November 14, 1955)

★

High School Gymnasium
Highway 63 at W. College Street
Bono, Arkansas 72416
(The building still exists, but it has
reportedly been converted to use
as offices and apartments.)
(September 6, 1955)

★

Earl Bell Community Center
1212 South Church Street
Jonesboro, Arkansas 72401
(870) 933-4604
(January 4, 1956)

★

**El Dorado High School
Auditorium**
501 Timberline Drive
El Dorado, Arkansas 71730
(870) 864-5100
(March 30, 1955)

★

**El Dorado Memorial
Auditorium**
100 West 8th Street
El Dorado, Arkansas 71730
(870) 881-4178
(October 17, 1955)

★

Elvis Concert Venues in Florida

The venues are arranged in chronological order by the date of the first con-
cert in a given city, followed, chronologically by other concerts in that city.

Peabody Auditorium
600 Auditorium Boulevard
Daytona Beach, Florida 32118
(904) 258-3169
(May 7, 1955; July 30, 1955;
August 9, 1956)

★

**Fort Homer Hesterly
Auditorium**
Florida National Guard
504 North Howard Avenue
Tampa, Florida 33606
(813) 272-2955
(May 8, 1955; July 31, 1955;
August 5, 1956; February 19,
1956)

★

**Curtis Hixon Hall
(now Curtis Hixon Park)**
Ashley Drive & Polk Street
Tampa, Florida 33606
(September 13, 1970; April 26,
1975; September 2, 1976)

★

Exhibition Hall
1320 Hendry St.
Fort Myers, Florida 33901
(941) 936-0363
(May 9, 1955 and July 25, 1955)

★

Southeastern Pavilion
Ocala, Florida 32678
(352)840-5606
(352) 629-1255
(May 10, 1955)

Municipal Auditorium
401 West Livingston Street
Orlando, Florida 32801
(407) 849-2376
(May 11, 1955; July 26–27,
1955; August 8, 1956)

Citrus Bowl Stadium
1610 West Church Street
Orlando, Florida 32805
(407) 849-2500
(February 15, 1977)

Gator Bowl/Stadium Baseball Park/Alltel Stadium
One Stadium Place
Jacksonville, Florida 32302
(904) 633-6100
(May 12–13, 1955; July 28–29,
1955; February 23–24, 1956)

Florida State Theater
Jacksonville, Florida 32203
(This venue was not found to be listed
under this name, nor was it found to
be listed under another name.)
(August 10–11, 1956)

Veteran's Memorial Coliseum
1145 East Adams Street
Jacksonville, Florida 32202
(904) 630-3900
(April 16, 1972; April 25, 1975;
September 1, 1976; May 30,
1977)

Palms Theater
West Palm Beach, Florida 33402
(This venue was not found to be listed
under this name, nor was it found to
be listed under another name.)
(February 20, 1956; February
13, 1977)

Florida Theater
1241 North Palm Avenue
Sarasota, Florida 34236
(This building still exists, but it has
closed.)
(February 21, 1956)

Bay Front Auditorium
(formerly the Municipal
Auditorium)
900 South Palafox Place
Pensacola, Florida 32501
(850) 444-7691
(February 26, 1956)

Polk Theater
121 South Florida Avenue
Lakeland, Florida 33801
(941) 682-8227
(August 6, 1956)

Lakeland Civic Center
700 West Lemon Street
Lakeland, Florida 33815
(941) 499-8100
(April 27–28, 1975; September
4, 1976)

Miami Beach Convention Center
1901 Convention Center Drive
Miami Beach, Florida 33139
(305) 673-7311
(September 12, 1970)

Florida Theater
St. Petersburg, Florida
(This venue was not found to be listed
under this name, nor was it found to
be listed under another name.)
(August 7, 1956)

Bay Front Center/Tropicana Arena
One Tropicana Drive
St. Petersburg, Florida 33705
(813) 892-5798
(September 3, 1976; February 14, 1977)

★

Sportarium
Hollywood, Florida 33021
(This venue was not found to be listed under this name, nor was it found to be listed under another name.)
(February 12, 1977)

★

Elvis Concert Venues in Georgia

Within this state the venues of Elvis concerts are arranged in chronological order by the date of the first concert given in a particular place, then followed, chronologically, by the rest of the concerts given in that place. This is done to give readers the cities in the order that Elvis first experienced them.

Silver Slipper
Atlanta, Georgia 30301
(This venue was not found to be listed under this name, nor was it found to be listed under another name.)
(October 8, 1954)

Fox Theater
Atlanta, Georgia 30301
(This venue was not found to be listed under this name, nor was it found to be listed under another name.)
(March 14–15, 1956)

Paramount Theater
Atlanta, Georgia 30301
(This venue was not found to be listed under this name, nor was it found to be listed under another name.)
(June 22–24, 1956)

Omni Coliseum
100 Techwood Drive Northwest
Atlanta, Georgia 30303
(404) 681-2100
The Omni Coliseum was the site of more Elvis concerts than any venue other than Nevada; Memphis, Tennessee; and

Shreveport, Louisiana (from where the *Louisiana Hayride* radio show was broadcast). The shows at the Omni took place on June 21, 29, and 30 (two shows), 1973; July 3, 1973; April 30–May 2, 1975; June 4–6, 1976; December 30, 1976.

★

City Auditorium
Waycross, Georgia 31501
(This venue was not found to be listed under this name, nor was it found to be listed under another name.)
(February 22, 1956)

★

Bell Auditorium
Augusta, Georgia
(This venue was not found to be listed under this name, nor was it found to be listed under another name.)
(March 20, 1956; June 27, 1956)

★

Sports Arena
Savannah, Georgia 31401
(This venue was not found to be listed
under this name, nor was it found to
be listed under another name.)
(June 25, 1956)

Civic Center
Savannah, Georgia 31401
(912) 651-6556
(February 17, 1977)

Macon City Coliseum
200 Coliseum Drive
Macon, Georgia 31201
(912) 751-9234
(April 15, 1972; April 24, 1975;
August 31, 1976; June 1, 1977)

★

Elvis Concert Venues in Louisiana 🎵

Within this state the venues of Elvis concerts are arranged in chronological
order by the date of the first concert given in a particular place, then fol-
lowed, chronologically, by the rest of the concerts given in that place. This is
done to give readers the cities in the order that Elvis first experienced them.

**Louisiana Municipal
Auditorium**
705 Grand Avenue
Shreveport, Louisiana 71101
(318) 673-7727
(This is where most of Elvis's appear-
ances on *Louisiana Hayride* took
place from 1954–1956; see pages
15–17. It is now a history museum.)

Lake Cliff Club
Shreveport, Louisiana 71101
(This venue was not found to be listed
under this name, nor was it found to
be listed under another name.)
(November 19, 1954; December
22, 1954)

Hirsch Coliseum
(This was known as the Hirsch
Youth Center when Elvis played
there in 1956.)
3207 Persian Boulevard
Shreveport, Louisiana 71109
(318) 631-0038
(December 15, 1956; June 7,
1975; July 1, 1976)

★

Golden Cadillac Club
New Orleans, Louisiana
(This venue was not found to be listed
under this name, nor was it found to
be listed under another name.)
(February 4, 1955)

New Orleans Auditorium
1201 St. Peter Street
New Orleans, Louisiana 70116
(504) 565-7470
(May 1, 1955; August 12, 1956)

★

West Monroe High School
201 Riggs Street
West Monroe, Louisiana 71291
(318) 323-3771
(February 18, 1955)

South Side Elementary School
500 South Vine Street
Bastrop, Louisiana 71220
(318) 281-4488
(February 24, 1955)

★

Baton Rouge High School Auditorium
2825 Government Street
Baton Rouge, Louisiana 70806
(504) 383-0520
(May 2, 1955)

Louisiana State University Assembly Center
Baton Rouge, Louisiana 70803
(504) 388-3202
(504) 388-6325
(504) 388-6621
(June 17–18, 1974; July 2, 1976; March 31, 1977 [canceled at intermission]; May 31, 1977)

Casino Club
Plaquemine, Louisiana
(This venue was not found to be listed under this name, nor was it found to be listed under another name.)
(July 1, 1955)

Monroe Civic Center
401 Lea Joyner Memorial Expressway
Monroe, Louisiana 71201
(318) 329-2225
(March 4, 7, and 8, 1974; May 3, 1975)

Lake Charles Civic Center
900 Lake Shore Drive
Lake Charles, Louisiana 70601
(318) 491-1256
(May 4, 1975)

★

Rapides Parish Coliseum
5600 Coliseum Boulevard
Alexandria, Louisiana 71303
(318) 442-9581
(March 29–30, 1977)

Elvis Concert Venues in Mississippi ♫

Within this state the venues of Elvis concerts are arranged in chronological order by the date of the first concert given in a particular place, then followed, chronologically, by the rest of the concerts given in that place. This is done to give readers the cities in the order that Elvis first experienced them.

Clarksdale City Auditorium
506 East 2nd Street
Clarksdale, Mississippi 38614

(601) 627-8431
(January 12, 1955; March 10, 1955; September 8, 1955)

American Legion Hall
Meridian, Mississippi 39302
(This venue is not known to still
exist under this name.)
(May 25, 1955)

★

**Meridian Community College
Stadium**
910 Highway 19 North
Meridian, Mississippi 39307
(601) 483-8241
(May 26, 1955)

★

**Bruce High School
Gymnasium**
430 East Countess Street
Bruce, Mississippi 38915
(601) 983-3350
(June 14, 1955)

★

**Belden High School
Gymnasium**
Belden, Mississippi 38826
(The high school in Belden was
demolished long ago.)
(June 15, 1955)

★

Slavonian Lodge Auditorium
120 Myrtle Street
Biloxi, Mississippi 39530
(228) 374-9771
(June 26, 1955)

★

**Airmen's Club
Keesler Air Force Base**
Biloxi, Mississippi 39534
(228) 377-1110 (Information)
(228) 377-3547 (Base historian)
(June 27 and 28, 1955;
November 7 and 8, 1955)

★

**Northeast Mississippi
Community College**
PO Box 311
Jefferson Street
Booneville, Mississippi 38829
(601) 728-9904
(601) 728-9028
(January 17, 1955)

★

Von Theater
Booneville, Mississippi 38829
(This venue is not known to still
exist under this name.)
(January 3, 1956)

★

**Alcorn County Court House
Assembly Hall**
600 East Waldron Street
Corinth, Mississippi 38834
(601) 286-7776
(January 18, 1955)

★

**Alcorn County Court House
Meeting Room**
600 East Waldron Street
Corinth, Mississippi 38834
(601) 286-7776
(April 7, 1955)

★

**Ripley High School
Gymnasium**
720 South Clayton Street
Ripley, Mississippi 38663
(601) 837-7583
(February 7, 1955)

★

American Legion Hall
Grenada, Mississippi 38901
(This venue is not known to still
exist under this name.)
(April 20, 1955)

★

High School Auditorium
Charleston, MS
(January 2, 1956)

★

Community House
Biloxi, Mississippi 39531
(The Community House was de-
stroyed in 1969 by Hurricane
Camille.)
(November 6, 1955)

★

Mississippi State Fair
1207 Mississippi Street
Jackson, Mississippi 39202
(601) 961-4000
(May 5, 1975; June 8–9, 1975;
September 5, 1976)

★

Elvis Concert Venues in North Carolina ♫

Within this state the venues of Elvis concerts are arranged in chronological order by the date of the first concert given in a particular place, then followed, chronologically, by the rest of the concerts given in that place. This is done to give readers the cities in the order that Elvis first experienced them.

Shrine Auditorium
New Bern, North Carolina 28560
(This venue was not found to be listed
under this name, nor was it found to
be listed under another name.)
(May 14, 1955; September 13,
1955)

★

City Auditorium/Civic Center
87 Haywood Street
Asheville, North Carolina 28802
(828) 259-5736
(May 17, 1955; September 16,
1955; July 22–24, 1975)

★

Memorial Auditorium
One East South Street
Raleigh, North Carolina 27601
(919) 831-6060
(May 19, 1955; September 21,
1955; February 8, 1956)

★

Fleming Stadium
Located at Stadium Street and
Denby Street
Wilson, North Carolina 27893
(September 14, 1955)

★

**Charles L. Coon High School
Auditorium**
Kenan Street South at Pine Street
Wilson, North Carolina 27893
(The school was closed, but the
building still stands.)
(February 14, 1956)

★

High School Auditorium
410 Unity Street
Thomasville, North Carolina 27360
(910) 476-4811
(September 17, 1955)

★

National Theater
(Now a parking lot across from
the Ragin' Cajun night club, it
was located near 303 South Elm
Street at Washington Street.)
Greensboro, North Carolina 27401
(February 6, 1956)

Coliseum
1921 West Lee Street
Greensboro, North Carolina
27403
(336) 373-7400
(April 14, 1972; March 13,
1974; July 21, 1975; June 30,
1976; April 21, 1977)

Center Theater
152 South Main Street
High Point, North Carolina 27260
(336) 885-6859 (Preservation
Society phone number)
(February 7, 1956)

Carolina Theater
222 North Tryon Street
Charlotte, North Carolina 28202
(704) 366-4239
(February 10, 1956—four shows)

Charlotte Coliseum
100 Paul Buck Boulevard
Charlotte, North Carolina 28217
(704) 357-4700
(June 26, 1956; April 13, 1972;
March 9, 1974; March 20,
1976; February 20–21, 1977)

★

Walter Williams High School
1307 South Church Street
Burlington, North Carolina 27215
(910) 370-6161
(February 15, 1956)

Carolina Theater
(now the Stevens Center)
405 West 4th Street
Winston-Salem, North Carolina
27101
(336) 723-6320
(February 16, 1956)

YMCA Gymnasium
119 West 3rd Avenue
Lexington, North Carolina 27292
(910) 249-2177
(March 21, 1956)

Cumberland County Civic Center
Highway 30 South
Fayetteville, North Carolina 28306
(910) 323-5088
(August 3–5, 1976)

Elvis Concert Venues in South Carolina

Within this state the venues of Elvis concerts are arranged in chronological order by the date of the first concert given in a particular place, then followed, chronologically, by the rest of the concerts given in that place. This is done to give readers the cities in the order that Elvis first experienced them.

Carolina Theater
Spartanburg, South Carolina 29301
(This venue was not found to be listed under this name, nor was it found to be listed under another name.)
(February 9, 1956)

★

Township Auditorium
1703 Taylor Street
Columbia, South Carolina 29201
(803) 252-2032
(March 19, 1956)

Carolina Coliseum
701 Assembly Street
Columbia, South Carolina 29201
(803) 251-6373
(February 18, 1977)

★

College Park Baseball Field
Charleston, South Carolina 29401
(803) 724-7321 (Charleston Parks Department)
(June 28, 1956)

Chapter 3

Memphis, Tennessee

Elvis Presley moved to Memphis, Tennessee, in 1948 at the age of thirteen, and he died there in 1977 at the age of forty-two. There are more sites that are of interest to Elvis fans in Memphis than in any other city in the United States. Graceland, his home for most of his adult life, is situated here, as are most of the houses in which the King lived during his life. The studio where he recorded his first songs is in Memphis and so is the studio where he recorded many of his best musical numbers. The church that he attended was in Memphis, as were the sites where he appeared in many of his earliest public performances. Most of the latter are still there.

Each year, in the days surrounding the anniversary of Elvis's birth (on January 8, 1935), there are numerous activities and events in and around Memphis. Always included is a ceremony at Graceland in which Elvis Presley Day is proclaimed throughout Memphis and Shelby County. Music and dance events are usually presented throughout the city during the annual birthday celebration.

The biggest Elvis commemorations occur during Tribute Week—also known as Elvis Week—which is the week surrounding the anniversary of Elvis's death on August 16, 1977. There are usually activities and events at Graceland, and throughout the city, for the entire week. These include concerts, dances, conventions, and dozens of other happenings attended by fans and media from around the world. The annual candlelight vigil is held at the Meditation Garden in Graceland on the evening of August 15.

We have subdivided this chapter into the following sections: (1) Graceland, (2) the area around Graceland, (3) Union Avenue between South Bellevue Boulevard and downtown Memphis, (4) downtown Memphis, and (5) outlying sites (north, south, east, and southeast). The anchor point is Memphis International Airport and/or, where applicable, Elvis Presley Boulevard (formerly U.S. Highway 51 South), with the walking and driving tours leading from point to point within each tour.

The image within the text shows an outline of Tennessee with "★ Memphis" marked.

Graceland 🏠 🏛

3764 Elvis Presley Boulevard South
(formerly U.S. Highway 51 South)
Memphis, Tennessee 38116

Mailing address:
P.O. Box 16508
Memphis, Tennessee 38186-0508
(901) 332-3322
(800) 238-2000
(888) 358-4776 (Graceland gift mail-order department)

There are a number of important Elvis sites that consider themselves in the running for the second most important Elvis site, but there is only one Number One. Graceland is the supreme Elvis shrine, both in terms of its historic and symbolic importance to the memory of Elvis and in the number of visitors that it has each year. It is estimated that 750,000 visitors come to Graceland annually, with over 30,000 of them coming just for Tribute Week in August.

Graceland is an estate of 13.67 acres located about ten miles south of downtown Memphis and about two miles west of Memphis International Airport. It was originally part of a 500-acre farm established during the Civil War by S. E. Toof, the publisher of the Memphis Daily Appeal, and named for his daughter Grace. At that time the area was rural and not part of any city or town, but by the early twentieth century it had become part of the Memphis suburb of Whitehaven. It was not until 1969 that Whitehaven—and Graceland within it—was incorporated into the Memphis city limits.

The familiar two-story white Graceland mansion was constructed in 1939 for Dr. Thomas Moore and his wife, Ruth, who was the niece of Grace Toof. In March 1957, when Dr. and Mrs. Moore's daughter Ruth Marie Moore sold the house to Elvis, it was being used as the Graceland Christian Church. He reportedly paid $100,000, with the only other bidder being the Memphis YMCA, which offered $35,000.

In August 1977, when Elvis passed away, Graceland was estimated to be worth $500,000, with an annual maintenance bill estimated to be roughly the same. In his will, Elvis left Graceland to his daughter, Lisa Marie, with her mother, Priscilla, as caretaker until the girl reached adulthood. Priscilla did not sell Graceland, but rather opened it to public tours, beginning on June 7, 1982. It has been open to the public ever since.

The Graceland complex now includes the Graceland mansion and estate—containing Meditation Garden—on the east side of Elvis Presley Boulevard, as well as Graceland Plaza on the west side of Elvis Presley

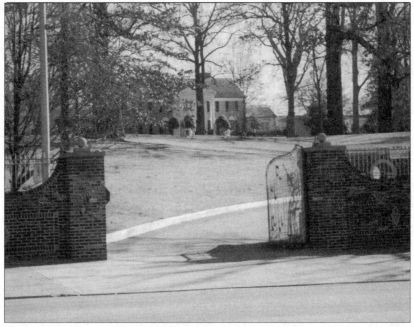

The walls of Graceland, the premier Elvis Presley site in the world. Elvis bought the property in 1957 and it remained his primary residence for the rest of his life. (Photo by Joe Watkins, used by permission.)

◆

Boulevard. Graceland Plaza is home to various Elvis museums, as well as the ticket office for the mansion and estate tours.

To reach Graceland from Memphis International Airport, drive west on either Brooks Road or Winchester Road to Elvis Presley Boulevard and turn left (south). From downtown Memphis, take Interstate 55 South to Exit 5B (Elvis Presley Boulevard) and drive approximately one mile south to Graceland. Enter the visitor parking facility located at Graceland Plaza on the west side of the street. Guest vehicles are not allowed to enter the actual mansion grounds. Currently, visitor parking costs $2.00 and is security-patrolled.

Admission to most of the sites at Graceland (see below) are by way of individual tickets, but a Platinum Tour package, which includes the mansion tour as well as all other Graceland attractions, is available. The Platinum Tour package represents a substantial savings over separate tickets to individual attractions as listed below. The adult Platinum Tour is $18.50, with seniors over sixty-two at $16.65, children seven through twelve $11.00, and children six and under admitted free. Because all such information is subject to change, it is a good idea to call ahead for details.

Graceland Mansion and Adjacent Grounds 🏠

Built with Tennessee limestone, the Graceland mansion originally contained twenty-three rooms, only five of which were bedrooms, but Elvis painted the trim of the exterior blue and gold and expanded the building with the addition of a trophy room over the back patio and a then state-of-the-art recording studio. RCA recorded material intended for commercial release at the Graceland studio. In 1976 they recorded "Way Down," "Pledging My Love," "Moody Blue," and "Solitaire" in two sessions, February 2 through February 8 and October 29 through October 31.

The Graceland estate and mansion are located on the east side of Elvis Presley Boulevard. The ticket office is across the street at Graceland Plaza. A shuttle bus takes ticket-holders across Elvis Presley Boulevard, through the distinctive gates, and up the driveway to the Graceland mansion. During the drive, guests may listen on individual headsets to a specially produced audio tour presentation—available in several languages—featuring an informative narrative, plus music and commentary from Elvis himself, and the personal recollections of Priscilla Presley.

The walking tour of the Graceland mansion includes the living room, music room, dining room, kitchen, television room, pool room, and Elvis's "jungle" den. The highlight of the mansion tour is the King's trophy building (separate from the trophy room within the mansion), which includes his vast collection of awards and gold records, along with an extensive display of personal mementos, stage costumes, jewelry, and photographs. The jumpsuit that he wore for his famous *Aloha from Hawaii* concert in 1973 is displayed here, as are his tuxedo and Priscilla's wedding dress from their 1967 nuptials.

Added in time for Mother's Day in 1998 is a tour of Elvis's parents' bedroom, restored as it was in 1958. Vernon and Gladys Presley used this ground-floor bedroom off the foyer from the time Elvis purchased Graceland in 1957 until Gladys died in 1958. Later the room was occupied by Elvis's grandmother Minnie Mae Presley and then by Elvis's aunt Delta Presley Biggs. There was no remodeling of the rooms over the years, and most of the 1958 furnishings and fixtures had been kept in storage. The Graceland archives staff restored the room using the original dresser, chests, night tables, light fixtures, and headboard. The furniture is traditional in design, with a painted white finish and gold accents. The headboard still has its original velvet upholstery in purple, one of Gladys Presley's favorite colors. The purple velvet draperies and bedspread have been re-created to match. The walls and carpeting are white. Adjacent to the bedroom is the accompanying bathroom, which features its original 1950s lavender tile and fixtures. The bathroom also has a poodle-dog

wallpaper design, which had to be re-created from surviving samples of the wallpaper used during the time Elvis's parents occupied this suite.

The tour continues with a visit to the adjacent grounds of the main house, which contain Elvis's racquetball building and his original business office. The tour concludes with a quiet visit to the Meditation Garden, where Elvis and members of his family have been laid to rest.

The guided tour lasts sixty to ninety minutes. Adult admission, $5.00 when Graceland opened in 1982, is now $10.00, with seniors over age sixty-two at $9.00, children seven through twelve at $5.00, and children six and under admitted free. Graceland operations are open seven days a week, year-round from 8:30 A.M. until 5:00 P.M. on weekdays and, on Labor Day, Memorial Day, and all weekends, from 7:30 A.M. until 6:00 P.M. However, the mansion tour is closed on Tuesdays from November through February, though other attractions and operations remain open. All operations are closed on New Year's Day, Thanksgiving Day, and Christmas Day. Because such information is subject to change, it is a good idea to call ahead for details and times.

Although the Graceland complex is closed on Christmas Day, the Christmas season is a special time of year here. Fans will remember that Elvis always liked to spend Christmas at Graceland, and that he always had the mansion and the lawn area around it elaborately decorated for the holiday. The tradition still continues, as each year, from the day after Thanksgiving through his birthday on January 8, Elvis's original Christmas lights and decorations are in place at the house and on the front lawn. The mansion interior and Graceland Plaza across the street are festively decorated as well.

The Meditation Garden

Located on the Graceland grounds near the mansion, the Meditation Garden (not Meditation Garden*s*) was designed and constructed at Elvis's request in 1963 by Anne and Bernie Granadier. It was originally just that, a meditation garden.

When Elvis's mother, Gladys, died in August 1958, she was buried at nearby Forest Hill Cemetery at 1661 Elvis Presley Boulevard. When Elvis died in August 1977, he was interred next to his mother at Forest Hill. However, the surge of fans visiting Elvis's grave site and an alleged plot to steal Elvis's body led to the removal of the bodies of both Gladys and Elvis to Graceland, where access could be controlled. Gladys and Elvis were formally interred in the Meditation Garden on the night of October 2, 1977. Elvis's father, Vernon Presley, was buried next to his wife and son on June 28, 1979. Minnie Mae Presley—Vernon's mother and Elvis's grandmother—who had lived at Graceland since Elvis bought the estate, was buried in the Meditation Garden following her death on May 8, 1980.

The Meditation Garden contains Elvis's headstone, in which his middle name is spelled "Aaron" rather than "Aron" as it is on his birth certificate. As has been pointed out occasionally in the media, Elvis's body is not buried directly beneath the headstone.

The Meditation Garden was opened to public access on November 27, 1977, five years before the Graceland mansion was open to public tours. Today the Meditation Garden is included as part of the Graceland mansion tour (see above) and it is also open for ninety minutes most mornings for free walk-up visits. The walk-up period ends thirty minutes prior to the start of regular tours. When visiting the Meditation Garden, please note that this is a place of quiet contemplation, and be mindful of others who have come to pay their respects.

Bijou Theater

A good initial stop for first-time visitors to Graceland Plaza, *Walk a Mile in My Shoes* is a 22-minute film presentation at the Bijou Theater in the middle of Graceland Plaza. Free to all visitors, the film takes guests through highlights of Elvis's life and career. It is shown on the hour and the half-hour every day that Graceland is open.

Sincerely Elvis (Museum)

Adjacent to the Bijou Theater and the main ticket office at Graceland Plaza, Sincerely Elvis is a small museum offering a self-paced tour featuring many of Elvis's personal items, as well as candid photos, home-movie clips, offstage clothing, home furnishings and accessories from mansion rooms not seen on the mansion tour, books, personal mementos, and horse-riding gear and sporting equipment that he used. Adult admission is $3.50, with seniors over sixty-two at $3.15, children seven through twelve at $2.25, and children six and under admitted free. Plaza hours of operation are the same as those for Graceland as a whole. Because all such information is subject to change, it is a good idea to call ahead for details and times.

Graceland Plaza Shops and Restaurants $

Chrome Grille (a diner near the Elvis Presley Automobile Museum that offers Southern-style plate lunches and world-famous Memphis barbecue in an automotive-theme atmosphere)

Elvis Threads (T-shirts, jackets, hats, and other Elvis and rock 'n' roll apparel)

Gallery Elvis (upscale art pieces and collectibles!

Good Rockin' Tonight (a wide selection of Elvis records, compact discs, videotapes, posters, and books!

Rockabilly's Diner (a nostalgic diner featuring a menu of cheese-burgers, hot dogs, pizza, chicken sandwiches, fries, and other casual fare!

Shake, Split & Dip (an old-fashioned ice cream parlor)

Elvis Presley's Heartbreak Hotel

Opened since the first edition of this guide in 1999, Elvis Presley's Heartbreak Hotel is a new and long-awaited addition to Graceland Plaza. Each of the 128 guest rooms features a gold-flecked royal blue carpet, as well as custom drapery and bedspreads in a blue and gold print. The walls are accented with framed black-and-white photos of Elvis. Naturally, there is an in-house television channel running continuous Elvis videos.

The Heartbreak Hotel also features four themed suites. The *Graceland Suite* "gives guests the sense of living in their own diminutive Graceland Mansion," and includes room designs inspired by Elvis's own living room, dining room, television room, billiard room and "jungle room" den. The art deco *Hollywood Suite* has celebrates Elvis as a movie star. Inspired by Elvis's recording career, the *Gold & Platinum Suite* has a 1950s/1960s retro decor. Last, but not least, the *Burning Love Suite* features a rich, romantic decor with "lots of red." The Heartbreak Hotel offers package deals that include accommodations, as well as tickets for tours of the Graceland mansion and other Graceland Plaza attractions. Reservations can be made by phoning 1-877-777-0606 (toll free) or 901-332-1000.

Elvis Presley Automobile Museum

Highlights from Elvis's renowned car collection are now on display at the Elvis Presley Automobile Museum, which is across Elvis Presley Boulevard from the Graceland mansion at the south end of Graceland Plaza. A green Cadillac convertible marks the entrance. Inside, guests walk down a landscaped, curbed, tree-lined road past colorful exhibits of vehicles owned and enjoyed by Elvis.

Included are the famous 1955 pink Cadillac that he purchased for his mother — which was still parked at Graceland when he died — his 1956 purple Cadillac convertible, his 1956 Continental Mark II, and his 1971 and 1973 Stutz Blackhawks, as well as his Harley-Davidsons and three-wheeled motorcycles. The displays also include automobile-related per-

sonal items that belonged to Elvis, such as his leather motorcycle jackets, gasoline credit cards, and his driver's license.

The centerpiece of the museum is a recreation of a vintage 1950s drive-in movie theater, where guests sit in authentic seats from 1957 Chevrolets to watch a brief video, with the sound coming from vintage drive-in speakerboxes.

Tickets for the self-guided, self-paced tour are available at the ticket office or in the gift shop next door to the museum entrance.

Adult admission is $5.00, with seniors over sixty-two at $4.50, children seven through twelve at $2.75, and children six and under admitted free. The museum is open seven days a week, year-round, except New Year's Day, Thanksgiving Day, and Christmas Day. Because all such information is subject to change, it is a good idea to call ahead for details and times.

The Lisa Marie ✈

Many stars today have private jets, but in the 1970s few celebrities boasted four-engine jetliners as personal airplanes. Then again, Elvis was unique in many ways, and he was the King. His private plane was a Convair 880 jetliner named for his daughter, Lisa Marie, and the aircraft's namesake spent her ninth birthday aboard. The call sign of the aircraft, or moniker by which it was known when communicating with the control tower and other aircraft was "Hound Dog One." Unofficially, it was known as "The Flying Graceland."

The Convair 880 was the first jetliner type developed by the Convair Division of General Dynamics Corporation, a San Diego, California, company famous in the 1940s and 1950s for its military aircraft and its popular family of medium-sized airliners with twin piston engines. The 880 jetliner was produced in the late 1950s in large part because of a specific order from Howard Hughes, the eccentric billionaire and aviation enthusiast, who wanted to purchase Convair aircraft to fly for TransWorld Airlines (TWA), which was then a subsidiary of the Hughes Tool Company. Convair's first jetliner was the four-engine Model 22, originally known as the Skylark. In practice, the aircraft would be known as the "Jet 880" or simply the "880," a number that was based on its cruising speed in feet per second—a clever way of demonstrating the importance of speed in the new world of jet air travel. Indeed, the 880 was the fastest of the first-generation jetliners, as it was powered by the General Electric CJ-805-3 turbojet, the commercial version of the J79 engine that powered the supersonic B-58 bomber. The 880's maiden flight occurred in January 1959.

However, the first airline to put the 880 into service was Delta rather than TWA, because Hughes could not get the needed financing for the 880s that he'd ordered, and because of a battle then raging for control of TWA. While Convair projected a need to sell more than 120 aircraft to

offset development costs and turn a profit, only sixty-five 880s were built, and this played a role in Convair quitting the airplane business. One important factor in its poor sales record was its lack of good fuel economy. During the oil crisis of the early 1970s, this proved disastrous, and by 1975 the last 880 operator had retired its 880 fleet and, as a result, used 880s flooded the market.

In November 1975, Elvis bought an 880 from Delta Air Lines for $1.2 million and named it *Lisa Marie*. He had it painted in a custom blue-and-white color scheme, and the vertical stabilizer was emblazoned with his TCB ("Taking Care of Business") logo which incorporated a gold lighting bolt. The *Lisa Marie* was registered as N880EP, with the "N" being the United States civil aircraft registration code, and the "880EP" standing simply for "Elvis Presley's 880."

The jet required a three-person flight crew, which included Elwood David as captain, Ron Strauss as co-pilot, and Jim Manning as flight engineer. Carol Bouchere served as flight attendant.

After spending over a million dollars purchasing the aircraft, Elvis targeted an additional $750,000 to have it remodeled in Fort Worth, Texas. The accoutrements included a conference room, a wet bar, four television sets, leather swivel chairs, a pair of couches, and a $14,000 queen-sized bed. It is not known why a king-sized bed was not installed in the King's airplane.

Though he had his Convair 880 for less than two years before his death, Elvis got a great deal of use out of her because he was on the road almost constantly during the last eighteen months of his life. When he died, the *Lisa Marie* was sold several times before being returned, grounded, and placed on display rather than being sold again.

Lisa Marie's specifications

Powerplant:
four General Electric CJ-805-3 turbojet engines rated at 11,200 pounds of thrust

Performance:
cruising speed: 556 mph at 35,000 feet
design maximum speed: 586.5 mph at 22,500 feet
ceiling: 41,000 feet
range: 4,050 miles

Weights:
empty: 93,000 pounds
gross: 193,500 pounds

Dimensions:
span: 120 feet, 0 inches
length: 129 feet, 4 inches
tail height: 36 feet, 4 inches

Original passenger capacity: 80–130

The Hound Dog II ✈

In addition to his Convair 880, Elvis owned a smaller Lockheed Jetstar corporate jet which had the name *Hound Dog II* and the radio call sign "Hound Dog Two." The Jetstar, Lockheed Model 329, evolved from a U.S. Air Force requirement for a utility transport jet. It first flew in 1958, and was first offered to commercial customers in 1961.

Hound Dog II's specifications
Powerplant:
four Pratt & Whitney JT-12 turbojet engines rated at 3,000 pounds of thrust
Performance:
cruising speed: 600 mph
ceiling: 45,000 feet
range: 3,000 miles
Weights:
gross: 40,920 pounds
Dimensions:
span: 53 feet, 7 inches
length: 58 feet, 9 inches
tail height: 20 feet, 6 inches

Elvis Airplane Tour ✈

Both the *Lisa Marie* and the *Hound Dog II* are available for viewing at the north end of Graceland Plaza. The tour begins in a re-creation of an airport terminal, with an entertaining video on the history of the aircraft. Guests step outside to take a quick look at *Hound Dog II* and then walk aboard the much larger *Lisa Marie* 880. The tour of "the Flying Graceland" includes Elvis's luxuriously appointed living room, his conference room, sitting room, and his private bedroom. The tour is presented by video monitors and is self-paced. Tickets may be purchased at the ticket office or in the gift shop next door to the terminal. Adult admission is $5.00, with seniors over sixty-two at $4.50, children seven through twelve at $2.75, and children six and under admitted free. The aircraft are open seven days a week, year-round, except New Year's Day, Thanksgiving Day, and Christmas Day. Because all such information is subject to change, it is a good idea to call ahead for details and times.

The Area around Graceland

(DRIVING SOUTH ON ELVIS PRESLEY BOULEVARD)

Home of Vernon Presley and His Second Wife

1266 Dolan Drive
Memphis, Tennessee 38116

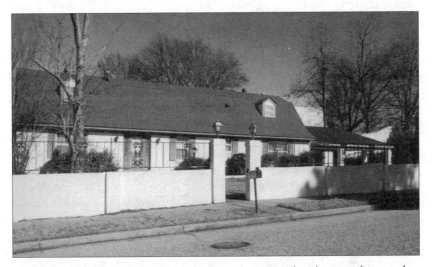

This house on Dolan Road adjacent to the Graceland grounds was the home of Vernon Presley and his second wife, Davada "Dee" Elliot Stanley, from 1961. The couple divorced in 1977 and Vernon sold the house in 1978. (Photo by Joe Watkins, used by permission.)

◆

Elvis's father, Vernon Presley, had been a widower for two years when he met and married Davada "Dee" Elliot Stanley in 1959 while Elvis was in the U.S. Army in Germany. After living in the mansion at Graceland for several years, Vernon, Dee, and Dee's three boys—David, Rick, and Billy—moved to this ranch-style home whose backyard was adjacent to the south side of the Graceland estate property. Vernon divorced Dee in 1977 and sold the house in 1978 to Hobart and Bonnie Burnett, owners of the Hickory Log Restaurant (in Memphis, now no longer in existence).

To reach Vernon's home, drive south on Elvis Presley Boulevard to Dolan Drive, the first street to the left south of the Graceland estate. The

address for this site has been reported in various sources as both 1266 Dolan Drive and 1850 Dolan Drive, but 1266 adjoins the Graceland property, and in an interview with Vernon given at the time of Elvis's death, his address was listed as 1266 Dolan Drive. Please note that this is a private home and not open to the public. View it from the street and please do not disturb the occupants, as such behavior reflects badly on the fans who come to Memphis to respectfully remember the life and times of Elvis Presley.

Piccadilly Cafeteria ✕

3968 Elvis Presley Boulevard
Memphis, Tennessee 38116
(901) 398-5186

This informal eatery, part of a chain in and around the city of Memphis, was a favorite hangout for Elvis and his friends while he was in Memphis during the 1960s and 1970s. During the 1960s, Priscilla reportedly did modeling work at after-school fashion shows at a Piccadilly Cafeteria, either this one or the one at 123 Madison Avenue in Memphis that is no longer there.

The Piccadilly menu is typical of the type of food that Elvis liked. It is similar to the fare at the Graceland Plaza diners but is more authentic because, while they attempt to capture a stylized view of an American diner of the 1950s, this is what non-tourists living in Memphis enjoy, and it is where Elvis actually ate.

To reach the Piccadilly Cafeteria, drive south past Graceland on Elvis Presley Boulevard for about a quarter of a mile. It will be on the left, in the Whitehaven Plaza shopping area.

The Piccadilly Cafeteria on Elvis Presley Boulevard was one of the favorite eateries of Elvis Presley himself. During the 1960s, Priscilla reportedly did modeling work at this Piccadilly Cafeteria. (Photo by Joe Watkins, used by permission.)

Memphis (south of Graceland)

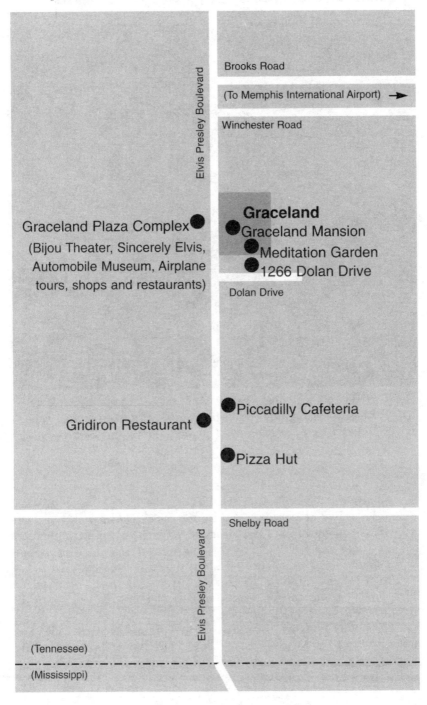

Brooks Road

(To Memphis International Airport) →

Winchester Road

Graceland

Graceland Mansion

Meditation Garden

1266 Dolan Drive

Dolan Drive

Graceland Plaza Complex
(Bijou Theater, Sincerely Elvis,
Automobile Museum, Airplane
tours, shops and restaurants)

Elvis Presley Boulevard

Piccadilly Cafeteria

Gridiron Restaurant

Pizza Hut

Shelby Road

Elvis Presley Boulevard

(Tennessee)

(Mississippi)

Gridiron Restaurant ✕

4101 Elvis Presley Boulevard
Memphis, Tennessee 38116
(901) 396-9826

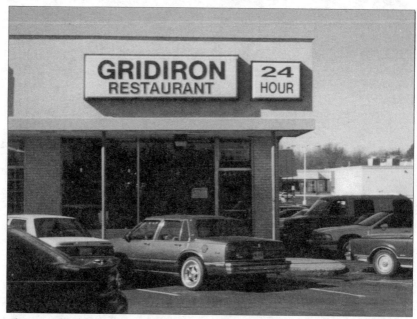

The Gridiron was a favorite hangout for Elvis and his friends while he was in Memphis during the 1960s and 1970s. It still serves the simple, straightforward food that Elvis loved. (Photo by Joe Watkins, used by permission.)

◆

As with the Piccadilly Cafeteria (above), the Gridiron is an informal eatery that is part of a chain in and around the city of Memphis, and was a favorite hangout for Elvis and his friends when he was in Memphis during the 1960s and 1970s. As with the Piccadilly Cafeteria, the Gridiron serves simple, straightforward food of the type that Elvis appreciated.

To reach the Gridiron Restaurant, drive south past Graceland on Elvis Presley Boulevard for about a quarter of a mile. It will be on the right near the South Plaza shopping area.

Geography buffs will note that at the Gridiron, you are only three miles north of the Mississippi state line, a fact that is illustrative of the importance of Memphis as a commercial hub for northern Mississippi, as well as for western Tennessee.

Pizza Hut ✗

4290 Elvis Presley Boulevard
Memphis, Tennessee 38116
(901) 332-1150

A block south of the Gridiron Restaurant and across the street is Elvis's favorite Pizza Hut. While he enjoyed pizza at other locations around Memphis, this Pizza Hut was conveniently located for a quick dash out the Graceland gates. He and his friends came here often during the 1970s. Today a mural on the wall and several portraits commemorate his visits, as does the content of the jukebox.

The Area around Graceland
(DRIVING NORTH ON ELVIS PRESLEY BOULEVARD)

National Bank of Commerce 🏦

3338 Elvis Presley Boulevard
Memphis, Tennessee 38116
(901) 346-6100

While he didn't actually appear here in person very often, this was Elvis Presley's bank! Elvis's checking account—number 011-143875—is reported to have had a balance of over a million dollars at the time of his death in August 1977.

Mac's Kitchen (formerly Chenault's) ✗

1402 Elvis Presley Boulevard South
Memphis, Tennessee 38106
(901) 946-3387

When stories of Elvis dining out are told, the name that often comes up is that of Chenault's, which was, with the exception of fast-food places, the Memphis restaurant and supper club that he frequented most often. He would host parties at Chenault's or go out with friends and family, since it was within minutes of the Graceland gates. It has gone through many changes of ownership through the years. For a while it was Helen's, and then GJ's Family Restaurant, but now it is Mac's Kitchen. Despite the $2.99 Chicken Sandwich Combo that was advertised on their marquee

Memphis (north of Graceland)

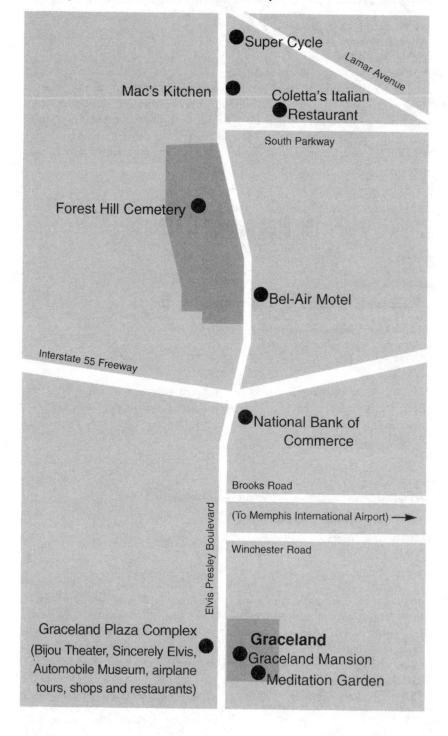

the last time we passed by, it is a rather uninviting place from the outside these days, with heavy steel bars over all the windows. It is still, however, a site worth visiting, for it was a building that Elvis visited, and visited often.

Forest Hill Cemetery

1661 Elvis Presley Boulevard
Memphis, Tennessee 38106
(901) 775-0310

Located a little less than four miles north of Graceland, Forest Hill Cemetery is where Elvis's mother, Gladys, was buried following her death on August 14, 1958. When Elvis died on August 16, 1977, he was interred next to his mother at Forest Hill following a funeral service on August 18. After a morbid body-snatching plot was revealed on August 29, the remains of both Elvis and Gladys were moved to the Meditation Garden at Graceland. Gladys's brother and longtime Graceland staffer, Travis Smith, and his wife, Lorraine, remain buried at Forest Hill.

Coletta's Italian Restaurant ✗

1063 South Parkway East
Memphis, Tennessee 38106
(901) 948-7652

This was probably Elvis's favorite Italian restaurant. It sits just a few blocks from Elvis Presley Boulevard, virtually unchanged since he last came in during the 1970s for ravioli (reportedly his favorite dish). It is also known that Priscilla occasionally stopped in to pick up pizzas—notably barbecue pizzas—to take back to Graceland. Coletta's still serves ravioli and barbecue pizza.

Bel-Air Motel ♫

1850 Elvis Presley Boulevard (1850 South Bellevue Boulevard)
Memphis, Tennessee 38106

Now just a decaying hulk, the Bel-Air Club at the Bel-Air Motel was reportedly the site of one of Elvis's first paid performances, in July 1954. He is known to have appeared at the Bon Air Club at 4862 Summer Avenue on July 17, 1954, so it is possible that reports of the two appearances became confused during the years.

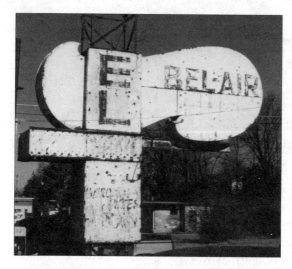

The Bel-Air Club at the Bel-Air Motel, now badly deteriorated, is reportedly the site of one of Elvis' first paid performances, in July 1954. (Photo by Joe Watkins, used by permission.)

To reach the Bel-Air Motel, take Elvis Presley Boulevard north from Graceland until the name changes to South Bellevue Boulevard. Just past the railroad tracks, number 1850 will be on the right.

(Former site of the) 1st Assembly of God Church

1085 East McLemore Avenue
Memphis, Tennessee 38106

Two blocks west of South Bellevue Boulevard on East McLemore Avenue is the site of the First Assembly of God Church, where Elvis sang in the choir during the Presley family's early years in Memphis. Note that the church is no longer at this site, and its congregation has moved to other places of worship in the vicinity.

(Former site of) Stax Records ♫

626 East McLemore Avenue
Memphis, Tennessee 38106

Located in the former Capitol Theater, Stax Records originated in 1960 as Satellite Records and became an important soul label in the 1960s and 1970s. This studio was the scene of many sessions by Otis Redding, Sam and Dave, Albert King, Rufus Thomas, and the Staples Singers. Elvis recorded here twice in 1973, first on July 21–25, and then on December 10 and 16.

Super Cycle 🚗

624 South Bellevue Boulevard
Memphis, Tennessee 38104
(901) 725-5991

Perhaps more than he loved cars, Elvis loved motorcycles, and Super Cycle was his emporium of choice. The three-wheeled motorcycle that is on display at the Elvis Presley Automobile Museum across the street from Graceland was customized here in 1975 and a replica is on display at Super Cycle, along with other bike-related Elvis memorabilia.

Union Avenue
(A DRIVING TOUR)

One of the major east-west thoroughfares in Memphis during Elvis's time, the section of Union Avenue between South Bellevue Boulevard and downtown Memphis contains several sites that are of interest to Elvis fans. These include Sun Studio—probably the second most important Elvis site in Memphis after Graceland—and several others that we mention because they are on the way.

Memphis (Union Avenue area)

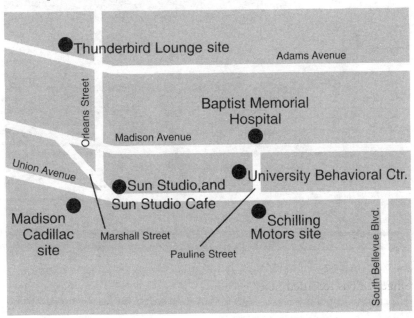

To reach Union Avenue from Memphis International Airport, take Brooks Road west to Elvis Presley Boulevard, turn right, and drive north for five miles. Note that Elvis Presley Boulevard becomes South Bellevue Boulevard, which ends at Union Avenue. Turn left on Union Avenue and drive west to visit the following sites, which are listed in the order that you will encounter them.

Union Avenue east of South Bellevue Boulevard is used as the anchor point for the driving tour of Elvis Sites in Outlying Areas of Memphis (east of downtown), which appears on page 82.

(Former site of) Schilling Motors 🚗

(formerly Schilling Lincoln-Mercury)
987 Union Avenue
Memphis, Tennessee 38104

Elvis had a well-known obsession with Cadillacs, and purchased many of them for his friends as well as for himself and his family. However, his preference for General Motors vehicles was not exclusive. Closed and scheduled for demolition in 1998, the building at 987 Union Avenue once held Schilling Lincoln-Mercury, the dealership at which Elvis purchased his Lincoln automobiles. These included the 1956

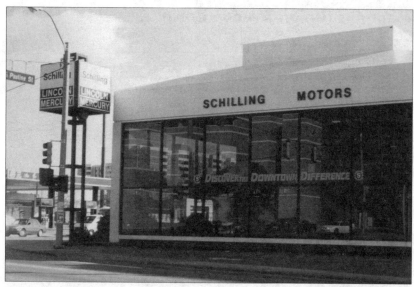

It was here at Schilling Motors (formerly Schilling Lincoln-Mercury) on Union Avenue that Elvis bought his 1956 Continental Mark II and the 1977 Lincoln Continental Mark V that he purchased for Ginger Alden. (Photo by Joe Watkins, used by permission.)

Continental Mark II (on display at the Elvis Presley Automobile Museum across from the Graceland estate) and the 1977 Lincoln Continental Mark V that he purchased for Ginger Alden, his girlfriend at the time of his death in 1977.

Baptist Memorial Hospital/Elvis Presley Memorial Trauma Center

Elvis Presley Memorial Trauma Center
899 Madison Avenue
Memphis, Tennessee 38103
(901) 227-2727

While driving west on Union Avenue, make a right turn on Pauline Street (about a quarter of a mile west of North Bellevue Boulevard) and drive north one block to Madison Avenue. The soaring tower of Baptist Memorial Hospital is now clearly visible. It was here that Elvis's only child, Lisa Marie Presley, was born on February 1, 1968, and where Elvis himself was a patient several times in the 1970s.

In March 1970 Elvis was admitted to Baptist Memorial Hospital for an eye infection, and glaucoma was discovered in his left eye. In October

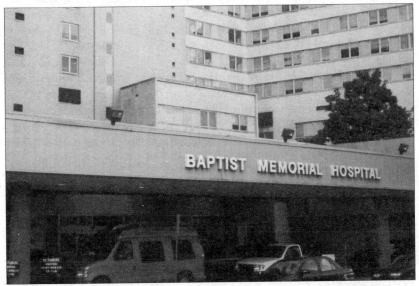

Baptist Memorial Hospital was where Lisa Marie was born in 1968, and where Elvis was a patient on many occasions. On August 16, 1977, paramedics brought Elvis here from Graceland, and it was here that he was pronounced DOA. (Photo by Joe Watkins, used by permission.)

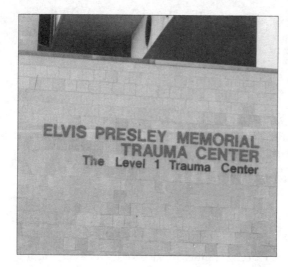

The Elvis Presley Memorial Trauma Center at Baptist Memorial Hospital has a Wall of Honor with plaques commemorating those who have donated more than a thousand dollars in Elvis's memory. Many donations are traditionally made during Tribute Week in August. (Photo by Joe Watkins, used by permission.)

1973 he was admitted for pneumonia and stayed in a room on the sixteenth floor.

In January 1975 Elvis was admitted for two weeks for hypertension and an impacted colon and stayed in a room on the eighteenth floor. During this stay, his father was admitted after suffering a heart attack. In August 1975 the King was admitted for two weeks for exhaustion. On April 1, 1977, when Elvis was admitted for five days for fatigue and intestinal flu, he stayed in a suite on the sixteenth floor.

On August 16, 1977, paramedics brought Elvis here from Graceland, but he was pronounced DOA (dead on arrival) in Trauma Room Two, which is now incorporated into the Elvis Presley Memorial Trauma Center. A Wall of Honor at the Trauma Center features plaques commemorating those who have donated more than a thousand dollars in Elvis's memory. Many donations are traditionally made during the annual Tribute Week in August.

Vernon Presley suffered his fatal heart attack here at Baptist Memorial Hospital on June 26, 1979.

University Behavioral Health Center

(Former site of) Mid-South Hospital
135 North Pauline Street
Memphis, Tennessee 38103
(901) 448-2400

From Baptist Memorial Hospital, turn back toward Union Avenue, noting the building at 135 Pauline Street. The Mid-South Hospital,

which formerly occupied this building, was the site of Elvis's 1975 face-lift.

(Former site of) Southern Motors, later Madison Cadillac 🚗

341 Union Avenue
Memphis, Tennessee 38103

Closed before 1990, Madison Cadillac was in the glass-walled show-room that is still located at 341 Union Avenue. Cadillacs were Elvis's car of choice and the ultimate automotive status symbol in the 1950s, when most Americans had never heard the phrase "Mercedes-Benz."

Many, if not most, of Elvis's Cadillacs were purchased here. In July 1975 he bought fourteen in one day at 341 Union Avenue. It is not known how many Cadillacs Elvis owned in his lifetime or how many of them he purchased for family and friends, but there were probably dozens. These include his gold-plated Cadillac, now at the Country Music Hall of Fame in Nashville; the 1976 Eldorado Coupe in the Imperial Palace Collection in Las Vegas; the famous 1955 pink Cadillac that he purchased for his mother and which was still parked at Graceland when he died; and his 1956 purple Cadillac convertible. The latter two are now on display at the Elvis Presley Automobile Museum across from the Graceland estate.

Sun Studio ♫

706 Union Avenue
Memphis, Tennessee 38103
(901) 521-0664

As noted before, Sun Studio is possibly the second most important Elvis site in Memphis after Graceland. It was here that Elvis's recording career began. The building at 706 Union Avenue had been a radiator repair shop when Sam Cornelius Phillips moved in and opened for business in 1950 as the Memphis Recording Service. For four dollars, anyone could walk in and record a two-sided acetate record. Among those who did was Jackie Brenston and the Delta Cats—featuring Ike Turner on piano—who showed up in 1951 to record "Rocket 88," believed by musicologists to be the first true rock 'n' roll record. For this reason, Sun Studio is acknowledged by many musical fans as the birthplace of rock and roll.

Sun Studio was the site of Elvis's first recording session in August 1953. In 1954, Sam Phillips signed Elvis to his Sun Records label, and Elvis cut six singles in this building. (Photo by Joe Watkins, used by permission.)

◆

It was in 1952 that Sam Phillips started his record company, Sun Records, on the same site as his Memphis Recording Service. With a good ear for talent—and good talent on which to cast his ear—Phillips had previously recorded blues artists such as B.B. King, Howlin' Wolf, and Bobby "Blue" Bland, and had leased these recordings to major labels. Among early Sun Records artists were Rufus Thomas and Little Walter.

The motto of the Memphis Recording Service was, "We record anything, anywhere, anytime," and a sign to this effect caught the eye of a truck driver named Elvis Presley, who decided to record a few songs for his mother. In August 1953 Elvis came in to record "My Happiness" and

"That's When Your Heartaches Begin." He returned on January 4, 1954, to record "I'll Never Stand in Your Way" and "Casual Love Affair."

Sam Phillips was present at the second session and he signed Elvis to the Sun Records label almost immediately. Elvis recorded six singles for Sun at 706 Union Avenue through August 1955, when he signed with the much larger RCA. These six singles were "Blues in My Condition" / "Sellin' My Whiskey," "That's All Right, Mama" / "Blue Moon of Kentucky," "Good Rockin' Tonight" / "I Don't Care If the Sun Don't Shine," "Milk Cow Blues Boogie" / "You're a Heartbreaker," "I'm Left, You're Right, She's Gone" / "Baby, Let's Play House," and "Mystery Train" / "I Forgot to Remember to Forget."

Among the other young artists of Elvis's generation who recorded at Sun Studio were Carl Perkins, Johnny Cash, Roy Orbison, and Jerry Lee Lewis, all of whom had great careers ahead of them. Perkins, who wrote "Blue Suede Shoes," recorded his version here, but Elvis recorded his rendition at RCA in New York City.

Sam Phillips and Sun Records left the building at 706 Union Avenue in 1960 for larger quarters at 639 Madison Avenue in Memphis, and Phillips sold Sun Records to Shelby Singleton in 1969. The Sun Elvis library of recordings was eventually sold to RCA, and Phillips went on to become the owner of Memphis radio station WLVS. After Sun departed, the 706 Union Avenue building became a plumbing shop, an auto parts store, and various other incarnations. The building was vacant in 1985 when Carl Perkins, Johnny Cash, Roy Orbison, and Jerry Lee Lewis used it to record their album *Class of '55*, which contained several Elvis tribute songs. In 1987, with Sam Phillips acting as a consultant, Sun Studio, Inc. reopened 706 Union Avenue as a working recording studio. Among the diverse array of artists who have come to record here since 1987 are Ringo Starr, John Fogerty, Tom Petty, Paul Simon, Bonnie Raitt, and the group U2.

Designed by Sam Phillips, the studio now consists of three areas: the Front Room, which measures twelve feet by seventeen feet; the Great Room, which is seventeen feet by twenty-eight feet; and the Control Room, measuring seventeen feet by twenty feet. The tape machines include an MCI JH24 24-track, a Soundcraft SCM 760 24-track, a Panasonic SV 3700 DAT recorder, a Tascam DA-30 DAT recorder, a Studer A-80 ¼-inch 2-track, an Akai MG ½-inch 12-track, an Ampex 300-3 ½-inch 3-track, and two Ampex 351 ¼-inch Mono machines.

Those wishing to simply see the studio are also welcome. Tours are offered most days for $7.85 and include a chance to stand before the actual microphone that Elvis used. Call ahead for times and more information.

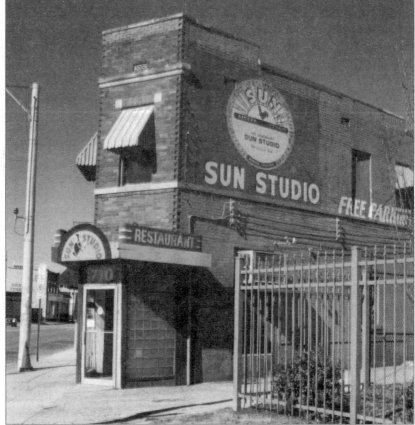

The Sun Studio Café still serves milkshakes made the way they were when Elvis ordered them. Also on the menu are fried peanut butter-and-banana sandwiches. (Photo by Joe Watkins, used by permission.)

◆

Sun Studio Café ✗

(formerly Taylor's Café)
710 Union Avenue
Memphis, Tennessee 38103
(901) 521-0664

Located immediately next door to Sun Studio, this was where those who worked and recorded at the studio came for breakfast, lunch, dinner, and late-night snacks. Sam Phillips ate here, and he also often used one of the booths as his office when he wanted to get out of his real office to do his paperwork. In the days when Carl Perkins, Jerry Lee Lewis, Johnny

Cash, and Elvis Presley were among its patrons, the establishment was known as Taylor's Café and was operated by Dell Taylor. The name change was adopted, of course, to take advantage of the fame of the neighboring business.

Unlike many such establishments, which have been remodeled repeatedly through the years, the Sun Studio Café still retains the original tin ceiling that looked down on the birth of rock and roll, and the original checkered tile floor across which Elvis strolled. Some of the present booths date from that era, and it has been pointed out that the milkshakes are still made just the way they were when Elvis ordered them. The rest of the menu features the simple Southern food that was favored then and which is still popular today. Now on the menu—although it probably wasn't back then—is Elvis's signature dish: the fried peanut butter-and-banana sandwich.

(Former site of the) Thunderbird Lounge ♫

170 Adams Street
Memphis, Tennessee 38105

The Sun Studio is near the corner of Marshall Avenue, which runs to the northwest. Take Marshall Avenue one block northwest to Orleans Street and turn right to Adams Street. The Thunderbird Lounge at 750 Adams Avenue, near the corner, was the site of Elvis's December 31, 1968, New Year's Eve party. The house band at the Thunderbird Lounge—Flash and the Board of Directors—included such future stars as B. J. Thomas and Ronnie Milsap.

To start the suggested downtown Memphis tour, drive west on Adams Street to Second Street, then turn south to Beale Street and Elvis Presley Plaza.

Downtown Memphis
(A WALKING TOUR)

The old downtown area of Memphis, recently rejuvenated by the improvements on Beale Street, affords visitors—especially blues-music lovers—quite an interesting stroll. However, it is especially important to Elvis fans, for this was the center of Elvis's world throughout his adolescence and the formative years of his career. He lived here, worked here, played here, and began his recording career here.

The tour that we suggest can be accomplished as a walking tour, a driving tour, or a combination of the two. The first sites that we discuss are

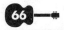

Downtown Memphis (A Walking Tour)

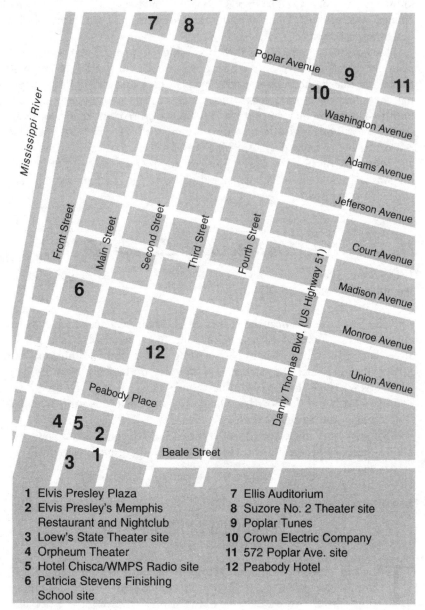

1 Elvis Presley Plaza
2 Elvis Presley's Memphis
 Restaurant and Nightclub
3 Loew's State Theater site
4 Orpheum Theater
5 Hotel Chisca/WMPS Radio site
6 Patricia Stevens Finishing
 School site
7 Ellis Auditorium
8 Suzore No. 2 Theater site
9 Poplar Tunes
10 Crown Electric Company
11 572 Poplar Ave. site
12 Peabody Hotel

sufficiently close together that walking is far easier than looking for numerous parking places. Our suggested tour uses Elvis Presley Plaza as its anchor point.

To begin the tour of downtown Memphis starting at Sun Studio, drive west on Union Avenue to Second Street, turn left, and drive three blocks to Beale Street. You will now be at Elvis Presley Plaza, and we sug-

gest that you park your vehicle near here for a short walking tour. Walk north to Poplar Avenue by way of Beale Street, circle back, and then drive to the outlying sites north of downtown.

Beale Street is today a major attraction in its own right, with many shops and music venues that will be of interest to Elvis fans. Many of these shops stock Elvis wares or display Elvis tributes. However, as they generally are not Elvis-specific venues, we have omitted them from these listings.

To reach Elvis Presley Plaza from Memphis International Airport, take Brooks Road west to Elvis Presley Boulevard, turn right, and drive north for five miles. Note that Elvis Presley Boulevard becomes South Bellevue Boulevard, which ends at Union Avenue. Turn left on Union Avenue or Interstate 240. Take either of these north to Union Avenue and turn west.

Elvis Presley Plaza

Intersection of Beale Street and Second Street
Memphis, Tennessee 38103

This plaza, which Elvis knew merely as a street corner during his lifetime, was set aside to commemorate him shortly after his death in August 1977. The original bronze statue located here—Elvis holding the head of a guitar that rested on the ground—was created by sculptor Eric Parks and unveiled on August 14, 1980. Gradually, the statue deteriorated, due mostly to the weather. It was replaced by a more dynamic statue sculpted by Andrea Lugar (her husband, Larry, did the casting of the bronze statue), which portrayed a gyrating Elvis playing a guitar. The old statue was restored and placed indoors in the Memphis Visitors Center overlooking the Mississippi River. The plaza with its new statue was rededicated on August 12, 1997, during the commemoration of the twentieth anniversary of Elvis's death.

This statue of Elvis was unveiled in Elvis Presley Plaza in 1997 on the twentieth anniversary of his death. The Plaza is in downtown Memphis at the foot of the popular Beale Street tourist area. (Photo by Joe Watkins, used by permission.)

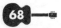

Elvis Presley's Memphis Restaurant and Nightclub ✕

(formerly Lansky Brothers)
126 Beale Street
Memphis, Tennessee 38103
(901) 527-6900

Immediately adjacent to Elvis Presley Plaza is the unusual circumstance of an Elvis site in the same location as a previous Elvis-related site. Usually, when one is torn down or taken away, the old Elvis site is replaced by something completely unrelated to the life or memory of the King. Not so with 126 Beale Street.

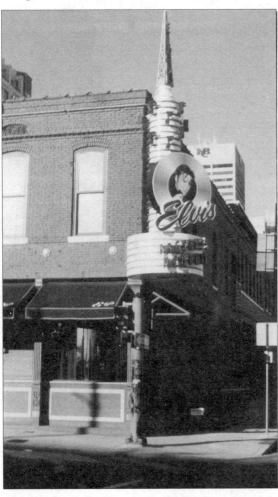

In 1997, Elvis Presley's Memphis, a restaurant and nightclub, opened in the building that previously housed Lansky Brothers, the clothier that supplied many of Elvis's favorite suits. The National Bank of Commerce tower can be seen in the background. Elvis banked at an NBC branch. (Photo by Joe Watkins, used by permission.)

At this address from 1949 to 1992 was the clothing store generally known as Lansky Brothers, but also known at various times as Lansky's Clothing Emporium, Lansky Men's Fashion Stores, or simply Lansky's. The store was started by Bernard and Guy Lansky, two sons of Polish émigré grocer Samuel Lansky. In the 1950s Lansky Brothers became well-known for leading-edge fashion—featuring bright, vivid colors and shiny, silky fabrics. In September 1956 Elvis Presley came here to purchase the clothes—black trousers, brightly colored shirts, and a plaid sport coat—that he would wear during his first appearance on Ed Sullivan's Sunday night TV variety program. After that, Elvis continued to shop at Lansky Brothers from time to time, as did such other musical artists as Ace Cannon, B.B. King, Bobby "Blue" Bland, Johnny Cash, Jerry Lee Lewis, the O'Jays, the Temptations, Roy Orbison, and Otis Redding. In 1981 Lansky Brothers opened a satellite store in the lobby of the prestigious Peabody Hotel, which remained open after the Beale Street store closed in 1992.

In November 1996 Bernard Lansky leased the 126 Beale Street property to Elvis Presley Enterprises for the development of the Elvis-theme restaurant and nightclub called Elvis Presley's Memphis Restaurant and Nightclub, which opened in July 1997. In coordination with Graceland, which is also managed by Elvis Presley Enterprises, Elvis Presley's Memphis Restaurant and Nightclub has become an important site for the events commemorating Elvis that take place annually during his birthday week in January and during Tribute Week in August.

From Elvis Presley's Memphis Restaurant and Nightclub, walk west to Main Street and turn right on what will become the Mid-America Pedestrian Mall.

(Former site of) Loew's State Theater 🎥

152 South Main Street
Memphis, Tennessee 38103

Just south of Beale Street is the former site of Loew's State Theater, where Elvis worked as an usher in the evenings for $12.75 a week while he was enrolled in high school. Bernard Lansky remembers him first coming into Lansky Brothers to admire the goods while he was working at Loew's. Reportedly, Elvis was fired by manager Arthur Groom for getting into a fistfight with another usher who had alerted the manager that the female concessionaire was giving Elvis free samples. On October 17, 1957, Elvis's Metro-Goldwyn-Mayer film *Jailhouse Rock* had its premiere at Loew's. In this movie, Elvis's character kills a man in a fistfight.

Orpheum Theater

(formerly the Malco Theater)
203 South Main Street
Memphis, Tennessee 38103
(901) 525-3000

At the corner of Beale Street and South Main Street is the recently restored Orpheum Theater. This classic, old-fashioned movie palace once housed the Malco Theater, one of many theaters (most long since demolished) that Elvis used to rent for private screenings of his favorite films. It is hard to imagine that Elvis lived his entire life before the wide availability of movies on videotape. If you are old enough personally to remember Elvis, this fact should make you feel your age.

(Former site of) Hotel Chisca/WMPS Radio ♫

272 South Main Street
Memphis, Tennessee 38103

Walking north toward the Mid-America Mall (formerly Main Street), you will pass the former site of the Hotel Chisca, which housed WMPS Radio. It was on WMPS, on July 7, 1954, that Dewey Phillips became the first disc jockey to broadcast an Elvis record. He played "That's All Right, Mama" fourteen times in a row on his legendary *Red Hot and Blue* show. Elvis also reportedly attended parties in the basement of the Hotel Chisca. The building is still there, but it is now the world headquarters for the Church of God in Christ.

(Former site of) Patricia Stevens Finishing School

111 Monroe Avenue
Memphis, Tennessee 38103

Just off Main Street is the former site of the finishing school where Priscilla Beaulieu, Elvis's future wife, studied modeling and dance after she graduated from high school in 1963.

Ellis Auditorium ♫

(now part of the Memphis Cook Convention Center Complex)
255 North Main Street
Memphis, Tennessee 38103
(901) 576-1200

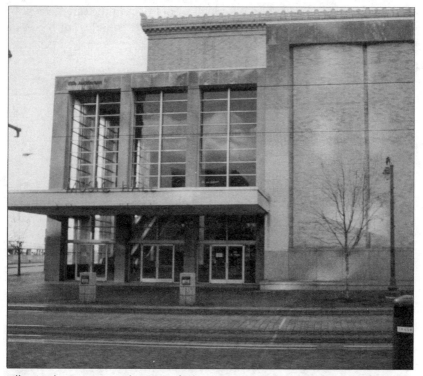

Ellis Auditorium was the site of Elvis's Humes High School graduation in 1953, and he played two concerts here on February 25, 1961.
(Photo by Joe Watkins, used by permission.)

◆

Part of the convention center complex, Ellis Auditorium is located at the corner of Poplar and Main Streets. It was here that Elvis's Humes High School graduation took place on June 3, 1953. Elvis performed two concerts here on February 25, 1961, and he appeared a month later at a benefit for local charities that was emceed by veteran comedian George Jessel. Ellis Auditorium is still intact, but the convention center is undergoing a $60 million renovation and the project includes a plan to replace Ellis Auditorium with a performing-arts facility.

(Former site of) Suzore No. 2 Theater

279 North Main Street
Memphis, Tennessee 38103

North of the Memphis Cook Convention Center complex is the former site of the Suzore No. 2 Theater, where Elvis used to take dates—notably Dixie Locke—to movies during his high school years in the early 1950s.

From the Memphis Cook Convention Center complex, turn east on Poplar Avenue.

Poplar Tunes ♫

308 Poplar Avenue
Memphis, Tennessee 38103
(901) 525-6348

Virtually unchanged since Elvis knew it in the 1950s, the Poplar Tunes Record Shop, started by Joe Coughi, was within walking distance of all of the homes in which Elvis lived from the time that the Presley family first moved from Tupelo, Mississippi, in 1948 until after he graduated from high school in 1953. As such, Poplar Tunes was the store where Elvis probably bought most of the records for his own collection during his formative years. After he began recording for Sun Records, Poplar Tunes is probably the first store to have sold an Elvis record.

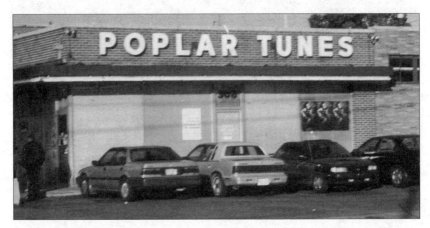

Poplar Tunes on Poplar Avenue was where Elvis probably bought his first record, and where the first Elvis record was likely sold in 1954. Inside, the walls are covered with Elvis memorabilia. (Photo by Joe Watkins, used by permission.)

(Former site of) Crown Electric Company

353 Poplar Avenue
Memphis, Tennessee 38105

It was at 353 Poplar Avenue that Elvis held his last job, begun in July 1953, before going into show business. Crown Electric was an electrical contracting firm that had previously been located at 475 North Dunlap Street. Elvis was reportedly paid an hourly wage of $1.25 to drive a company truck and to work in the firm's warehouse.

(Former sites of the) First Two Houses in Memphis Occupied by the Presley Family

370 Washington Avenue
Memphis, Tennessee 38105

When Vernon, Gladys and Elvis Presley moved to Memphis from Tupelo in September 1948, they would live for two months in the rooming house that formerly occupied this site. Washington Avenue runs parallel to Poplar Avenue and is one block to the south.

572 Poplar Avenue
Memphis, Tennessee 38105

In November 1948, the Presley family made the short move to a large, single-family house on this site which had been converted to accommodate sixteen families. The Presleys lived in one room on the ground floor until September 20, 1949, sharing the kitchen with the other residents. Sadly, this building was demolished long ago.

Peabody Hotel

149 Union Avenue
Memphis, Tennessee 38103, (901) 529-4000

Located on Union Avenue off Third Street, the Peabody Hotel was the original Downtown Memphis luxury hotel. After declining, it was restored to its former glory in the 1980s. When he was growing up in the 1950s, Elvis knew the Peabody as a prestige location. It was here that the 1953 Humes High School Senior Prom, attended by Elvis, was held. Sam Phillips of Sun Records also promoted concerts at the Peabody Skyway

on the top floor of the hotel, which were broadcast on WREC Radio. None of these involved Elvis.

Today, Bernard Lansky, the clothier to Elvis from 1956 on, operates a shop on the lobby level of the Peabody Hotel, which has a great deal of Elvis memorabilia on display.

From the Peabody Hotel, turn south on Second Street to Elvis Presley Plaza to conclude your walking tour of downtown Memphis.

Elvis Sites in Outlying Areas of Memphis
(DRIVING NORTH OF DOWNTOWN)

From Elvis Presley Plaza in downtown Memphis, drive north on Third Street and turn right on Poplar Avenue. If you missed the Poplar Avenue sites on the Downtown Memphis Walking Tour, or if you want another look, now is your chance. Poplar Tunes Record Shop does have a large parking lot. Just past Poplar Tunes, make a left on Lauderdale Street. One block north of Poplar Avenue, you will enter the sprawling grounds of the Lauderdale Courts housing project. The next corner will be Winchester Avenue.

Elvis's Home during High School 🏠

185 Winchester Avenue
Memphis, Tennessee 38109

One week after Elvis started at Humes High School in 1948, he and his family moved from their former one-bedroom apartment on Poplar Avenue to the Lauderdale Courts Housing Project at 185 Winchester Avenue. Elvis lived longer at this address than at any other in Memphis prior to moving to Graceland. The family arrived in September 1949 and was evicted January 7, 1953, five days after Elvis's eighteenth birthday, and four months before he graduated from high school. The reason for the eviction was that Lauderdale Courts was a federally funded housing project for lower-income families, and the Presleys were deemed to be making too much money.

While at Lauderdale Courts, the Presley family paid $35 monthly to live in apartment 328 (some sources say apartment 327). Elvis practiced his singing and guitar-playing in the basement laundry room and on the grassy Market Mall, and performed at parties in the Lauderdale Courts Recreation Hall. Also living at Lauderdale Courts in the early 1950s were Ruth Black and her son Bill, who later became Elvis's bass player.

The grim, red-brick Lauderdale Courts Housing Project was where Elvis lived through his high school years. Located at 185 Winchester Avenue, this entrance to the sprawling complex was the door Elvis used when he came home from school each day. (Photo by Joe Watkins, used by permission.)

◆

Completed in 1938 as a federal Works Progress Administration project, Lauderdale Courts covered twenty-six acres and contained over four hundred housing units in grim, red-brick buildings. The building in which the Presleys lived had sixty-six apartments. In 1997 the Memphis Housing Authority, working with the United States Department of Housing and Urban Development, had decided to demolish the building as part of a de-densification program, but presently a number of heritage organizations and Elvis fan clubs are involved in efforts to save 185 Winchester Avenue and possibly to turn it into an Elvis museum.

From Winchester Avenue, return to Lauderdale Street and drive north under the Interstate 40 freeway.

St. Jude Children's Research Hospital

332 North Lauderdale Street
Memphis, Tennessee 38105
(901) 495-3306

As you emerge from the Interstate 40 underpass, St. Jude Children's Research Hospital is on your right. Founded by entertainer Danny Thomas (of *Make Room for Daddy* TV sitcom fame), the hospital has aided over 15,000 critically ill children since it opened in 1962. Elvis was invited to the grand opening, and it was here that Elvis first met country singer and legend Patsy Cline. Elvis later donated a boat to the hospital via Danny Thomas. It was not just any boat, it was Franklin Delano Roosevelt's presidential yacht *Potomac* (and the former Coast Guard cutter *Electra*), which Elvis had bought at an auction in 1964. The donation took place at Long Beach, California, and the yacht was sold to raise money for the hospital. Ironically, it was used later to smuggle marijuana from Mexico. It is now based at the museum at the former Naval Air Station Alameda on San Francisco Bay, where it has been restored to how it looked when Roosevelt used it. It is open to the public. Coincidentally, Danny Thomas and Elvis were neighbors on Hillcrest Road in Beverly Hills in 1967.

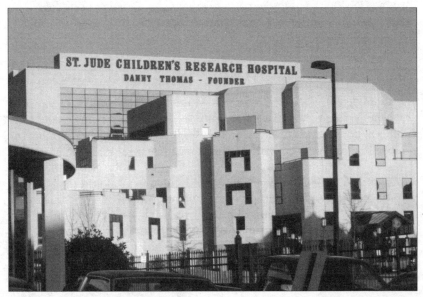

St. Jude Children's Research Hospital was founded by entertainer Danny Thomas, and Elvis donated his yacht to a fund-raiser for the hospital. *(Photo by Joe Watkins, used by permission.)*

St. Joseph Hospital

210 Jackson Avenue
Memphis, Tennessee 38105
(901) 577-2833

Easily visible behind St. Jude as you emerge from the Interstate 40 underpass, St. Joseph Hospital is a block away on the same street, which changes from North Lauderdale Street to Jackson Avenue as it curves to the left. It was here that Gladys worked as a nurse's aide and scrubwoman from 1949 through 1952 while Elvis was in (junior) high school. The route that you have just driven is the same one that Gladys would have walked from the Presley apartment at Lauderdale Courts.

Turn right on St. Jude Drive, which runs between the two hospitals. Where this street intersects with North Parkway and St. Jude Place, take North Parkway, which continues straight on. Make a left turn on North Manassas Street and drive north.

Humes Junior High School

(formerly Humes High School)
659 North Manassas Street
Memphis, Tennessee 38107
(901) 579-3226

The archetype of Elvis's original appeal involved the swoons of bobby-socked, poodle-skirted, letter-sweatered, teenaged high school girls, circa the 1950s. In our present retro view of the 1950s, we see Elvis at the apex of a pantheon of teenage idols who look down upon a stylized view of high school-aged people in their cars, at the malt shop and, of course, at the high school. With this in mind, let us visit Elvis's own high school.

Elvis entered Humes High School in 1948 and graduated on June 3, 1953. Originally known as North Side High School, the building itself is a block-long, red-brick edifice that was named (prior to Elvis's attendance) for Laurence Carl Humes, who served as president of the Memphis Board of Education from 1918 to 1925. (While the school was officially titled the L. C. Humes High School, it was generally referred to as the Humes High School.) It is worth noting that rockabilly star Johnny Burnette, and later "Memphis Mafia" member Red West, were both classmates of Elvis at Humes.

At the time Elvis was a student, segregation was still in effect, so Humes was an all-white school. In those days Humes consisted of grades seven through twelve. Today Humes is an integrated junior high school.

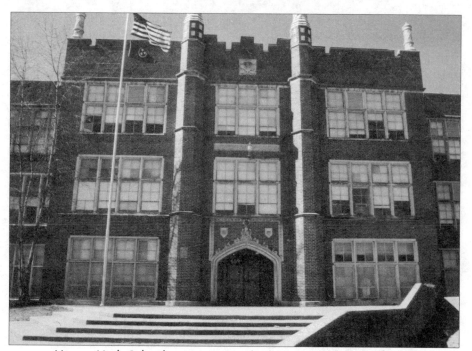

Humes High School, now a junior high, was the high school that Elvis attended from 1948 to 1953. The school administration has offered tours of the school during Tribute Week in August. (Photo by Joe Watkins, used by permission.)

◆

Elvis attended class in many rooms in the building, but there is no record of particular classes in specific rooms. A visit to selected rooms and corridors will give fans something of an idea of what it was like for Elvis, although various remodelings and repaintings have obscured things to a degree.

The football field at Humes is of minor interest, not because of games in which Elvis played, but because he quit the team after a few practices when Coach Rube Boyce Jr. hassled him about his hair length.

The most important site for Elvis fans at Humes is the auditorium—now known as the Elvis A. Presley Auditorium—where Elvis was on stage several times. Of special note was his April 9, 1953, appearance at the *Annual Minstrel Show.* He sang John Lair's "Keep Them Cold Icy Fingers Off Me," and received such applause that he did Teresa Brewer's "Till I Waltz Again with You" as an encore. In 1955 Elvis, now a popular professional, returned to Humes to do a benefit concert. Contrary to some misconception, the 1953 graduation ceremony was not held at the Humes auditorium, but rather at Ellis Auditorium, which is located at Main and Poplar in downtown Memphis (see page 71).

As Humes is an operating school, it may be visited only with the permission of the school administration, and in such a way as to not disrupt classes that are in session. Phone ahead to schedule a visit and note that the building is closed when school is not in session. The administration, however, is well aware of the importance of the site to Elvis fans. They are generally accommodating, and they have set aside an entire room to serve as an Elvis museum. It contains pictures of Elvis and various Elvis and Humes memorabilia, including a gold bust of Elvis that was presented on the tenth anniversary of his death, along with a priceless copy of the 1953 Humes yearbook signed by Elvis.

During the annual Tribute Week in August, the school administration has been known to open the school for Elvis fan tours and activities. In 1997, during the commemorative activities surrounding the twentieth anniversary of Elvis's death, the symposium *Conversations on Elvis at Humes* was held at the school. At the event, friends, colleagues, and family of Elvis shared stories and answered questions from the audience. Proceeds benefited the school.

The Third Presley Family Home in Memphis 🏠

698 Saffarans Avenue
Memphis, Tennessee 38107

Located one block north of Humes Junior High School, the third home of the Presley family in Memphis was a seven-room house that accommodated four families. The Presleys paid $52 a month for two of the rooms. They moved here from Lauderdale Courts in January 1953 after they were evicted for making "too much" money. They stayed only through April 1953, when they found a better place at 462 Alabama Avenue.

Please note that this is a private home and not open to the public. View it from the street and please do not disturb the occupants, as such behavior reflects badly on the fans who come to Memphis respectfully to remember the life and times of Elvis Presley.

(Former site of) American Sound Studios ♪

827 Danny Thomas Boulevard North
Memphis, Tennessee 38103

After his memorable recording sessions at the Sun Studio in 1954 and 1955, Elvis would not record in Memphis again until 1969. The site would be American Sound Studios, established in 1964 by Chips Moman and Bob Crewe, and where talents such as Dusty Springfield and Neil Diamond came to record. Ronnie Milsap, who would go on to be a country-music superstar, was a session man at American Music Studios, and he played on Elvis's recordings in 1969. Working in two sessions, January 13–23 and February 17–22, Elvis recorded thirty-five tracks. Among them were some of his best work for over a decade, including the classics "Don't Cry Daddy," "In the Ghetto," "Kentucky Rain," and "Suspicious Minds."

To reach Danny Thomas Boulevard, simply drive west on Saffarans Avenue.

(Former site of the) Fourth Presley Family Home in Memphis 🏠

462 Alabama Avenue
Memphis, Tennessee 38105

The Presley family was living in a brick apartment building on this site near Lauderdale Courts when Elvis graduated from Humes High School. They arrived in April 1953 and stayed through 1954, paying $50 per month. They were residing here when Elvis recorded his first "one-of" acetate record for his mother—"My Happiness" / "That's When Your Heartaches Begin"—at the Memphis Recording Service. (In the early 1950s there were no home tape-recording devices. If you wanted to record something, you would have to go to a studio where they would cut whatever you wanted on a hard wax, or acetate, disk. This disk would be the only copy, hence the term "one-of" for "one of a kind.")

The building was subsequently demolished and the site is now an on-ramp for the Interstate 40 freeway. In any case, to visit the site drive south on Danny Thomas Boulevard and turn left on Alabama Avenue. To reach Alabama Avenue from Humes High School, drive south on Manassas Street from Saffarans Avenue to the place where Manassas Street intersects Poplar Avenue and turn right. Alabama Avenue will be an almost immediate "one o'clock" right turn.

Elvis Sites in Outlying Areas of Memphis
(DRIVING SOUTH OF DOWNTOWN)

Two of the three sites south of downtown Memphis are in the old industrial area, have no presently visible Elvis connection, and are of archeological interest only. The third is a good place for lunch. From Elvis Presley Plaza in downtown Memphis, drive south on Second Street and turn right on Carolina Avenue. Drive west to Kansas Street.

Memphis (south of downtown)

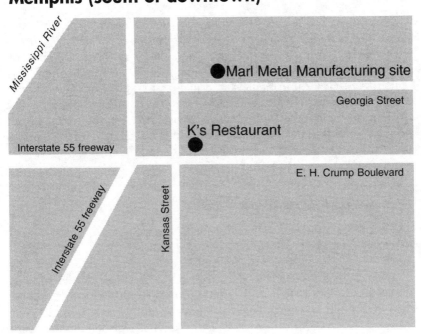

(Former site of) **Marl Metal Manufacturing Company**

208 Georgia Avenue
Memphis, Tennessee 38126

Turn north on Kansas Street one block to Georgia Avenue. Elvis worked—for a dollar an hour—after school (3 P.M. to 11 P.M.) from September through November 1952 at this factory that manufactured

metal dinette sets. His parents made him quit because he was falling asleep at school.

K's Restaurant ✕

(formerly K's Drive-In)
166 East E. H. Crump Boulevard
Memphis, Tennessee 38106
(901) 948-3127

You often see posters featuring a stylized illustration of Elvis at a drive-in restaurant. While this is clearly fanciful, there really was a drive-in at which Elvis hung out in high school, and he really did ride here on his motorcycle. And it's still here! Driving south on Kansas Street, you will cross E. H. Crump Boulevard, a major east-west thoroughfare coming off the Memphis-Arkansas Bridge. In business since 1938, K's was a drive-in during the 1950s, and it was Elvis's drive-in. Today K's is open only for breakfast and lunch, which includes barbecue and K's famous made-from-scratch, deep-dish apple pie.

(Former site of) Precision Tool

1132 Kansas Street
Memphis, Tennessee 38106

Return to Kansas Street and drive south. Elvis had a brief summer job at this factory that manufactured casings for artillery shells. He got the job through his uncles Travis and John Smith, who were employed at Precision Tool at $30 per week. Elvis worked here for one month. Some sources suggest that it was June 1951, others that it was September 1953. The former makes more sense, because it is believed that he was dismissed when it was discovered that he was under age.

Elvis Sites in Outlying Areas of Memphis
(DRIVING EAST OF DOWNTOWN)

This driving tour is anchored on Union Avenue east of South Bellevue Avenue. The sites on Union Avenue west of South Bellevue Avenue are described in the Union Avenue section, beginning on page 57. As noted, Union Avenue was one of the major east-west thoroughfares in Memphis during Elvis's time, and it still is. This

Memphis (east of downtown)

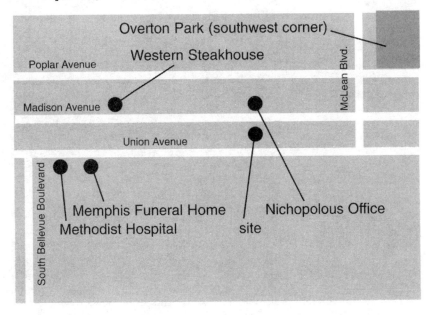

driving tour concentrates on sites that are not on Union Avenue, but which are within a block or two on either side.

To reach Union Avenue from Memphis International Airport, take Brooks Road west to Elvis Presley Boulevard, turn right, and drive north for five miles. Note that Elvis Presley Boulevard becomes South Bellevue Boulevard, which ends at Union Avenue. Turn right on Union Avenue and drive east. From downtown Memphis, simply drive east on Union Avenue.

Methodist Hospital

1265 Union Avenue
Memphis, Tennessee 38104
(901) 726-7000

In August 1958, six months after Elvis was drafted into the U.S. Army, his mother, Gladys Love Presley, age forty-six—who was living with him at Killeen, Texas, near Fort Hood—was stricken with acute hepatitis. She was taken back to Memphis and hospitalized at Methodist Hospital. At three o'clock in the morning on August 14, she suffered a heart attack related to the hepatitis and died in the hospital. At the request of Elvis and his father, no autopsy was performed and, as a conse-

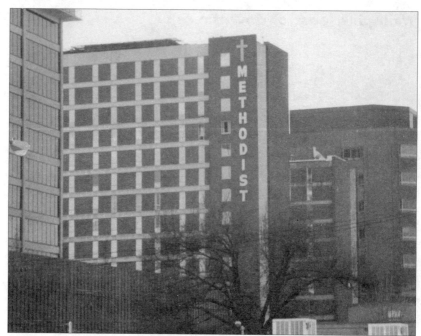

Elvis's mother, Gladys Love Presley, died at Methodist Hospital on the morning of August 14, 1958. Hospitalized for hepatitis, she suffered a heart attack. (Photo by Joe Watkins, used by permission.)

◆

quence, there have been rumors, but no evidence provided, that the heart attack was not the cause of death.

Memphis Funeral Home

1177 Union Avenue
Memphis, Tennessee 38114
(901) 725-0100

Located almost across the street from Methodist Hospital—where Gladys Love Presley passed away in August 1958—this funeral home was where final arrangements were made for Gladys, Elvis, and Vernon Presley in 1958, 1977, and 1979 respectively. It was known as the National Funeral Home until 1962 because it was affiliated with the National Life and Burial Insurance Company.

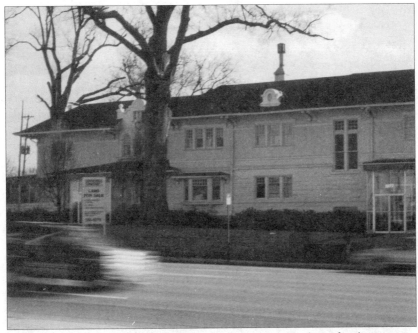

The Memphis Funeral Home on Union Avenue was where final arrangements were made for Gladys, Elvis, and Vernon Presley in 1958, 1977, and 1979 respectively. (Photo by Joe Watkins, used by permission.)

◆

(Former site of the) Office of Dr. Nichopolous

1734 Madison Avenue
Memphis, Tennessee 38104

Just past the Memphis Funeral Home site, turn left off Union Avenue at McNeil Street and make a right on Madison Avenue. The building at 1734 Madison Avenue is still a medical office complex, and in Elvis's lifetime it contained the offices of Dr. George Constantine Nichopolous (Dr. Nick), the personal physician to Elvis and members of his family and entourage, as well as to Elvis contemporaries such as music artist Jerry Lee Lewis. During 1977 alone, Dr. Nichopolous allegedly issued over 5,000 prescriptions to Elvis for assorted drugs, including narcotics and amphetamines. In 1979 the Tennessee Board of Medical Examiners charged him with allegedly overprescribing drugs to patients. He was later found not guilty of malpractice.

(Former site of the) Prescription House 🏠

1737 Madison Avenue
Memphis, Tennessee 38104

The house-shaped store across the street from the medical offices at
1734 Madison Avenue once housed the pharmacy where Elvis had many
of his prescriptions filled. He reportedly had eight of them filled the day
before he died in August 1977.

This building once housed the Prescription House, where Elvis had
many of his prescriptions filled. It was across the street from the offices
of Dr. Nichopolous. (Photo by Joe Watkins, used by permission.)

◆

Western Steakhouse and Lounge ✗

1298 Madison Avenue
Memphis, Tennessee 38104
(901) 725-9896

On a happier note than Elvis's sad pharmaceutical quagmire is the
nearby location of his favorite steakhouse. If he would have stuck to steak
and avoided the pills, he most likely would still have gained weight, but
he would have been happier and, undoubtedly, he would have lived much
longer. As late as 1998, the Western Steakhouse was still in the hands of
the owners who were here when Elvis came in for rib-eye steaks and

country brown potatoes. His back-corner booth is still there, virtually the way it was when he was last there.

Overton Park Municipal Band Shell ♫

Overton Park
Memphis, Tennessee 38112

From Madison Avenue, return to Union Avenue and continue west on Union Avenue to McLean Boulevard and turn left. Drive north to Poplar Avenue and turn right two blocks to Overton Park. One of the largest municipal parks in Memphis, Overton Park contains the band shell that was the scene of Elvis's first paid concert. On July 30, 1954, Elvis opened the show for Slim Whitman, Billy Walker, and the Louvin Brothers (Ira and Charlie). Elvis sang "That's All Right, Mama" and "Blue Moon of Kentucky." He made a second appearance at the shell on August 10, 1954, again opening for Slim Whitman. The audience response was so enthusiastic that Webb Pierce, who was supposed to perform next, refused. Elvis's last appearance at the Overton Park Municipal Band Shell was on August 15, 1955, when he appeared with Johnny Cash.

(Former site of the) Kang Rhee Institute of Self-Defense 🏠

1911 Poplar Avenue
Memphis, Tennessee 38104

Elvis developed an interest in martial arts while he was in the U.S. Army in Germany, and earned his black belt in karate in 1960 (some sources suggest 1970). In about 1969, Elvis started studying tae kwon do with the Korean-born master Kang Rhee at the Kang Rhee Institute of Self-Defense. The two became good friends, and Elvis invited Rhee to be part of his entourage on concert tours. In 1973 the King bought the master a Cadillac Eldorado car. For many years after Elvis's death, Kang Rhee entertained fans who came to see the martial-arts studio where Elvis had learned many of the moves that he used on stage. In 1990 Kang Rhee moved his studio and his display of Elvis memorabilia to a new location:

Kang Rhee Institute of Self-Defense
706 North Germantown Parkway
Cordova, Tennessee 38018
(901) 757-5000 (Call ahead for an appointment.)

Broadway Pizza ✗

2581 Broad Avenue
Memphis, Tennessee 38112
(901) 454-7930

Continue west on Poplar Avenue to East Parkway and turn left. Drive north to Broad Avenue and turn right. Broadway Pizza (located on Broad rather than Broadway) was reportedly Elvis's favorite pizza place in Memphis. Dewana Ann Plaunk, the daughter of the owner, studied at the Kang Rhee Institute of Self-Defense at the same time as Elvis, and Broadway Pizza is filled with martial-arts memorabilia related to both Elvis and Dewana. The store also has locks of Elvis's hair—framed and behind glass—on display. This is a true shrine.

(Former site of the) Bon Air Club ♫

4862 Summer Avenue
Memphis, Tennessee 38122

From Broad Avenue, return to East Parkway and drive north to Summer Avenue. Turn right on Summer Avenue and drive until you reach the street address number 4862. Though it is long gone from this site, the Bon Air Club is important to Elvis fans for being the scene of his appearance on July 17, 1954. This was his first time on stage after the release of his first record. He sang two songs during an intermission in a concert headlined by Doug Poindexter and the Starlite Wranglers. The latter band included Elvis's friends Scotty Moore and Bill Black, who were to become part of Elvis's own backup band. He appeared with them two weeks later at the Overton Park Municipal Band Shell.

Lowell G. Hays and Sons $

4872 Poplar Avenue
Memphis, Tennessee 38117
(901) 767-2840

Return to Poplar Avenue (which runs parallel to the south of Summer Avenue) on Perkins Road. In the 1970s, after Elvis had returned to the stage, jewelry became an important aspect of his persona, and Lowell G. Hays and Sons was Elvis's favorite jeweler. The famous diamond-encrusted, lightning bolt-TCB ("Taking Care of Business") rings

that Elvis shared with his closest friends were designed and crafted here, as were many other items for himself, his friends, and his entourage. Fans may still purchase TCB jewelry here, but it is the real thing, not inexpensive costume jewelry.

Elvis Sites in Outlying Areas of Memphis
(NEAR LAMAR AVENUE, DRIVING SOUTHEAST OF DOWNTOWN MEMPHIS)

This driving tour is anchored on Lamar Avenue, a major artery which runs diagonally in a southeasterly direction from South Bellevue Boulevard, starting about a quarter mile south of Union Avenue. Lamar Avenue is also designated as a section of U.S. Highway 78 and Tennessee Route 4. To reach Union Avenue from Memphis International Airport, take Brooks Road west to Elvis Presley Boulevard, turn right, and drive north for five miles. Note that Elvis Presley Boulevard becomes South Bellevue Boulevard. From downtown Memphis, drive east on Union Avenue to South Bellevue Boulevard and turn south, driving for seven blocks. The addresses on Lamar Avenue are listed in the order that they will be encountered. Directions to the other sites are provided in relation to Lamar Avenue or in relation to the previous non-Lamar site.

Immaculate Conception High School 🎓

1725 Central Avenue
Memphis, Tennessee 38104
(901) 276-6341

The first major intersection on Lamar Avenue after South Bellevue Boulevard is Central Avenue, a broad, divided boulevard. Make an "eleven o'clock" left on Central Avenue and drive east. Known as "Virginity Row" in the 1960s, Immaculate Conception High School was the protected environment in which Priscilla Beaulieu was enrolled after Elvis convinced her father to let her move to Graceland. She was a seventeen-year-old junior when she started here in January 1962, and she graduated on June 14, 1963, with Elvis not present in the auditorium. At her request—because of media attention and possible disruption of the graduation by Elvis fans—he waited outside with the "Memphis Mafia," where he signed autographs for a group of nuns. The scene was a far cry from Elvis's own graduation from Humes High School ten years earlier. His graduation gift to Priscilla, a red Corvair, was presented to her at Graceland.

Immaculate Conception High School was attended by Priscilla Beaulieu from January 1962 through June 14, 1963. Elvis did not attend her graduation, but rather waited outside, signing autographs for a group of nuns.
(Photo by Joe Watkins, used by permission.)

From Immaculate Conception High School, return to Lamar Avenue, turn left, and drive southeast.

Mid-South Coliseum 🎵

996 Early Maxwell Boulevard
Memphis, Tennessee 38104
(901) 274-3982

After he returned to concert touring in the 1970s, Elvis played Memphis three times. He had, of course, outgrown the clubs and halls at which he performed in the 1950s. By the 1970s, rock concerts—especially featuring the King of Rock and Roll—were held in coliseums! Elvis performed at the 11,667-seat Mid-South Coliseum in Memphis on March 16, 17, and 20, 1974; June 10, 1975; and July 5, 1976. The tour upon which he was about to embark when he died would have concluded at the Mid-South Coliseum on August 27–28, 1977. During the annual Tribute Week in August, events related to the memory of Elvis are often held at the Mid-South Coliseum.

Memphis (Lamar Avenue area)

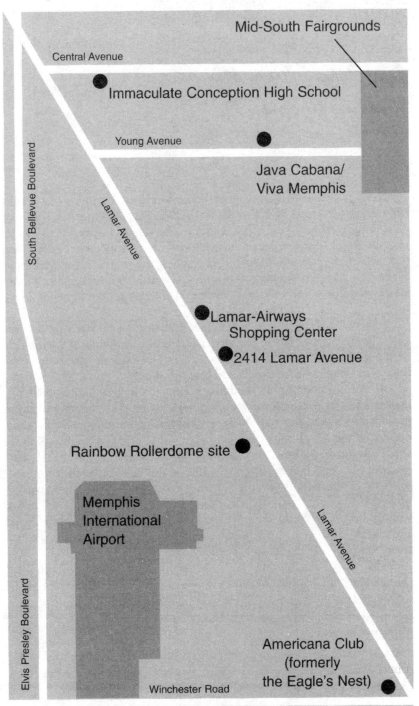

Mid-South Fairgrounds

Central Avenue

Immaculate Conception High School

South Bellevue Boulevard

Young Avenue

Lamar Avenue

Java Cabana/
Viva Memphis

Lamar-Airways
Shopping Center

2414 Lamar Avenue

Rainbow Rollerdome site

Memphis
International
Airport

Lamar Avenue

Elvis Presley Boulevard

Americana Club
(formerly
the Eagle's Nest)

Winchester Road

From Lamar Avenue, turn east on Southern Avenue to the Mid-South Fairgrounds. Turn into the fairgrounds and follow the signs. The Coliseum is large and easily seen. It resembles an enormous flying saucer.

Java Cabana/Viva Memphis Wedding Chapel 🏛

2170 Young Avenue
Memphis, Tennessee 38104
(901) 2727210

Returning toward Lamar Avenue on Southern Avenue, make a side trip to Young Avenue, which is parallel to Southern Avenue, two (or four, depending on where you turn) blocks to the north. Located here in the Cooper-Young district, Java Cabana is an Elvis shrine and coffeehouse that serves cappuccino in the front and operates the Viva Memphis Wedding Chapel in the back. Not only does an Elvis impersonator officiate at weddings, but a Priscilla impersonator serves refreshments afterward.

Memphis magazine stated that Java Cabana "paved the way for the city's caffeine scene, and is already legendary in the annals of Memphis's retro-bohemian history. The local epicenter of bongo-toting, poetry-reading, folk music-singing intellectuals and hipsters alike."

At the Viva Memphis Wedding Chapel, a nondenominational ordained minister will perform weddings for anyone. The chapel specializes in unusual themes, but traditional weddings are also welcome. There are no restrictions on music, photography, or vows. Legally recognized, non-legal but equally serious, and just-for-fun ceremonies are available. The ever-popular item is the "King and Cilla" wedding, complete with impersonators of the famous couple. Theme weddings start at $175, with a fifty-percent deposit required. Wedding licenses may be acquired at the County Clerk's Office for $35, with no waiting period. The Clerk's Office address is: Shelby County Civil Court Clerk, 140 Adams Avenue, Memphis, TN 38103; (901) 576-4031.

The chapel is decorated with Memphis music themes, including shrines to great Memphis musicians.

The First Single-Family House Occupied by the Presley Family in Memphis 🏠

2414 Lamar Avenue
Memphis, Tennessee 38114

In 1954, Elvis and his family moved to their first detached, single-family house. They lived here at 2414 Lamar Avenue for about a year. The house was later converted for use as a commercial building. (Photo by Joe Watkins, used by permission.)

◆

The Presley family had lived in Memphis for six years before they moved to a detached, single-family house. From 1948, when they first moved to the city from Tupelo, Mississippi, until 1954, when Elvis started to make some money from his music, they resided in apartments and rooming houses, living the existence of the poor country people that they had been. Late in 1954 they moved from the 462 Alabama Street apartment house to this building on busy Lamar Avenue. They would remain here until the middle of 1955, when they moved to 1414 Getwell Street. In 1968 the former Presley home at 2414 Lamar Avenue was converted to a commercial-use building. Originally it became the Tiny Tot Nursery School, and now it is an accountant's office.

Lamar-Airways Shopping Center ♫

2256 Lamar Avenue at Airways Boulevard
Memphis, Tennessee 38114
(There is no phone number because it is a complex of individual stores.)

In the iconography of rockabilly music and early rock and roll, one of the most striking images is that of the three-piece band with its gyrating singer, performing from the back of a flatbed truck. It symbolizes the spontaneity, mobility, rootlessness, and the working-class foundations of the music of the mid-1950s. It was also convenient for the musicians. They didn't have to unload and reload heavy equipment, and the bed of the truck was an instant stage at a perfect performing level.

The opening of this sprawling strip-mall complex on September 9, 1954, marked the first time that Elvis and his band performed from the back of a truck. They played in the parking lot as part of the general celebration, and the performance was not associated with a specific store. Most, if not all, of the store names have changed by now, but the parking lot is still the same.

Rainbow Rollerdome

2881 Lamar Avenue
Memphis, Tennessee 38114

Like sock hops and drive-ins, roller rinks were part of teenage life in the 1950s. For Elvis and many of his pals, the roller rink of choice was the fifty-cents-per-person Rainbow Rollerdome, near the Rainbow Lake Pool on Lamar Avenue. Legend has it that Elvis took Dixie Locke skating here while he was in high school, and it was at the Rainbow that he first met Sonny West in 1958. When you watch his moves on stage in his films from the 1950s, you can imagine his skill on the skating floor. For Elvis, skating at the Rainbow would continue after his teenage years—after he had money, he would rent the place for the evening and invite friends. Elvis rented the Rainbow Rollerdome on March 23, 1958, the night before he was inducted into the Army.

The Rainbow is long gone, but the building still remains. Recently it was remodeled for use as a Pancho's Mexican food restaurant, but presently it is being used by the Pancho's chain as a warehouse.

Americana Club ♬

(formerly the Eagle's Nest)
4090 Winchester Road at Lamar Avenue and Clearpool Road
Memphis, Tennessee 38118
(901) 368-0994

In 1954 Elvis formed his legendary band—originally known as the Blue Moon Boys—with Scotty Moore on guitar and Bill Black on bass, both of whom were previously members of the Starlite Wranglers. Bill and Scotty also played on Elvis's legendary Sun Records sessions. Early in 1954 the trio played the Bon Air Club and probably the Bel-Air Club, and they opened for Slim Whitman at the Overton Park Municipal Band Shell. However, the first place that they had a consistent, ongoing gig was at the Eagle's Nest, a tough rockabilly nightclub on what was—and to a certain extent still is—the edge of town.

Their opening show in 1954 was on August 7, followed by shows on August 16 and 27; September 18, 24, and 25; October 1, 6, 9, 13, 20, 29, and 30; and November 17. The last Elvis show at the Eagle's Nest was on December 10, 1954. In 1955 the band would be going to places that

The Americana Club on Winchester Road at Lamar Avenue was known as the Eagle's Nest in the fall of 1954 when Elvis, Scotty Moore, and Bill Black played a historic series of shows here. Buoyed by the success of these appearances, and of Elvis's early Sun Records releases, they toured the South and Texas through 1955 and 1956. (Photo by Joe Watkins, used by permission.)

the crowd at the Nest could never have imagined. According to a number of accounts, Elvis also appeared here in the fall of 1953, but that has not been absolutely confirmed. Some of his concerts involved appearances by—and his being backed by—Tiny Dixon and the Eagles.

The Eagle's Nest was also referred to as "the Clearpool" because of the proximity of Clearpool Road. Now the Americana Club, the former Eagle's Nest still has the feel of "the joint" where Elvis and his band played most of their 1954 Memphis shows.

1977 Home of Ginger Alden 🏠

4152 Royal Crest Place
Memphis, Tennessee 38115

At the time of his death in August 1977, Elvis was engaged to twenty-three-year-old Ginger Alden, with a marriage date set for Christmas 1977. They met in 1976 after Elvis had arranged to meet Ginger's sister Terry, who was Miss Tennessee that year. It was Ginger, rather than Terry, who became Elvis's girlfriend, and they spent much of his remaining life together, both in Memphis and on the road. He bought her this house, as well as a Lincoln Continental Mark V car and a $70,000 diamond ring.

The couple spent more time together at Graceland than at 4152 Royal Crest Place, so if Elvis was at the Royal Crest house at all, it was, at most, just on a few occasions. Ginger was with him at Graceland the night and day prior to his death, and it was she who discovered his body. She went on to enjoy a modest film career in the 1980s.

To reach Royal Crest Place from Lamar Avenue, turn left onto Winchester Road at the Americana Nightclub and drive east. Turn right at Mendenhall Road, left on Raines Road, and drive for about a mile into the Ridgeway Estates development. Royal Crest Place will be on your left.

(Former site of the) Last House Rented by Elvis in Memphis 🏠

1414 Getwell Road
Memphis, Tennessee 38111

From Royal Crest Place, return to Winchester Road and drive west to Getwell Road, the next major intersection after Lamar Avenue, and turn right. Getwell Road narrows from an expressway to a city street shortly before you reach number 1414.

Now a Dollar Mania convenience store, 1414 Getwell Road was once the site of the second detached house occupied by the Presley family in Memphis, and the last *rented* house that Elvis occupied in Memphis. It had a lawn with several large trees, all of which were removed to make way for the present parking lot. The family, including Vernon's mother, Minnie Mae (aka "Dodger"), lived here from the middle of 1955 until May 1956, when Elvis bought the house at 1034 Audubon Drive.

The First House Owned by Elvis Presley

1034 Audubon Drive
Memphis, Tennessee 38117

On March 12, 1956, flush with his immense and sudden success, Elvis purchased first house for $40,000. It was a modest, one-story ranch style home that still stands, albeit now with a metal fence. The entire family, including grandmother Minnie Mae "Dodger" Presley, moved in on May 11, 1956, but they remained for just over one year.

On March 25, 1957, Elvis purchased Graceland, into which the family moved on May 16, 1957. They wanted to relocate to a property with larger grounds so that they would have more privacy from Elvis' fans, who swarmed over the yard at the Audubon Drive property.

Please note that this is a private home and not open to the public. View it from the street and do not disturb the occupants, as this is rude and it gives a bad name to fans who come to Memphis to respectfully remember the life and times of Elvis Presley.

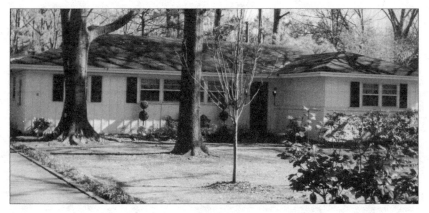

Elvis and his entire family — including grandmother Minnie Mae — lived at the 1034 Audubon Drive house from April 1956 through May 1957, when they all moved to Graceland. (Photo by Joe Watkins, used by permission.)

Chapter 4

Virginia and the Mid-South beyond Memphis

This chapter includes sites that are located in Kentucky, West Virginia, Virginia, and in Tennessee outside of Memphis. There are no Elvis movie sites in this region, nor are there any places that he lived. The principal sites are located in Nashville—where the Country Music Hall of Fame complex includes the former RCA Studio B, where he recorded, and an exhibit centering on his gold-plated Cadillac—and Pigeon Forge, Tennessee, home of the Elvis Presley Museum.

The concert venues for each state are grouped together, with the entries being in chronological order by the date of the first concert given in a particular locale.

Elvis Presley Museum 🏛

2638 Parkway
Pigeon Forge, Tennessee 37863
(423) 428-2001

Known as "The World's Largest Private Collection of Elvis Memorabilia," the Elvis Presley Museum is almost certainly the largest Elvis Presley memorabilia museum outside of the Graceland complex in Memphis, although there are other, occasionally exhibited collections that may rival it in size. In Holly Springs, Mississippi, Paul McLeod's Graceland Too probably has more items of memorabilia, but the Elvis Presley Museum in Pigeon Forge has more items—including cars and jewelry—that Elvis actually owned.

The Elvis Presley Museum was started in 1982 by Mike L. Moon, a friend of Elvis's, who obtained most of the memorabilia in the collection from Elvis himself or from other close Elvis friends, such as J. D. Sumner and Charlie Hodge. The Elvis Presley Museum is now owned by Lynn and Mike Wyrick, Mike Moon's daughter and son-in-law.

The museum contains several automobiles—including Elvis's last white Lincoln limousine—as well as jewelry—including Elvis's original, diamond-encrusted, $250,000 TCB ("Taking Care of Business") ring. There are also a number of Elvis's guns, jumpsuits, and personal effects.

Adult admission is $8.99 plus tax, with students above the age of twelve admitted for $5.99 plus tax, children six through twelve $3.99 plus tax, and children under six admitted free. The Elvis Presley Museum is open seven days a week, except Thanksgiving Day and Christmas Day. Summer hours are from 9:00 A.M. until 10:00 P.M., and winter hours are from 10:00 A.M. until 6:00 P.M. As all such information is always subject to change, it is a good idea to call ahead for details and times. The Elvis Presley Museum has a souvenir shop and a courtyard. Refreshments are available nearby.

Pigeon Forge, which is also home to Dolly Parton's Dollywood museum and entertainment complex, is about thirty miles east of Knoxville, Tennessee. From Knoxville, take U.S. Highways 411 and 441 east to Sevierville. At this point, the two highways divide. Take U.S. Highway 441 five miles south to Pigeon Forge.

Country Music Hall of Fame Museum 🏛

Four Music Square East
Nashville, Tennessee 37203
(615) 256-1639
(615) 255-5333

The Country Music Hall of Fame was begun in 1961 by the Country Music Association. In turn, the Country Music Hall of Fame opened its museum in Nashville in 1967. This museum is the best single collection of country music artifacts and memorabilia in the world, and the museum's interpretive exhibits are among the best places anywhere to gain an understanding of the history and evolution of country music. Because of his country roots and that of much of his early music, Elvis has always been important to country-music fans and to the Country Music Hall of Fame, which includes some important Elvis memorabilia in its collection.

The centerpiece of the museum's Elvis collection is the famous gold-plated Cadillac, a 1959 Cadillac Fleetwood that was customized for the King of Rock and Roll by the legendary California custom-car king, George Barris. It has actual gold-plated trim, and the white paint contains

Elvis's "Gold Plated" 1959 Cadillac Fleetwood has a bar, an electric shoe buffer and a black and white television set. According to the stories, Elvis was afraid to use the car for fear of marring the paint job. Other stories say that he used to take Priscilla driving in the car. (Photos by the author, copyright Bill Yenne.)

◆

twenty-four-carat-gold metal flecks. The backseat has a bar, an electric shoe buffer, and a black-and-white television set. An unseen robot mechanism lifts the top of the car every few minutes to reveal the interior in detail. Before ending up here at the museum, the vehicle was on display throughout the world. According to the stories, Elvis was afraid to use the car for fear of marring the custom paint job.

Also in the museum are various important items of Elvis memorabilia, including the guitar that he used during his sessions at Sun Studio in Memphis in 1954–1955 and a gold lamé jacket that he wore in the early 1970s.

Across the street and included as part of the Country Music Hall of Fame Museum tour is the former RCA Studio B, which is preserved with the original—albeit crude by today's standards—recording equipment that was in service when Elvis recorded here. While much of RCA's taping of Elvis's songs took place in Los Angeles, his first RCA sessions, in January 1956, occurred here at Studio B. From 1958 on he would record most of his movie soundtracks at Radio Recorders in Los Angeles, but most of his other work was done here in Nashville. His last sessions at Studio B were in June 1971. With the installation of a custom-made studio at Graceland, Elvis intended to do all of his recording there, and he probably would not have come back to Studio B. RCA itself abandoned Studio B in 1977, and it became part of the museum.

The Country Music Hall of Fame Museum and Studio B are open daily from 9:00 A.M. until 5:00 P.M. Because all such information is sometimes subject to change, it is a good idea to call ahead for details and times.

Ryman Auditorium ♫

116 Fifth Avenue North
Nashville, Tennessee 37219
(615) 254-1445

The most hallowed shrine in the world of country music, the Ryman Auditorium was the home of the *Grand Ole Opry*, which was broadcast to the nation from here over the airwaves of WSM Radio from 1941 to 1972. While Elvis was invited to appear on *Louisiana Hayride* more than four dozen times, he performed at the Ryman Auditorium—on the *Grand Ole Opry* —just once, on October 2, 1954. (When the *Grand Ole Opry* moved to Opryland, the auditorium, its former home, remained empty and in disrepair. It has now been restored to what it was in the 1950s and is presently being used as an auditorium.)

Don and Kim Epperly's Miniature Graceland 🏛

605 Riverland Road Southeast
Roanoke, Virginia 24014
(504) 56-ELVIS (563-5847)

Perhaps the most lovingly constructed Elvis shrine anywhere, the Epperlys' Miniature Graceland is a Barbie doll-scale replica of Elvis's home in Memphis, Tennessee, complete with mansion and Meditation Garden. They have been adding to the model since 1987 and it now includes a scale model of Elvis's birthplace in Tupelo, Mississippi, and a model of Elvis's concert appearance at the Roanoke Coliseum. The latter is complete with Barbie dolls in vintage 1970s costume representing fans in the audience. An Elvis doll is always on the property, but he is moved frequently. Just as with the real Graceland, the Epperlys' scale model is decorated annually with a kaleidoscopic array of Christmas lights, and a candlelight vigil is always held here on August 16, the anniversary of Elvis's death in 1977.

Elvis Concert Venues in Kentucky ♫

Within this state the venues of Elvis concerts are arranged in chronological order by the date of the first concert given in a particular place, then fol-

lowed, chronologically, by the rest of the concerts given in that place. This is done to give readers the cities in the order that Elvis first experienced them.

Rialto Theater
Louisville, Kentucky
(This venue was not found to be listed under this name, nor was it found to be listed under another name.)
(December 8, 1955)

National Guard Armory
Buechel Armory
Louisville, Kentucky 40218
(502) 595-4330
(November 25, 1956)

Freedom Hall, Expo Center
937 Phillips Lane
Louisville, Kentucky 40209
(502) 595-3166
(November 7, 1971 matinee;
June 26, 1974; July 23, 1976;
May 21, 1977)

Elvis Concert Venues in Tennessee

(except Memphis) 🎵

Within this state the venues of Elvis concerts are arranged in chronological order by the date of the first concert given in a particular place, then followed, chronologically, by the rest of the concerts given in that place. This is done to give readers the cities in the order that Elvis first experienced them.

Grand Ole Opry, Ryman Auditorium
116 Fifth Avenue North
Nashville, Tennessee 37219
(615) 254-1445
(October 2, 1954)

Davidson Municipal Auditorium
417 Fourth Avenue North
Nashville, Tennessee 37219
(615) 862-6390
(July 1, 1973—two shows)

★

Kingsport Civic Auditorium
1550 Fort Henry Drive
Kingsport, Tennessee 37664
(423) 229-9457
(September 22, 1955)

★

University of Tennessee
Stokley Athletics Center
Knoxville, Tennessee 37916
(243) 974-5084
(April 8, 1972; March 15, 1974;
May 20, 1977)

★

Middle Tennessee State University
1301 East Main Street
Murfreesboro, Tennessee 37130
(615) 898-2300
(March 14 and 19, 1974; April 29, 1975; May 6–7, 1975)

★

Freedom Hall/Civic Center
Freedom Hall
1320 Pactolas Road
Johnson City, Tennessee 37604
(423) 461-4872
(March 17–19, 1976)

Elvis Concert Venues in Virginia ♪

Within this state the venues of Elvis concerts are arranged in chronological order by the date of the first concert given in a particular place, then followed, chronologically, by the rest of the concerts given in that place. This is done to give readers the cities in the order that Elvis first experienced them.

Norfolk City Auditorium
Norfolk, Virginia 23510
(This venue was not found to be listed under this name, nor was it found to be listed under another name.)
(May 15, 1955; September 11–12, 1955)

Montecello Auditorium
Norfolk, Virginia
(This venue was not found to be listed under this name, nor was it found to be listed under another name.)
(February 12, 1956)

★

Mosque Theater
Richmond, Virginia
(This venue was not found to be listed under this name, nor was it found to be listed under another name.)
(May 16, 1955; February 5, 1956; March 22, 1956; June 30, 1956)

WRVA Radio
200 North 22nd Street
Richmond, Virginia 23223
(804) 780-3400
(September 18–19, 1955)

The Coliseum
601 Leigh Street
Richmond, Virginia 23219
(804) 780-4970
(April 10, 1972; March 12, 1974; March 18, 1974; June 29, 1976)

★

American Legion Auditorium
Roanoke, Virginia
(This venue was not found to be listed under this name, nor was it found to be listed under another name.)
(May 18, 1955; September 15, 1955)

Roanoke Civic Center Coliseum
710 Williamson Road
Roanoke, Virginia 24016
(540) 981-2241
(April 11, 1972; March 10, 1974; August 2, 1976)

★

County Fairgrounds
Danville, Virginia 24541
(September 20, 1955)

★

Paramount Theater
Newport News, Virginia
(This venue was not found to be listed
under this name, nor was it found to
be listed under another name.)
(February 13, 1956)

Hampton Coliseum
1000 Coliseum Drive
Hampton Roads, Virginia 23666
(757) 838-4203
(April 9, 1972; March 11, 1974;
July 31–August 1, 1976)

Elvis Concert Venue in West Virginia ♪

Charleston Civic Center
200 Civic Center Drive
Charleston, West Virginia 25301
(304) 345-1500
(July 11–12, 1975; July 24, 1976)

Chapter 5

The North

T his chapter lists Elvis-related sites that are located in the geographic triangle roughly formed by the states of Ohio, Maryland, and Maine. Included in particular are the sites in New York City, where Elvis recorded a number of important songs and where he went on stage for several ground-breaking television appearances in 1956 and 1957. After his last appearance on CBS-TV's *The Ed Sullivan Show* on January 6, 1957, Elvis returned to the Big Apple professionally just once. More than a decade later, after his departure from, and return to, the concert stage, Elvis played four shows at Madison Square Garden. His four shows in three days established new attendance records for Manhattan's largest indoor concert venue, but they were his only New York City concerts in the 1970s.

New York City was important to the early development of Elvis's career insofar as it was, in the 1950s, the absolute center of the American broadcast media. As is true today, the network news emanated from New York City, but in the 1950s all of the game shows, variety shows, and soap operas did, as well. By the 1960s, changes in technology and demographics facilitated a gradual shift to Los Angeles. However, in 1956, at the time Elvis made his nationwide TV debut, the Big Apple was the only apple.

Ironically, Elvis made his first trip to New York City to try out for a television variety show, but he was turned down. It was in March 1955 that Elvis, along with Scotty Moore and Bill Black, went north to audition for Arthur Godfrey's *Talent Scouts* on CBS-TV. Billing themselves as the Blue Moon Boys, the trio from Tennessee were given a thumbs-down, while Pat Boone, later a singer of some fame, won first place in the try-outs. A year later Elvis was one of the hottest up-and-coming acts in town.

In this chapter, the concert venues for each state are grouped together, with the entries being in chronological order by the date of the first concert given in a particular locale. The exception to this grouping logic is New York City.

The Ed Sullivan Theater ♪

(formerly CBS Studio 50)
1697 Broadway
New York, New York 10019
(212) 975-4321

Now the home of the CBS network's *The Late Show with David Letterman*, this studio between West 53rd and West 54th Streets was the center of action for CBS variety-show broadcasts in the 1950s. It was the site of seven of Elvis's nine televised New York City stage appearances, including his first and his last.

In December 1955 Elvis was signed as a guest on *Stage Show*, the one-hour variety show hosted by big-band greats Tommy Dorsey and Jimmy Dorsey, which originated from CBS Studio 50. The program then aired at eight o' clock on Saturday nights as a lead-in to *The Honeymooners*, starring Jackie Gleason, who was the producer of both shows. Signed for four episodes, Elvis had his contract extended to six. His first four appearances were on four consecutive Saturdays, beginning on January 28, 1956, followed by appearances on February 4, 11, and 18. The final two appearances were on March 17 and 24. The Dorsey Brothers' big band played with Elvis on his rendition of "Heartbreak Hotel" on the February 11 show.

Elvis's most famous New York City television appearances were those on the highly rated *Ed Sullivan Show*, which had been known as Toast of the Town from 1948 to 1955. Elvis's performances are remembered for Sullivan's eventual insistence that the camera not show Elvis's hips, which he shook when he performed. Indeed, Sullivan reportedly did not like "Elvis the Pelvis," and didn't want him on the show at all. He only acquiesced to Elvis's appearance because of the high ratings of Presley's earlier outings with the Dorsey Brothers and Steve Allen. After the two men had met, however, Sullivan described Elvis as a "decent, fine boy." Elvis was paid $50,000 for three shows, a large sum in those days.

Ironically, the first appearance of Elvis on *The Ed Sullivan Show* did not take place in New York City and Ed Sullivan did not host the program. On September 9, 1956, Elvis was in Los Angeles working on *Love Me Tender* (1957), his feature-film debut, so it was arranged that he provide his segment live from CBS Television City in Los Angeles. Charles Laughton, back in New York City, introduced Elvis from CBS Studio 50.

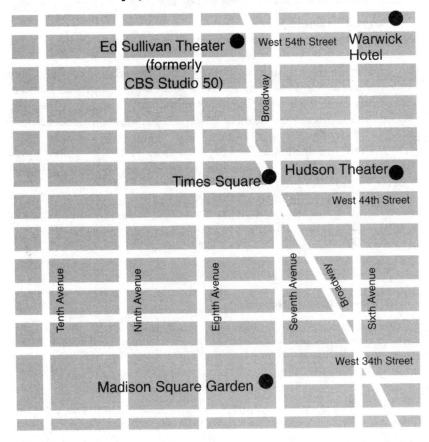

New York City (midtown Manhattan)

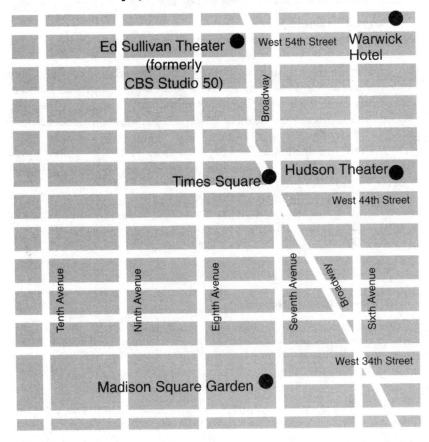

Elvis's second appearance took place in New York City, but not at Sullivan's usual digs at CBS Studio 50. *The Ed Sullivan Show* on October 28, 1956, originated from the Maxine Elliot Theater.

Elvis's final appearance on *The Ed Sullivan Show* took place at CBS Studio 50 on January 6, 1957, with Elvis singing six songs, as opposed to the three on his earlier appearances. Trivia buffs will also note that it was only at the January 6 performance that Sullivan had the cameras show Elvis only from the waist up. In Sullivan's defense, this was not his idea, but came in response to complaints that the network had received after the earlier shows.

The Maxine Elliot Theater ♫

109 West 39th Street
New York, New York 10018

Elvis made three appearances on the top-rated *Ed Sullivan Show*, but only one was at Sullivan's usual theater at CBS Studio 50. Elvis's first was in Los Angeles at CBS Television City, and his second was aired from the Maxine Elliot Theater on October 28, 1956. No longer in existence, the Maxine Elliot Theater was founded and managed by Maxine Elliot (1871–1940), a famed American Shakespearean actress, in 1908. It was here that Orson Welles appeared on stage in The Tragical History of Doctor Faustus and Julius Caesar in 1937. Elvis's final Ed Sullivan Show took place at CBS Studio 50 on January 6, 1957.

The theater was bought by CBS for use as a television studio, but the building was torn down in 1959. An office building now exists at this locale.

The Hudson Theater ♫

(now within the Millennium Broadway Hotel complex)
145 West 44th Street
New York, New York 10036
(212) 768-4400

In the 1950s entertainer Steve Allen probably hosted more prime-time network television shows—including the original *Tonight Show*—than anyone. He recognized Elvis's talent and cultural importance long before Ed Sullivan. Allen premiered the second incarnation of his The *Steve Allen Show* at the Hudson Theater on June 24, 1956, and he invited Elvis to appear on his second show, but he insisted that Elvis wear a tuxedo. Elvis sang two songs on the July 1, 1956, telecast, with the second being "Hound Dog," for which Allen brought a basset hound on stage. At the end of the program, Elvis participated in a comedy skit along with Steve, Andy Griffith, and Imogene Coca.

Now incorporated into the fifty-two-story Millennium Broadway Hotel complex, the historic 1903 Hudson Theater is the second-oldest surviving Broadway theater in New York City (only the Lyceum is older). Its most spectacular feature is the backlit stained-glass ceiling in the lobby, designed by Tiffany Studios. Ethel Barrymore, Douglas Fairbanks, William Holden, Helen Hayes, and many other great performers headlined at the Hudson. In the 1930s and 1940s it became a radio studio, and in the 1950s it became the television facility from which Steve Allen

broadcast the first *Tonight Show*. The theater was saved from demolition and granted landmark status in 1987. It is now operated by the Millennium Broadway and is available for rental for private celebrations or corporate events.

(Former site of) RCA Studios ♪

155 East 24th Street
New York, New York 10010

After he signed with RCA Records in November 1955, most of Elvis's recording work was done either in Nashville or Los Angeles. However, during the early months of 1956, he was in New York City almost continuously for his television appearances, so RCA used their New York facility for much of the early taping. His first RCA sessions were in Nashville on January 10 and 11, but he recorded at RCA in New York on January 30 and 31, on February 3, and on July 2. Because taping was done "live" in those days, with no complicated overdubbing, Elvis was able to lay down an amazing number of tracks. Among those that he recorded in the New York City sessions were "Hound Dog," "Blue Suede Shoes," and "Don't Be Cruel." The building that used to house RCA Studios is now part of Baruch College.

The Warwick Hotel

65 West 54th Street
New York, New York 10019
(212) 247-2700

Located within a ten-minute walk of CBS Studio 50, the Warwick was the hotel at which Elvis stayed during his visits to New York City between November 20, 1955, when he came to town to sign his contract with RCA Records, and January 1957, when he made his final TV appearance on *The Ed Sullivan Show*. Reportedly, he stayed in room 527 for all, or at least most, of his visits.

It was from his room at the Warwick that Elvis appeared via "split screen" technology on the WRCA-TV interview show *Hy Gardner Calling*. The telecast interview took place live on the night of July 1, 1956, after Elvis's appearance on *The Steve Allen Show*.

Madison Square Garden ♫

2 Pennsylvania Plaza
New York, New York 10121
(212) 465-6727

There used to be a saying in show business that you hadn't made it in showbiz until you made it in New York City. Elvis certainly "made it" in New York City in 1956, but his career went through many changes over the next sixteen years. He made his comeback on television in 1968, returned successfully to the stage in 1969, and then he went on tour. However, he had not "made it" in New York City for more than a decade.

When it was announced in 1972 that Elvis would play Madison Square Garden, he quickly became the first performer to sell out four shows at this famous entertainment palace. He appeared on June 9 for one show, on June 10 for two performances, and on June 11 for one concert. The combined audience numbered 80,000 and included such celebrities as John Lennon and Bob Dylan. Songs performed at the evening show on June 10 were released the same month as the album *Elvis as Recorded at Madison Square Garden*.

The First Presleyterian Church ⛪

43 Lafayette Avenue
Dumont, New Jersey 07628
(201) 385-4596

As may be suggested by its name, the First Presleyterian Church is partly a spoof and partly an exercise in irony that demonstrates how significant Elvis Presley has become in popular culture. The First Presleyterian Church of Elvis the Divine was founded by Dr. Karl N. Edwards of Hoboken, New Jersey, and Reverend Mort Farndu, of Denver, Colorado. Dr. Edwards suggests that Elvis sightings "are proof of the King's divinity."

The founders spent five years developing church doctrine and sacred rituals before going public. Presleyterians are required to face Las Vegas daily and make a pilgrimage to Graceland at least once during their lives. According to church doctrine, "Presleyterian men are masters of the house, while women are required to wear bikinis and cook." Presleyterians also support involuntary prayer in public schools, and believe that children should be forced to praise Elvis daily. "Back in the 1950s, everyone in public school worshiped Elvis. There's been a steady

Reverend Mort Farndu and Dr. Karl N. Edwards of the First Presleyterian Church of Elvis the Divine, with Tammy Fae Berkowitz, call to the holy spirit of Elvis. (Photo by H. Karlin, GKX Group, used by permission.)

◆

decline in our educational values and morals since we've taken the King out of the classroom," Reverend Farndu has said.

Presleyterianism teaches us that there is no discrepancy between science and theology, no disparity between putting your trust in physics and technology or believing in Elvis. The First Presleyterian Church of Elvis the Divine notes in particular that it never condemned Galileo for observing that the Earth revolved around the Sun.

Church dietary laws are strict, Dr. Edwards points out. Every Presleyterian home must always be stocked with "the 31 Holy Items" that Elvis kept at Graceland at all times. Included among these are ground-round meat and banana pudding (to be made fresh each night). "Imagine if Elvis was on your very street and he passed over your house because you didn't have that banana pudding," Dr. Edwards said. "Or if you had it—but it wasn't fresh."

..

The White House

1600 Pennsylvania Avenue
Washington, D.C. 20500
(202) 456-1111
(202) 456-7041 (Visitor information)

Elvis was born during the presidency of Franklin D. Roosevelt and died while fellow Southerner Jimmy Carter was president. However, the King actually met only one United States president face-to-face. This historic event occurred on December 21, 1970, when Elvis arrived at the White House in Washington, D.C. He spoke with presidential aide and future Watergate conspirator H. R. Haldeman, and asked to see President Richard M. Nixon. At 12:30 P.M., Elvis, along with Sonny West and Jerry Schilling, entered the Oval Office to meet with Richard Milhous Nixon.

During their meeting, Nixon presented Elvis with a DEA (Drug Enforcement Agency) badge, and Elvis presented the president with a World War II–era Colt .45 pistol. (The pistol had not been detected by Secret Service personnel prior to Elvis entering the Oval Office.)

Today the White House is open for tours Tuesday through Saturday, and is closed every Sunday and Monday. All White House tours are free. The most common way to visit is on a walk-through tour. These self-guided public tours are scheduled Tuesday through Saturday, from ten o'clock each morning until noon. Visitors move from room to room at their own pace, and once inside the White House, most take about fifteen to twenty minutes. Visitors usually walk along the ground-floor corridor and look through the doors of the Vermeil Room and library, walk upstairs to the State floor, and through the East, Green, Blue, Red, and State dining rooms, and exit from the north portico lobby. A United States Secret Service tour officer is stationed in each room to answer questions. Free tickets are required year-round for the tours. The National Park Service distributes the tickets in the White House Visitor's Center, located at the southeast corner of 15th and E Streets. Look for the three American flags and the blue awnings. The closest Metrorail station to the White House is Federal Triangle (Blue and Orange lines). Advance tickets are not available. They are issued on the morning of the tour only, on a first-come, first-served basis starting at 7:30 A.M. As the number of tickets for each day is limited (about 4,500), visitors should arrive as early as possible. Unfortunately, there is no way to predict what time one should arrive to guarantee tickets. One person may obtain up to four tickets. All individuals, including children, are required to have a ticket. The ticket counter closes at noon, or earlier if the supply for that day is distributed. Each ticket indicates when and where you join the line.

The second way to visit, if you have at least eight to ten weeks' advance notice, is to contact the local or Washington office of your congres-

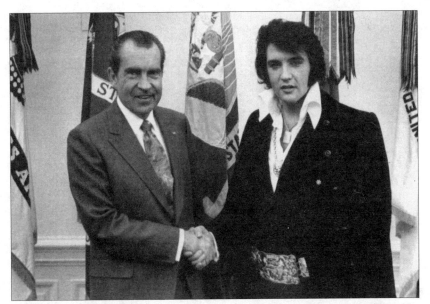

President Richard Milhous Nixon (left) greets Elvis at their Oval Office meeting on December 21, 1970. Elvis wore his sunglasses through most of the conference. The president did not wear sunglasses at any time during the meeting. (Photo from the National Archives.)

◆

sional representative, or one of your senators, to request free, reserved tickets for the congressional guided tours of the White House. The tours are conducted in groups of seventy, and you will wait in line to enter the White House. The Oval Office is, regrettably, not on the tour. However, most of the tour guides are knowledgeable about the day that the King met the president, and they are happy to discuss it with visitors.

The Washington Hotel

515 15th Street Northwest
Washington, D.C. 20004
(202) 638-5900

In December 1970, when he arrived in Washington, D.C., for his famous meeting with President Richard Nixon, Elvis checked into room 506 of the Washington Hotel, using the alias "John Burrows." According to her book *Are You Lonesome Tonight?* (1987), Elvis's friend Lucy de Barbin first met Elvis at the Washington Hotel.

Brooklyn High School

9200 Biddulph Road
Cleveland, Ohio 44144
(216) 351-8477

St. Michael's Hall

3115 Scranton Road
Cleveland, Ohio 44109
(216) 861-1635

The first filming of Elvis by a major studio was not *Love Me Tender* (1957), his debut feature film, but rather a documentary entitled *The Pied Piper of Cleveland* that Universal Pictures shot on October 15, 1955, at the Circle Theater in Cleveland, Ohio. It was actually not about Elvis, but about a day in the life of the popular Cleveland disc jockey Bill Randle, who then divided his time between Cleveland and New York City. Coincidentally, he had been the first disc jockey outside the South to play an Elvis Presley record on the air.

The film was produced by Randle himself, with director Arthur Cohen and cinematographer Jack Barnett. It was Randle who signed the talent that would appear on two shows to be filmed with state-of-the-art 35mm cameras on October 19. The top act was the now-forgotten Four Lads, but Bill Haley and the Comets, and Pat Boone, also appeared. Because Elvis was scheduled to be in town playing a concert with Kitty Wells at the Circle Theater, he too was added to the roster of performers. The two shows were at Brooklyn High School and at St. Michael's Hall. Elvis's songs included "That's All Right, Mama," "Blue Moon of Kentucky," "Good Rockin' Tonight," "Mystery Train," and "I Forgot to Remember to Forget."

The film was edited, and several weeks later a forty-eight-minute version was screened at the local Euclid Shore Junior High School. Parts of it were seen on Cleveland's WEWS-TV (Channel 5) in 1956, but aside from this exposure, no one outside of those involved in the production has ever seen *The Pied Piper of Cleveland*. The 35mm original is believed still to languish in the vaults at Universal. There has been occasional discussion about releasing it, but apparently the legal issues involving all of the stars have, to date, prevented this happening.

In 1992 a London businessman named Ray Santilli was in Cleveland trying to locate the print of *The Pied Piper of Cleveland* that Bill Randle is said to have, when he got the lead that led him to the famous *Alien Autopsy Film*. This movie, aired on television worldwide in 1995, allegedly shows U.S. Army doctors conducting an autopsy on one of the

occupants of a UFO that crashed near Roswell, New Mexico, in July 1947. As the story goes, Jack Barnett, who worked on *The Pied Piper of Cleveland* and who died in 1957, was somehow involved in making *Alien Autopsy Film* for the U.S. Army at Roswell. Other versions of the story suggest that Burnett was not involved, and that the name "Jack Barnett" was an alias used to protect the real identity of the Roswell cameraman. Other people insist that *Alien Autopsy Film* is an obvious fake.

Elvis Concert Venues in Connecticut ♫

Within this state the venues of Elvis concerts are arranged in chronological order by the date of the first concert given in a particular place, then followed, chronologically, by the rest of the concerts given in that place. This is done to give readers the cities in the order that Elvis first experienced them.

New Haven Coliseum
275 South Orange Street
New Haven, Connecticut 06510
(203) 772-4200
(July 16–17, 1975; July 30, 1976)

Hartford Civic Center
Trumbull Street at Asylum Street
Hartford, Connecticut 06103
(860) 727-8010
(July 28, 1976)

★

Elvis Concert Venues in Maine ♫

Within this state the venues of Elvis concerts are arranged in chronological order by the date of the first concert given in a particular place, then followed, chronologically, by the rest of the concerts given in that place. This is done to give readers the cities in the order that Elvis first experienced them.

Augusta Civic Center
Community Drive
Augusta, Maine 04330
(207) 626-2405
(May 24, 1977)

★

Cumberland County Civic Center
One Civic Center Square
Portland, Maine 04101
(207) 775-3458
(The stage was being set for Elvis's evening concert on August 17, 1977, when news of his death was made public. Filming for the documentary *This Is Elvis* [1981] was scheduled to start with this show and the filming equipment was already in place.)

Elvis Concert Venues in Maryland 🎵

Within this state the venues of Elvis concerts are arranged in chronological order by the date of the first concert given in a particular place, then followed, chronologically, by the rest of the concerts given in that place. This is done to give readers the cities in the order that Elvis first experienced them.

Baltimore Convention Center
One West Pratt Street
Baltimore, Maryland 21201
(410) 659-7000
(November 9, 1971; May 29, 1977)

★

University of Maryland Field House
University Boulevard at Adelphi Road
College Park, Maryland 20742
(301) 985-7000
(301) 405-1000
(September 27–28, 1974)

Elvis Concert Venues in Massachusetts 🎵

Within this state the venues of Elvis concerts are arranged in chronological order by the date of the first concert given in a particular place, then followed, chronologically, by the rest of the concerts given in that place. This is done to give readers the cities in the order that Elvis first experienced them.

Boston Garden
Causeway Street
Boston, Massachusetts 02114
(In 1995 the venerable Boston Garden, the longtime home of the Boston Celtics, was replaced as Boston's premier concert venue by the modern and impersonal Fleet Center. The Garden was finally torn down in 1998.)
(November 10, 1971)

★

Springfield Civic Center
1277 Main Street
Springfield, Massachusetts 01103
(413) 787-6610
(July 14–15, 1975; July 29, 1976)

Elvis Concert Venues in New York State 🎵
(outside of New York City area)

Within this state the venues of Elvis concerts are arranged in chronological order by the date of the first concert given in a particular place, then followed, chronologically, by the rest of the concerts given in that place. This is done to give readers the cities in the order that Elvis first experienced them.

Buffalo Memorial Auditorium
140 Main Street
Buffalo, New York 14224
(716) 851-5663
(Elvis's 1972 Buffalo concert was the opening show of the tour that was filmed and distributed by Metro-Goldwyn-Mayer as *Elvis on Tour* [1972]. This fifteen-city tour ended in Albuquerque, New Mexico.)
(April 1, 1957; April 5, 1972; June 25, 1976)

★

Nassau Veterans Memorial Coliseum
Hempstead Turnpike
Uniondale, New York 11553
(June 22–24, 1973; July 19, 1975)

★

Niagara Falls Convention Center
305 4th Street
Niagara Falls, New York 14303
(716) 286-4769
(June 24, 1974; July 13, 1975)

★

Onondaga War Memorial Auditorium
515 Montgomery Street
Syracuse, New York 13202
(315) 435-2650
(July 25, 1976; July 27, 1976)

★

Rochester War Memorial Auditorium
(formerly Community War Memorial Auditorium)
100 Exchange Boulevard
Rochester, New York 14614
(716) 546-2030
(July 26, 1976; May 25, 1977)

Elvis Concert Venues in Ohio

Within this state the venues of Elvis concerts are arranged in chronological order by the date of the first concert given in a particular place, then followed, chronologically, by the rest of the concerts given in that place. This is done to give readers the cities in the order that Elvis first experienced them.

Circle Theater
Cleveland, Ohio 44001
(This venue was not found to be listed under this name, nor was it found to be listed under another name.)
(February 26, 1955; October 19, 1955; October 20, 1955)

Cleveland Convention Center Public Hall Auditorium
500 Lakeside Avenue East
Cleveland, Ohio 44114
(216) 348-2200
(November 6, 1971; June 21, 1974)

★

Veterans Memorial Auditorium
300 West Broad Street
Columbus, Ohio 43215
(614) 221-4341
(May 26, 1956)

★

University of Dayton (the Field House)
941 Alberta Street
Dayton, Ohio 45409
(937) 229-2158
(May 27, 1956)

University of Dayton (Arena)
941 Alberta Street
Dayton, Ohio 45409
(937) 229-2158
(April 7, 1972; October 6, 1974; October 26, 1976)

★

Toledo Sports Arena
One Main Street
Toledo, Ohio 43605
(419) 698-4545
(November 22, 1956)

★

Hobart Arena
255 Adams Street
Troy, Ohio 45373
(937) 339-2911
(November 24, 1956)

★

Cincinnati Gardens
2250 Seymour Avenue
Cincinnati, Ohio 45212
(513) 631-7793
(November 11, 1971; June 27, 1973)

Riverfront Coliseum
100 Broadway Street
Cincinnati, Ohio 45202
(513) 241-1818
(March 21, 1976; June 25, 1977)

Elvis Concert Venues in Pennsylvania ♫

Within this state the venues of Elvis concerts are arranged in chronological order by the date of the first concert given in a particular place, then followed, chronologically, by the rest of the concerts given in that place. This is done to give readers the cities in the order that Elvis first experienced them.

Sports Arena
Philadelphia, Pennsylvania
19148
(This venue no longer exists, having been replaced on the same site by the Spectrum Arena.)
(April 5–6, 1957)

Spectrum Arena
(now Coor State Spectrum)
Broad at Pattison Avenue
Philadelphia, Pennsylvania
19148
(215) 336-3600
(November 8, 1971; June 23, 1974; June 28, 1976; May 28, 1977)

Civic Arena/Civic Center Arena
66 Mario Lemieux Place
Pittsburgh, Pennsylvania 15219
(412) 642-1800
(June 25–26, 1973; December 31, 1976)

★

Elvis Concert Venue in Rhode Island ♫

Civic Center Auditorium
One LaSalle Square
Providence, Rhode Island 02903
(401) 331-0700
(June 22, 1974; June 26, 1976; May 23, 1977)

Chapter 6

Texas

Elvis played more concerts at more sites in Texas than in any other state, especially during the early years, when he was frequently on the road with Scotty Moore and Bill Black. However, he shot no motion pictures in Texas. This was the direct opposite of California, where he made all or part of all his films but played a relatively small handful of live concerts over the decades.

It was also in Texas that Elvis underwent basic training after he was drafted into the U.S. Army in 1958. For about half of 1958, he would divide his time between Fort Hood and Waco, where he stayed at the home of disc jockey Eddie Fadal. For many years after, Waco would be the site of Fadal's Elvis shrine, which contained one of the largest collections of Elvis memorabilia outside Tennessee.

In this chapter, the concert venues are listed in alphabetical order by the names of the cities. Traveling with Scotty and Bill, Elvis first ventured into Texas in 1954, but in 1955 the Blue Moon Boys, as the trio was called, were on tour almost continuously and more than half the gigs they played were in Texas. Most of the high school auditoriums that the group played at are still there, and there are still people around who can remember when Elvis Presley first came to town. Of the small honky-tonks and nightclubs that welcomed the Blue Moon Boys, all have faded away or changed hands many times—with the notable exception of the Reo Palm Isle Club in Longview, which is still known as the Reo Palm Isle Ballroom.

When Elvis returned nearly a generation later as a conquering superstar, he had fully outgrown the smaller venues. While he was away, the United States in general, and Texas in particular, had seen a veritable building boom of vast new stadiums. These centers, as typified by the Houston Astrodome, dwarfed and replaced the old municipal auditoriums, many of which dated back to the 1920s or 1930s. While the old auditoriums that Elvis played in the 1950s are now largely just fading mem-

ories, the stadiums in which he performed during the 1970s remain, still hosting major events. As one drives across the Lone Star State today, one is never far from a former Elvis concert site, where it is still possible to go in and gaze wistfully at the stage and remember the electricity that crackled between the star and his audience.

Fort Hood

Fort Hood, Texas

Elvis was drafted into the U.S. Army on December 19, 1957, but was granted a sixty-day deferment to complete filming *King Creole* (1958). He reported for duty on March 24, 1958, and was inducted at Fort Chaffee, Arkansas. Four days later he was sent to Fort Hood in Texas for basic training. He would remain officially based at Fort Hood until September 1958, when he shipped out to Germany, where he served most of his two years in the army. (It was while he was based at Fort Hood that he went back to Memphis on leave in August 1958 to be at the side of his dying mother.)

At Fort Hood, Elvis was assigned to Company A of the Second Medium Tank Battalion of the Second Armored Division. Formed in 1940, the Second Armored Division saw extensive action in the European Theater in World War II and was part of the U.S. Army's commitment to NATO defense of Western Europe in the Cold War. Long after Elvis left, the Second Armored Division fought in Iraq during the Gulf War of 1991. It was disbanded on December 15, 1996, as part of the U.S. Army's reduction-of-conventional-forces policy. During his time overseas, Elvis would be assigned to the Thirty-second Armored Scout Battalion.

Fort Hood, which served as headquarters for the Second Armored Division for most of its life, is named for Confederate General John Bell Hood, who served with the Texas Brigade during the Civil War as the commander of what became known as Hood's Texas Brigade. The original site of the fort was selected in 1941, and construction of South Camp Hood began in 1942. North Camp Hood, located seventeen miles to the north, was established soon after. With 217,337 acres, Fort Hood remains the largest active duty "armor" post (meaning it hosts tank units) in the United States. It is home to the First Cavalry Division and the Fourth Infantry Division, as well as Headquarters Command III Corps, Third Personnel Group, Third Signal Brigade, Third Air Support Operations Group, Thirteenth Corps Support Command (COSCOM), Thirteenth Finance Group, Twenty-first Cavalry Brigade (Air Combat), Eighty-ninth Military Police Brigade, 504th Military Intelligence Brigade, the Dental Activity (DENTAC), the Medical Support Activity (MEDDAC), and the U.S. Army's Test and Experimentation Command (TEXCOM).

When Elvis arrived at Fort Hood, he lived in a barracks on the base for about two months, then moved off base to live with his parents, who had relocated to Texas to be near him. They lived briefly in a mobile home before moving to a house at 906 Oak Hill Drive in nearby Killeen, Texas. Of course, Elvis devoted his days on the base to his training, and he spent many weekends in Waco with his friend Eddie Fadal.

The Elvis Texas House 🏠

906 Oak Hill Drive
Killeen, Texas 76541

This four-bedroom, red-brick home was rented by Elvis in May 1958, and it was where he lived with his parents and his grandmother, Minnie Mae "Dodger" Presley. It was while she was living here that Gladys Presley became ill with hepatitis. She was taken back to Memphis, where she died at Methodist Hospital on August 14, 1958. Elvis was given a thirty-day leave from the army and shipped out to Germany on September 19. He never lived in the Lone Star state again. If you visit Oak Hill Drive, please note that this is a private home and not open to the public. View it from the street and please do not disturb the occupants, as this behavior reflects badly upon the fans who come to remember respectfully the life and times of Elvis Presley.

Eddie Fadal's Waco House 🏠

2807 Lasker Avenue
Waco, Texas 76707

Between March and August 1958, Elvis spent a great deal of his time at the Waco home of his friend Edward "Eddie" Fadal. Although Elvis had his parents installed in a home in Killeen, he would drive the forty-five miles to Waco most weekends or whenever he had time off from his military duties. Fadal had met Elvis in 1956, when Eddie was a disc jockey at KRLD radio in Dallas and Elvis was touring Texas playing at high school gymnasiums and fairgrounds. When Elvis started visiting on a regular basis, Eddie added a wing to his house so that Elvis could have privacy during his stays. In August, when Gladys Presley got sick and Elvis returned to Memphis to be near her, Eddie Fadal accompanied him. When Elvis's mother died, the Fadal family planted a live oak tree on the Lasker Avenue property. The last we heard, it is still there.

Eddie and Elvis remained friends through the years. When Elvis died in 1977, a saddened Eddie Fadal moved out of the 2807 Lasker Avenue

house. Over the years the house became an Elvis shrine, filled with Eddie's collection of memorabilia and autographed record albums, as well as clothes that Elvis wore while in Waco. Elvis fan clubs used the house as a rendezvous point, and a commemorative monument was placed in the backyard. Eddie Fadal died on April 12, 1994.

Please note that this site is now a private home and no longer open to the public. View it from the street and please do not disturb the occupants, as this behavior reflects badly on the fans who come to remember respectfully the life and times of Elvis Presley.

Elvis Concert Venues in Texas ♪

Unlike with the other states, the venues of Elvis concerts in Texas—a longer list than in any other state—are given in alphabetical order by city for easier cross-reference. Within each city the concert venues are listed chronologically, starting with the date of the first concert given in that city.

Fair Park Auditorium
West Texas Fair
1801 East South 11th Street
Abilene, Texas 79602
(915) 677-0709
(February 15, 1955; October 11, 1955)

Expo Center/Taylor County Coliseum
1700 Highway 36
Abilene, Texas 79602
(915) 677-4376
(October 9, 1974)

Abilene, Texas
(This venue is unknown)
(March 27, 1977)

★

Alpine High School Auditorium
Loop Road
Alpine, Texas 79830
(915) 837-3473
(February 10, 1955)

★

Civic Center
401 South Buchanan Street
Amarillo, Texas 79101
(806) 378-4297
(June 19, 1974; March 24, 1977)
(Note that Elvis also performed in Amarillo at what was known then as the City Auditorium on October 13, 1955, and at what was called, at the time, the Municipal Auditorium on April 13, 1956.)

★

Skyline Club
Austin, Texas 78701
(This venue was not found to be listed under this name, nor was it found to be listed under another name.)
(October 6, 1955)

Austin Coliseum
400 South 1st Street
Austin, Texas 78704
(512) 476-5461
(January 18, 1956)

Municipal Auditorium
400 South 1st Street
Austin, Texas 78704
(512) 476-5461
(March 28, 1977)

★

City Auditorium
1558 Carroll Street
Beaumont, Texas 77701
(409) 835-9374
(January 17, 1956)

★

Breckenridge High School Auditorium
500 West Lindsey Street
Breckenridge, Texas 76424
(254) 559-2231
(April 13, 1955)

American Legion Hall
611 East Walker Street
Breckenridge, Texas 76424
(254) 559-9135
(June 10, 1955)

★

Saddle Club
Bryan, Texas 77801
(This venue was not found to be listed under this name, nor was it found to be listed under another name.)
(August 23, 1955)

★

G. Rolle White Coliseum
Texas A&M University
805 Rudder Tower
College Station, Texas 77843
(409) 845-3211
(March 19, 1955; October 3, 1955)

★

Conroe High School Football Field
3200 West Davis Street
Conroe, Texas 77304
(409) 756-4416
(August 24, 1955)

★

Hoedown Club
Corpus Christi, Texas 78401
(This venue was not found to be listed under this name, nor was it found to be listed under another name.)
(July 3, 1955)

Corpus Christi Coliseum
402 South Shoreline Boulevard
Corpus Christi, Texas 78401
(512) 884-8227
(April 16, 1956)

★

Sportarium
Dallas, Texas
(This venue was not found to be listed under this name, nor was it found to be listed under another name.)
(April 16, 1955; May 28, 1955; May 29, 1955; June 18, 1955; September 3, 1955)

Cotton Bowl
3750 Midway Plaza
Dallas, Texas 75210
(214) 670-8400
(October 11, 1956)

Convention Center/Memorial Auditorium
650 South Griffin Street
Dallas, Texas 75202
(214) 939-2700
(November 13, 1971; June 6, 1975; December 28, 1976)
(The 1975 show was recorded by RCA for release as a live album.)

★

De Kalb High School
152 Southwest Maple Street
De Kalb, Texas 75559
(903) 667-2422
(March 4, 1955)

Hodges Park
Deleon, Texas 76444
(July 4, 1955)

El Paso Coliseum
4100 East Paisano Drive
El Paso, Texas 79905
(915) 534-4229
(April 11, 1956; November 10, 1972)

Tarrant County Convention Center
1111 Houston Street
Fort Worth, Texas 76102
(817) 884-2262
(June 18, 1972; June 15–16, 1974; June 3, 1976; July 3, 1976)
(Also note that Elvis performed in Fort Worth at what was then called the North Side Coliseum on May 29, 1955, and January 20, 1956, and at the North Side Convention Center on April 20, 1956. Neither of these venues is still listed in local directories. Call [817] 884-2262 for more information.)

Owl Park Baseball Field
Gainesville, Texas 76240
(April 14, 1955)

Rural Electrification Administration Building
Gilmer, Texas
(This venue was not found to be listed under this name, nor was it found to be listed under another name.)
(January 26, 1955)

KSIJ Radio/Mint Club
Gladewater, Texas
(This venue was not found to be listed under this name, nor was it found to be listed under another name.)
(November 22, 1954)

Roundup Club
Gladewater, Texas
(This venue was not found to be listed under this name, nor was it found to be listed under another name.)
(November 23, 1954)

Gladewater High School Gymnasium
2201 West Gay Avenue
Gladewater, Texas 75647
(903) 845-5591
(April 30, 1955; November 19, 1955)

Bear Stadium
Gladewater, Texas
(This venue was not found to be listed under this name, nor was it found to be listed under another name.)
(August 10, 1955)

Baseball Park
State Highway 183 at Guadalupe
Gonzales, Texas 78629
(210) 672-2520
(August 26, 1955)

Recreation Hall, Humble Oil Camp
Hawkins, Texas
(This venue was not found to be listed under this name, nor was it found to be listed under another name.)
(January 24, 1955)

★

Rodeo Arena
Henderson, Texas 75652
(August 9, 1955)

★

Magnolia Gardens
Houston, Texas
(This venue was not found to be listed under this name, nor was it found to be listed under another name.)
(November 21, 1954; March 20, 1955; April 10, 1955; April 24, 1955; May 22, 1955; June 19, 1955; August 7, 1955)

Cook's Hoedown Club
Houston, Texas
(This venue was not found to be listed under this name, nor was it found to be listed under another name.)
(November 21, 1954; December 28, 1954; March 20, 1955; April 10, 1955; April 24, 1955; May 22, 1955; June 19, 1955; August 7, 1955)

Palladium Club
Houston, Texas
(This venue was not found to be listed under this name, nor was it found to be listed under another name.)
(November 25–26, 1954)

Eagle's Hall
Houston, Texas
(This venue was not found to be listed under this name, nor was it found to be listed under another name.)
(January 1, 1955; March 19, 1955)

City Auditorium
Houston, Texas
(This venue was not found to be listed under this name, nor was it found to be listed under another name.)
(April 2, 1955; October 8, 1955; April 21, 1956)

Sam Houston Coliseum
Located at Walker and Smith Street
Houston, Texas
(October 13, 1956)
(The coliseum was in the process of being torn down in 1998.)

The Astrodome
8400 Kirby Drive
Houston, Texas 77054
(713) 799-9629
(February 27–March 1, 1970; March 3, 1974)

Hofheinz Pavilion
University of Houston
3875 Holman at Cullen
Houston, Texas 77204
(713) 743-9444
(November 12, 1971; June 4–5, 1975; August 28, 1976)

★

Driller Park
Kilgore, Texas 75662
(August 12, 1955)

Reo Palm Isle Club

(now Reo Palm Isle Ballroom)
Highway 31 and Loop 281
Longview, Texas 75606
(903) 753-4440
(January 27, 1955; March 31,
1955; August 11, 1955;
November 18, 1955)

Cotton Club

Lubbock, Texas
(This venue was not found to be listed
under this name, nor was it found to
be listed under another name.)
(January 6, 1955; April 29,
1955; October 15, 1955)

Fair Park Coliseum/Auditorium

(replaced by Municipal Coliseum)
2720 6th Street
Lubbock, Texas 79410
(806) 767-2241 (coliseum infor-
mation line)
(February 13, 1955; June 3,
1955; October 15, 1955; April
10, 1956)

Johnson-Connelley Pontiac Showroom

Lubbock, Texas
(This venue was not found to be listed
under this name, nor was it found to
be listed under another name.)
(June 3, 1955)

Municipal Coliseum

2720 6th Street
Lubbock, Texas 79410
(806) 767-2241 (Coliseum infor-
mation line)
(November 8, 1972; May 31,
1976)

Midland High School

906 West Illinois Avenue
Midland, Texas 79701
(915) 689-1100
(January 7, 1955; May 31,
1955; October 12, 1955)

Odessa High School Auditorium

1301 Dotsy Avenue
Odessa, Texas 79763
(915) 337-6655
(January 4, 1955)

Odessa High School Field House

1301 Dotsy Avenue
Odessa, Texas 79763
(915) 337-6655
(January 4, 1955; February 16,
1955; May 31, 1955)

Ector County Auditorium

Odessa, Texas 79762
(replaced by Ector County
Coliseum)
(April 1, 1955; October 14, 1955)

Ector County Coliseum

4201 Andrews Highway
Odessa, Texas 79762
(915) 366-3541
(May 30, 1976)

★

Boys Club Gymnasium

1530 1st Street Northeast
Paris, Texas 75460
(903) 784-6360
(October 4, 1955)

★

City Auditorium
72 West College Avenue
San Angelo, Texas 76903
(915) 657-4237
(January 5, 1955; February 17, 1955)

★

Municipal Auditorium
100 Auditorium Circle
San Antonio, Texas 78205
(210) 207-8511
(January 15, 1956; April 15, 1956)

Coliseum
3201 East Houston Street
San Antonio, Texas 78218
(210) 226-1177
(October 14, 1956)

Convention Center
8505 Broadway Street
San Antonio, Texas 78217
(210) 212-4095
(April 18, 1972; October 8,
1974; August 27, 1976)
(The first of these concerts was filmed
by Metro-Goldwyn-Mayer, and
footage was used as part of the docu-
mentary film *Elvis on Tour*, which was
released on November 1, 1972.)

★

Southwest Texas State University
601 University Drive
San Marcos, Texas 78666
(512) 245-2111
(October 6, 1955)

★

Seymour High School Auditorium
550 Stadium Drive
Seymour, Texas 76380
(940) 888-2947
(April 25, 1955)

★

Stamford High School
507 South Orient Street
Stamford, Texas 79553
(915) 773-2701
(April 15, 1955; June 17, 1955)

★

City Recreation Hall
378 West Long Street
Stephenville, Texas 76401
(254) 965-3864
(July 4, 1955)

★

Mayfair Building
East Texas State Fairgrounds
2112 West Front Street
Tyler, Texas 75702
(903) 597-2501
(January 25, 1955; August 8,
1955)

★

Heart O' Texas Fair
4601 Bosque Boulevard
Waco, Texas 76710
(254) 776-1660
(April 23, 1955; April 17, 1956;
October 12, 1956)

★

M-B Corral Club
Wichita Falls, Texas
(This venue was not found to be listed
under this name, nor was it found to
be listed under another name.)
(April 25, 1955)

Spudder Park
Wichita Falls, Texas 76301
(August 22, 1955)

Chapter 7

The Midwest and the Plains

Elvis grew up well aware of the lines of delineation that existed between North and South. When you trace the routes of the early concert tours that he did with Scotty Moore and Bill Black, you note the trio going east from Tennessee into Georgia and Florida and covering practically every town with a stoplight in Texas, but they made only tentative forays into the Midwest until after Elvis had a nationwide number one hit with "Heartbreak Hotel" in May 1956. Elvis was on nationwide television in January 1956, but he didn't play Chicago until March 1957. He and the boys had traveled more than two thousand miles in Texas before they ever performed in St. Louis, only two hundred miles from Memphis!

It really wasn't until the 1970s, the era of exhaustive Elvis megatours, that the King visited the major cities of the Midwest on a regular basis. Ironically, it was in Indianapolis, the heart of America's heartland, not in Hollywood or Honolulu, that he gave his last concert.

Meanwhile, an informal poll conducted in the early 1990s revealed that there were more Elvis impersonators in the Chicago area than in any other major city in the United States except Las Vegas. Perhaps this is because the King never spent much time there, and the fans and impersonators were compensating for that unhappy fact.

In this chapter, the concert venues for each state are grouped together, with entries in chronological order by the date of the first concert given in a particular locale.

Trade Winds Courtyard Inn and Restaurant

2128 West Gary Boulevard
Clinton, Oklahoma 73601
(580) 323-2610

A creature of habit who often had his favorite table at restaurants, Elvis also had favorite motels where he would stay on his long jaunts across the continent during the 1950s and 1960s. In Oklahoma, a day's drive from Memphis, he would stop at the Trade Winds in Clinton — on what was then US Route 66. He would slip into his favorite room and his friends or Colonel Parker would arrange for meals to be sent over from the restaurant next door. His favorite accommodation, Room 215, is now known as the Elvis Presley Suite. Call ahead for reservations.

The Elvis is Alive Museum

Southeast Interstate 70 Exit
Wright City, Missouri 63390
(636) 745-3107

A popular stop along Interstate 70 west of St. Louis, Bill Beeny's museum features one of the largest plywood cutouts of Elvis in the world. Mr. Beeny also operates a gift shop and a cafe that offers peanut butter and banana sandwiches. His collection includes more than 3,500 pictures of Elvis, a Cadillac that Elvis used, and some personal items.

The centerpiece of the museum is a wax Elvis effigy in a casket, with a recreation of his funeral. However, Mr. Beeny doesn't believe that Elvis attended his own funeral. He is one of the leading exponents of the theory that Elvis actually survived past 1977, and that he may still be alive (hence the name of the museum). He theorizes that the woman who married and divorced Michael Jackson was not Lisa Marie Presley, but a double.

Elvis Concert Venues in Illinois

The venues are arranged in chronological order by the date of the first concert in a given city, followed, chronologically by other concerts in that city.

International Amphitheater
Chicago, Illinois 60607
(773) 254-6900 (New
International Amphitheater)
(March 28, 1957)

Chicago Stadium
Chicago, Illinois 60607
(June 16 and 17, 1972; October
14 and 15, 1976; May 1 and 2,
1977)

U of Illinois Assembly Hall
1817 South Neil Street
Champaign, Illinois 61820
(217) 333-3630/(217) 333-3470
(October 22, 1976)

Southern Illinois University
Mailcode 4304
Carbondale, Illinois 62901
(618) 453-2121
(October 27, 1976)

Elvis Concert Venues in Indiana

The venues are arranged in chronological order by the date of the first concert in a given city, followed, chronologically by other concerts in that city.

Lyric Theater
Indianapolis, Indiana 46201
(This venue is not known to still
exist under this name.)
(December 4 through 7, 1955)

State Fair Coliseum
1202 East 38th Street
Indianapolis, Indiana 46205
(317) 927-7536
(April 12, 1972)

Convention/Expo Center
100 South Capitol Avenue
Indianapolis, Indiana 46225
(317) 262-3410
(October 5, 1974)

★

Market Square Arena
300 East Market Street
Indianapolis, Indiana 46204
 The Market Square Arena had
the distinction of hosting the
last Elvis concert ever. The
show here on June 26, 1977
concluded a gruelling 55-show
series of back-to-back tours that
had begun in Hollywood, Florida
in February. Built in 1974 as the
original home of the Indiana
Pacers, the Arena itself was
demolished on July 8, 2001

★

Memorial Coliseum
4000 Parnell Avenue
Fort Wayne, Indiana 46805
(219) 482-9502
(March 30, 1957; June 12,
1972; October 25, 1976)

Roberts Memorial Stadium
2600 East Division Street
Evansville, Indiana 47711
(812) 476-1383
(June 13, 1972 and Oct. 24, 1976)

Notre Dame Center
(South Bend)
Notre Dame, Indiana 46556
(219) 631-5000
(September 30 and October 1,
1974; October 20, 1976)

Glenn Civic Center
(Formerly Hulman Civic Center)
7849 Wabash Avenue
Terre Haute, Indiana 47803
(812) 877-1388
(July 9, 1975)

Indiana University
400 East 7th Street
Bloomington, Indiana 47405
(812) 332-0211
(June 27, 1974 and May 27, 1976)

Elvis Concert Venues in Iowa

Within this state the venues of Elvis concerts are arranged in chronological order by the date of the first concert given in a particular place, then followed, chronologically, by the rest of the concerts given in that place. This is done to give readers the cities in the order that Elvis first experienced them.

Veteran's Memorial Auditorium
833 Fifth Avenue
Des Moines, Iowa 50309
(515) 323-5400
(May 22, 1956; June 20, 1974;
June 23, 1977)

Iowa State University
James W. Hilton Coliseum
Ames, Iowa 50011
(515) 294-4111
(May 28, 1976)

★

Municipal Auditorium
401 Gordon Drive
Sioux City, Iowa 51101
(712) 279-4850
(May 23, 1956)

★

Elvis Concert Venues in Kansas

Within this state the venues of Elvis concerts are arranged in chronological order by the date of the first concert given in a particular place, then followed, chronologically, by the rest of the concerts given in that place. This is done to give readers the cities in the order that Elvis first experienced them.

Wichita Forum
Wichita, Kansas 67201
(This venue was not found to be listed under this name, nor was it found to be listed under another name.)
(May 18, 1956)

Municipal Auditorium
Topeka, Kansas 66601
(This venue was not found to be listed under this name, nor was it found to be listed under another name.)
(May 21, 1956)

Henry Levitt Arena
Wichita, Kansas 67201
(This venue was not found to be listed under this name, nor was it found to be listed under another name.)
(June 19, 1972)

★

Elvis Concert Venues in Michigan ♫

Within this state the venues of Elvis concerts are arranged in chronological order by the date of the first concert given in a particular place, then followed, chronologically, by the rest of the concerts given in that place. This is done to give readers the cities in the order that Elvis first experienced them.

Fox Theater
2211 Woodward Avenue
Detroit, Michigan 48201
(313) 964-0105
(May 25, 1956)

Olympia Stadium
(now Joe Louis Stadium)
600 Civic Center Drive
Detroit, Michigan 48226
(313) 396-7444
(March 31, 1957; September 11, 1970; April 6, 1972; September 29, 1974, matinee; October 4, 1974; April 22, 1977)

★

Pontiac Silverdome
1200 Featherstone Road
Pontiac, Michigan 48342
(248) 858-7358
(December 31, 1975)

★

Wings Stadium
3600 Vanrick Drive
Kalamazoo, Michigan 49001
(616) 345-1125
(October 21, 1976; April 26, 1977)

★

Crisler Arena
University of Michigan
Central Campus
333 East Stadium Street
Ann Arbor, Michigan 48109
(734) 998-7236
(April 24, 1977)

★

Saginaw Civic Center
303 Johnson Street
Saginaw, Michigan 48607
(517) 759-1320
(April 25, 1977; May 3, 1977)

Elvis Concert Venues in Minnesota ♫

Within this state the venues of Elvis concerts are arranged in chronological order by the date of the first concert given in a particular place, then followed, chronologically, by the rest of the concerts given in that place. This is done to give readers the cities in the order that Elvis first experienced them.

Auditorium
St. Paul, Minnesota 55101
(This venue was not found to be listed under this name, nor was it found to be listed under another name.)
(May 13, 1956)

Civic Center
143 4th Street West
St. Paul, Minnesota 55102
(612) 224-7361
(October 2–3, 1974; April 30, 1977)

★

City Auditorium
Minneapolis, Minnesota 55401
(This venue was not found to be listed
under this name, nor was it found to
be listed under another name.)
(May 13, 1956)

★

**Metropolitan Sports Center
(Minneapolis)**
1700 105th Avenue Northeast
Blaine, Minnesota 55449
(612) 785-5600
(November 5, 1971; October
17, 1976)

★

Proctor Arena
800 North Boundary Avenue
Duluth, Minnesota 55810
(218) 624-7988
(October 16, 1976; April 29,
1977)

..

Elvis Concert Venues in Missouri 🎵

Within this state the venues of Elvis concerts are arranged in chronological order by the date of the first concert given in a particular place, then followed, chronologically, by the rest of the concerts given in that place. This is done to give readers the cities in the order that Elvis first experienced them.

National Guard Armory
300 South Main Street
Sikeston, Missouri 63801
(573) 472-5315
(January 21, 1955)

★

National Guard Armory
820 North 5th Street
Poplar Bluff, Missouri 63901
(573) 840-9520
(March 9, 1955)

★

B&B Club
Gobler, Missouri
(This venue was not found to be listed
under this name, nor was it found to
be listed under another name.)
(April 8, 1955; September 28,
1955)

★

Cape Girardeau Arena
410 Kiwanis Drive
Cape Girardeau, Missouri 63710
(573) 335-5421
(July 20, 1955)

★

Missouri Theater
St. Louis, Missouri
(This venue was not found to be listed under this name, nor was it found to be listed under another name.)
(October 21–23, 1955)

Kiel Auditorium
1401 Clark Avenue
St. Louis, Missouri 63103
(314) 622-5435
(January 1, 1956; March 29, 1957; September 10, 1970; June 28, 1973; March 22, 1976)

★

Shrine Mosque
601 St. Louis Street
Springfield, Missouri 65806
(417) 869-9164
(May 17, 1956)

★

Municipal Auditorium
Kansas City, Missouri
(This venue was not found to be listed under this name, nor was it found to be listed under another name)
(May 24, 1956; November 15, 1971; June 29, 1974)

★

Kemper Arena
1800 Genessee Street
Kansas City, Missouri 64102
(816) 274-6222
(April 21, 1976; June 18, 1977)

★

Southwestern Missouri State University
901 South National Avenue
Springfield, Missouri 65804
(417) 836-6660
(June 17, 1977)

Elvis Concert Venues in Nebraska ♫

Within this state the venues of Elvis concerts are arranged in chronological order by the date of the first concert given in a particular place, then followed, chronologically, by the rest of the concerts given in that place. This is done to give readers the cities in the order that Elvis first experienced them.

University of Nebraska Coliseum
501 North 14th Street
Lincoln, Nebraska 68508
(402) 472-7211
(May 19, 1956)

Pershing Municipal Auditorium
226 Centennial Mall South
Lincoln, Nebraska 68508
(402) 441-7500
(June 20, 1977)

★

Civic Auditorium Arena
1804 Capitol Avenue
Omaha, Nebraska 68102
(402) 444-4750
(May 20, 1956; June 30, 1974; July 1, 1974; April 22, 1976; June 19, 1977)

Elvis Concert Venues in Oklahoma

Within this state the venues of Elvis concerts are arranged in chronological order by the date of the first concert given in a particular place, then followed, chronologically, by the rest of the concerts given in that place. This is done to give readers the cities in the order that Elvis first experienced them.

High School Auditorium
17th and James Streets
Guymon, Oklahoma 73942
(405) 338-4350
(June 1, 1955)

McMahon Memorial Auditorium
Lawton, Oklahoma 73502
(This venue was not found to be listed under this name, nor was it found to be listed under another name.)
(June 23, 1955)

Southern Club
Lawton, Oklahoma 73502
(This venue was not found to be listed under this name, nor was it found to be listed under another name.)
(June 23, 1955)

★

Municipal Auditorium
(now Oklahoma City Civic Center)
Oklahoma City, Oklahoma 73102
(405) 297-2584
(October 16, 1955; April 19, 1956)

State Fair of Oklahoma Fairgrounds
500 Land Rush Street
Oklahoma City, Oklahoma 73101
(405) 948-6700
(November 16, 1970)

Myriad Convention Center
One Myriad Gardens
Oklahoma City, Oklahoma 73102
(405) 232-8871
(July 2, 1973; July 8, 1975; May 29, 1976)

Tulsa State Fairgrounds Pavilion
21st Street at South Pittsburg Avenue
Tulsa, Oklahoma 74112
(918) 744-1113
(April 18, 1956)

Civic Assembly Center
500 West 3rd Street
Tulsa, Oklahoma 74103
(June 20, 1972)

Oral Roberts University
7777 South Lewis Avenue
Tulsa, Oklahoma 74171
(918) 495-6161
(March 1–2, 1974; July 4, 1976)

Lloyd Noble Center
University of Oklahoma
2900 Jenkins Avenue
Norman, Oklahoma 73109
(405) 325-4666
(March 25–26, 1977)

Elvis Concert Venues in South Dakota ♪

Within this state the venues of Elvis concerts are arranged in chronological order by the date of the first concert given in a particular place, then followed, chronologically, by the rest of the concerts given in that place. This is done to give readers the cities in the order that Elvis first experienced them.

Sioux Falls Arena
1201 North West Avenue
Sioux Falls, South Dakota 57104
(605) 367-7288
(October 18, 1976; June 22, 1977)

Rushmore Plaza Civic Center
444 Mount Rushmore Road
Rapid City, South Dakota 57701
(605) 394-4115
(June 21, 1977)

★

Elvis Concert Venues in Wisconsin ♪

Within this state the venues of Elvis concerts are arranged in chronological order by the date of the first concert given in a particular place, then followed, chronologically, by the rest of the concerts given in that place. This is done to give readers the cities in the order that Elvis first experienced them.

Mary E. Sawyer Auditorium
La Crosse, Wisconsin 54601
(This venue was not found to be listed under this name, nor was it found to be listed under another name.)
(May 14, 1956)

★

Milwaukee Arena
(now part of the Wisconsin Center complex)
400 West Kilbourn Avenue
Milwaukee, Wisconsin 53203
(414) 908-6000
(June 14–15, 1972; June 28, 1974; April 27, 1977)

★

Dane County Coliseum
1881 Expo Mall
Madison, Wisconsin 53713
(608) 267-3976
(October 19, 1976; June 24, 1977)

★

Brown County Expo Center
(Veterans Memorial Coliseum)
1901 South Oneida Street
Green Bay, Wisconsin 54304
(414) 494-3401
(April 28, 1977)

Chapter 8

The Mountain West and Southwest

The history of Elvis's experience in the Mountain Time Zone can be grouped into three segments. First there was the "early-concert-tour segment" that consisted of a mere five performances. In February 1955, while they were touring Texas, Elvis and the Blue Moon Boys—Scotty Moore and Bill Black—did a few shows in Roswell and Carlsbad, New Mexico, and they played Albuquerque, Phoenix, and Tucson, Arizona, in 1956. It would be fourteen years before Elvis sang a sixth concert in the Mountain Time Zone, and seventeen years before he played a third state—Colorado.

In the meantime, the second segment of Elvis's official visits to Mountain Time began in October 1967, when he came to Arizona to begin filming *Stay Away, Joe* (1968). Less than a year later, he was back for the shooting of *Charro!* (1969), a "serious" western in which Elvis acted, but sang only the title song, which was heard over the opening credits. The movie's music score was written by Hugo Montenegro, who had composed the score for Clint Eastwood's milestone western, *The Good, the Bad, and the Ugly* (1966).

Even after Elvis had returned to the stage in the 1970s for the grueling schedule of nonstop touring that marked the final segment of his career, he played only five concerts in the Mountain Time Zone outside Arizona, and he never performed at all in Idaho, Montana, or Wyoming.

As with most of the earlier sections, the concert venues for each state are grouped together with the entries being in chronological order by the date of the first concert given in a particular locale.

The Arizona Movie Set Tour 🎥

When movie companies do location shooting—especially in open country away from towns and cities—one thing that they pride themselves on is their ability to restore the natural terrain to its original condition. While this

143

The Arizona Movie Set Tour

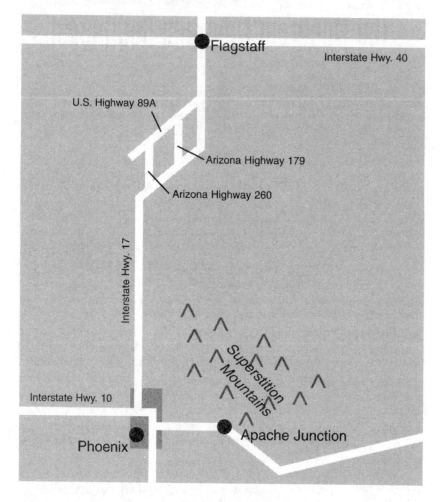

is admirable from the point of view of the people who live in and around the areas in question, it is very hard on fans who want to stand on the set where the stars once stood. Unlike *Viva Las Vegas* (1964), *It Happened at the World's Fair* (1963), and Elvis's Hawaii location films, the Arizona settings for *Stay Away, Joe* and *Charro!* were really just backdrops. There was no Las Vegas Strip, World's Fair fairgrounds, or Coco Palms Resort that would remain when the movie crews packed up and went home. There was only the Southwest landscape of rust-red mesas and boiling cumulus. Even the "Navajo reservation" in *Stay Away, Joe* was built especially for the film and carefully dismantled more than thirty years ago, after production ended.

The landscape, however, has endured for thirty years as it has for three thousand, and it is available for viewing. We suggest that you bring

with you a copy of one or both of the movies on your tour so that you can scan them in your motel room each night after seeing the sites and scenery that Elvis experienced. Both videos are in color, and as you will see when you visit, that's a good thing!

Using Phoenix as the anchor point, this tour is designed to visit the areas where Elvis performed the characters Joe Lightcloud and Jess Wade on camera, and to breathe the air and listen to the wind whistling through the same arroyos where Elvis walked and stopped to listen.

The principal sites on this tour are the area around Sedona and Cottonwood, where *Stay Away, Joe* was filmed, and the Superstition Mountains east of Apache Junction, where *Charro!* was shot.

Both Sedona and Cottonwood are located on U.S. Highway 89A near Flagstaff, Arizona. From Flagstaff, simply drive south on this highway for about twenty miles to Sedona, and another seventeen miles to Cottonwood on the same road. The town is named for the trees that grow along the road and along the Verde River. This road is narrow and slow, but after a few miles of the scenery, it will be evident why producer Douglas Laurence and director Peter Tewksbury chose this area as a location. The area south of Flagstaff is a wonderland of light and shadow, where the colors of the mesas drift from fiery red to deep purple in a matter of moments. Red Rock State Park, near Sedona, is one of the most photographed Arizona landscapes, after the Grand Canyon and Monument Valley.

From Phoenix, take Interstate 17 north for about two hours to Exit 287, and then take Arizona Route 260 north for twelve miles to Cottonwood. The turnoff for Sedona is Exit 298, which is eleven miles beyond Exit 287 on the interstate. From this exit, drive north for fifteen miles to Sedona. You can, of course, drive between the two towns on U.S. Highway 89A, and this is highly recommended.

Elvis first made this drive in 1967, coming in from Los Angeles for the *Stay Away, Joe* shooting that began on October 18, well after the summer's hottest months had passed. By the time that the film crew and cast left in November, there would have been a tinge of winter in these mountains and the nights would have been quite cold.

In the nineteenth century, this was a farming area that benefited economically from the mining operations at nearby Jerome that have long since ended. Before Elvis came, Sedona and Cottonwood were fairly sleepy, out-of-the-way places, but in the 1970s and 1980s, the New Age movement discovered Sedona, and the explosive population growth in the Phoenix area since the 1960s has increased the number of tourists coming here. Cottonwood was, and is, also the central trading center in the Verde Valley. For more information, contact the Verde Valley Chamber of Commerce at 1010 South Main Street, Cottonwood, Arizona 86326, (602) 634-7593.

Charro! was Elvis's only National General picture, and it marked a turn for him from lighthearted situation movies to a somewhat more seri-

ous acting role. It was his third-to-last Hollywood feature film, and it indicates what might have been a new beginning for him as an actor had he not decided to abandon acting a year after *Charro!* was released.

Charles Marquis Warren, who was hired to write the screenplay, was a former western-genre novelist who had scripted such films as *The Streets of Laredo* (1949) and *Springfield Rifle* (1952) before turning to television. Warren later not only wrote, but also produced and directed, many episodes of TV's *Rawhide, The Virginian*, and *Gunsmoke*. With this in mind, National General hired him to fill both the producer's and the director's chair for *Charro!*

As a location, Warren chose the Superstition Mountain Wilderness Area east of Phoenix, which had been used for a number of other films through the years. This rugged and picturesque landscape still holds the secret of the legendary Lost Dutchman Gold Mine, which was discovered in 1870 by a "Dutchman"—actually a German or "Deutsche man"— named Jake Walz, and then lost in 1891, when Walz died without revealing its location. Since that time, it has evolved into the most talked-about lost mine in the West.

Unlike the situation with *Stay Away, Joe*, which was filmed in the fall, National General chose—for scheduling reasons—to shoot *Charro!* in the hottest part of the summer, when temperatures can easily reach 110 degrees in the middle of the day. Elvis and the crew arrived in Arizona and began shooting on July 22, 1968. They lived and worked through much of August in the sweltering heat. You can see the strain on Elvis's face, even in the film stills.

To visit the Superstition Mountains and experience "*Charro!* country," start at Phoenix. As you leave Sky Harbor Airport, you'll cross the Salt River (Rio Saltillo), a few dozen miles downriver from where the Dutchman Jake Walz had his homestead. After crossing the Salt River, take either Apache Boulevard or U.S. Highway 60 (the Superstition Freeway) east to Apache Junction; take the exit marked "Apache Trail, Salt River Lakes, State Highway 88." This will put you in Apache Junction. It is a moderately sized town—about 20,000 people—that is less than twenty miles from Tempe, but far enough from the Phoenix urban sprawl that when you arrive there, you really start feeling as though you are getting a long way from civilization. This would be a good place to spend that first night in advance of the obligatory early start. There were also a few scenes for *Charro!* that were filmed in Apache Junction.

From Apache Junction, turn north on Arizona Route 88—known familiarly as "the Apache Trail"—and really start to get the flavor of the Superstition Mountains. Even the road takes you back in time—not back to the Dutchman's era, because there was no road here in the Dutchman's period—but back to 1922, when Governor George Hunt built this road as a shortcut from Phoenix to Globe. The road has been maintained, but

never widened, since then. It remains almost exactly the way it was when Elvis traveled it decades ago.

As you leave Apache Junction, you can start to see the Superstitions off to the right—dry, rugged, and a bit ominous. In the afternoon, when the thunderstorms start to spike the peaks with lightning, you can smell the electricity that probably helped convince the Pima people, the Indian tribe that inhabited the region, that there was magic in these hills.

Not far from Apache Junction on Route 88, the Apache Trail passes Arizona's tribute to Jake Walz, the 292-acre Lost Dutchman State Park, with a handful of campsites, a visitors center, and water. In this country, one cannot stress the need for water too much. Check your radiator and fill your canteen!

Beyond the Lost Dutchman State Park is the 159,700-acre Superstition Wilderness Area, which is part of the vast Tonto National Forest. Both the Dutchman's mine and the scenes from Charro! are within the Superstition Wilderness Area. Looming above this state park is the (singular) 3,000-foot Superstition Mountain itself, and visible as you wind your way north by northeast toward Government Well. It is the peak that has become a sort of icon for the whole ethos of mystery in the Superstition Mountains (plural). According to most legends, the mountain is nowhere near the famous mine. There is a poster or pamphlet cover tacked to a bar we visited somewhere on a Southwest backroad that pictures Superstition Mountain as a sort of Mount Rushmore of human skulls. In broad daylight it's hard to imagine, but at dusk, with the shadows creeping up the west side, there are some sights that make you wonder.

After *Charro!* wrapped in August 1968, Elvis returned to Los Angeles as quickly as he could, back to the estate on Monovale Drive in Beverly Hills that his wife Priscilla had picked out for them. Elvis's next visit to Arizona came two years later, when he played to fifteen thousand fans at the Coliseum in Phoenix on September 9, 1970. He didn't have time, nor perhaps the inclination, to travel back into the Superstition Mountains to watch the shadows and look for the magic.

The Superstition Inn

1342 South Power Road
Mesa, Arizona 85206
(602) 641-1164
(800) 780-7234 (reservations)

The Superstition Inn is where Elvis stayed in July and August 1968 while he was in Arizona to film *Charro!* Located between Phoenix and Apache Junction, the Best Western Superstition Inn and Suites now offer an outdoor heated pool, spa, guest laundry, and exercise room. Rooms in-

clude a microwave and a refrigerator, as well as cable television with free HBO and ESPN. Children under sixteen stay free, pets are allowed, and there is free parking. And yes, it is air-conditioned.

Elvis Concert Venues in Arizona ♫

Within this state the venues of Elvis concerts are arranged in chronological order by the date of the first concert given in a particular place, then followed, chronologically, by the rest of the concerts given in that place. This is done to give readers the cities in the order that Elvis first experienced them.

Fairgrounds
1826 West McDowell Road
Phoenix, Arizona 85007
(602) 252-0717
(June 9, 1956)

Veterans Memorial Coliseum
(within the fairgrounds)
1826 West McDowell Road
Phoenix, Arizona 85007
(602) 258-6771
(September 9, 1970; April 22, 1973)

★

Rodeo Grounds
4823 South 6th Avenue
Tucson, Arizona 85714
(520) 741-2233
(June 10, 1956)

Community Center Arena
(now the Tucson Convention Center)
260 South Church Avenue
Tucson, Arizona 85701
(520) 791-4101
(November 9, 1972; June 1, 1976)

★

Arizona State University
P.O. Box 872203
Tempe, Arizona 85287
(602) 965-9011
(March 23, 1977)

Elvis Concert Venues in Colorado ♫

Within this state the venues of Elvis concerts are arranged in chronological order by the date of the first concert given in a particular place, then followed, chronologically, by the rest of the concerts given in that place. This is done to give readers the cities in the order that Elvis first experienced them.

Denver Coliseum
4600 Humboldt Street
Denver, Colorado 80216
(303) 295-4444
(April 8, 1956; November 17, 1970; April 30, 1973)

McNichols Arena
1635 Bryant Street
Denver, Colorado 80204
(303) 640-7300
(April 23, 1976)

Elvis Concert Venues in New Mexico

Within this state the venues of Elvis concerts are arranged in chronological order by the date of the first concert given in a particular place, then followed, chronologically, by the rest of the concerts given in that place. This is done to give readers the cities in the order that Elvis first experienced them.

Sports Arena
Carlsbad, New Mexico 88220
(This venue was not found to be listed under this name, nor was it found to be listed under another name.)
(February 11, 1955)

American Legion Hall
2605 Legion Street
Carlsbad, New Mexico 88220
(505) 885-2493
(February 12, 1955)

★

Pueblo Auditorium
North Junior High School
(now the Roswell School District Educational Services Building)
300 North Kentucky Street
Roswell, New Mexico 88201
(505) 625-8285
(Though the Roswell School District has designated the building for other uses now, Pueblo Auditorium still remains, and, with permission, it can be visited during regular business hours. There are still people at the Roswell School District who remember Elvis's visit, which occurred just eight years after the well-remembered so-called UFO visit to the Roswell area.)
(February 14, 1955)

★

National Guard Armory (Albuquerque)
4001 Northwest Loop Northeast
Rio Rancho, New Mexico 87124
(505) 867-2327
(April 12, 1956)

★

Tingley Coliseum
300 San Pedro Road Northeast
Albuquerque, New Mexico 87108
(505) 265-1791
(The Tingley Coliseum show was the last in a concert tour that was filmed by Metro-Goldwyn-Mayer for release, in 1972, as *Elvis on Tour*. This documentary was shot entirely during Elvis's fifteen-city tour that began in Buffalo, New York.)
(April 19, 1972)

Elvis Concert Venue in Utah

Salt Palace Center
100 South West Temple
Salt Lake City, Utah 84101
(801) 534-4777
(November 16, 1971; July 2, 1974)

Chapter 9

Las Vegas, Nevada

The glittering, gambling mecca of Las Vegas is the fastest-growing city in the United States and one of the world's most popular tourist destinations. It is also the epitome of the thrills and up-all-night excitement associated with the entertainment industry. Yet it was just a sleepy desert town until, in 1931, the legislature of Nevada took the historic step of making wagering legal in the state. The first major casino-hotel, the one-hundred-room Apache, opened in 1932 and the downtown area around Fremont Street became the epicenter of action.

The first major hotel complex on Las Vegas Boulevard—the famous "Strip"—was El Rancho Las Vegas. It opened in 1941 and was followed a year later by the Last Frontier Hotel, which later became the New Frontier, and in turn evolved into the present-day Frontier. The Last Frontier was one of the first hotels to bring big-name Hollywood celebrities into town to entertain in its showroom, and Elvis was among them.

By the late 1940s, Fremont Street was being referred to as "Glitter Gulch," a place of bright lights and nonstop entertainment. The Golden Nugget and the El Dorado opened in 1946, with the Golden Nugget being the first structure designed from the ground up to be a casino. The same year, Benjamin "Bugsy" Siegel, along with Charles "Lucky" Luciano and other alleged underworld characters, opened the Flamingo Hotel on Las Vegas Boulevard, about a mile south of El Rancho Las Vegas, near what was essentially the edge of town on the highway leading to Los Angeles. If one was driving in from Hollywood, the Flamingo was the first major landmark. It was also one of the first to offer Hollywood-style entertainment.

Elvis made his first Las Vegas appearance at the New Frontier Hotel between April 23 and May 6, 1956, but the longish-haired "Hillbilly Cat" was not terribly well received by the cocktail crowd in their evening gowns and tuxedos. Times would change, and so would both Elvis and the Las Vegas audiences. When he returned in July 1969, he was a lightning bolt

Las Vegas, Nevada

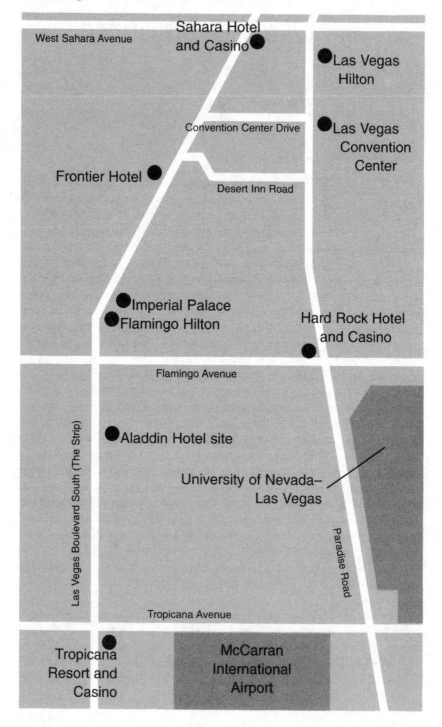

Sahara Hotel and Casino

West Sahara Avenue

Las Vegas Hilton

Convention Center Drive

Las Vegas Convention Center

Frontier Hotel

Desert Inn Road

Imperial Palace

Flamingo Hilton

Hard Rock Hotel and Casino

Flamingo Avenue

Las Vegas Boulevard South (The Strip)

Aladdin Hotel site

University of Nevada–Las Vegas

Paradise Road

Tropicana Avenue

Tropicana Resort and Casino

McCarran International Airport

unlike any that had ever struck the Las Vegas stage. Making two month-long stays annually through 1975, Elvis literally owned the town for these six years. If southern California had been Elvis's home away from Graceland through the 1960s, then Las Vegas was his home away from Graceland for much of the last decade of his life. These appearances would help to mold and define his lasting image—with his jumpsuit and sideburns—as well as his legacy.

During his moviemaking years, Elvis made only one film in Las Vegas, but that movie, *Viva Las Vegas* (1964), is still regarded as one of the definitive movies about the gambling capital, and its title song is still used as an anthem in many of the stage shows around town. In *Viva Las Vegas*, Elvis is cast as race-car driver Lucky Jackson, opposite Ann-Margret as Rusty Martin, the pool manager at the Flamingo Hotel. The plot involves a comedic and good-natured competition between Lucky and the suave Count Elmo Mancini—played by Cesare Danova—for the affections of Rusty, who plays hard-to-get. After a bloody race sequence, filmed near Las Vegas, Lucky gets the girl.

In the decade after Elvis's death in 1977, memory of him faded. However, in 1987 the immense revival in interest in Presley's career transformed him into a permanent Las Vegas icon. Indeed, Elvis impersonators have become a staple of the Las Vegas entertainment scene. In the 1992 movie comedy *Honeymoon in Vegas*, starring James Caan, Nicolas Cage, Sarah Jessica Parker, and Pat Morita, the final scene involves a battalion of skydivers in white jumpsuits who bill themselves as "The Flying Elvises." The skydivers, many of whom were working Elvis impersonators, included Bruno "Little Elvis" Hernandez, Clearance "Black Elvis" Giddens, and Robert "Oriental Elvis" Kim, as well as Eddie Bear, Gary Benson, George Chung, Elvis Jr., David Jenner, E. P. King, Johnny Lawson, Rick Marino, and Roddy Ragsdale. The movie actually inspired the creation of a real team of Las Vegas-based skydivers known as "The Flying Elvi," who have become an immensely successful demonstration team. This squad is described in detail in this chapter.

Today an Elvis impersonator parade is the grand finale in the *Legends in Concert* show at the Imperial Palace, which itself is a key feature of the entertainment scene on the Las Vegas Strip.

The Strip defines Las Vegas geographically, and the Strip itself is defined as the six-mile section of Las Vegas Boulevard South that runs from south to north between McCarran International Airport and Fremont Street. Most of the major hotel-casinos—known locally as "properties"—are located on or near the Strip. In describing the Las Vegas Elvis sites for this book, we will begin at McCarran International Airport and travel north, ending at Fremont Street. Directions will be given in relation to the Strip (Las Vegas Boulevard South) and you will note that most of the properties have addresses on the Strip.

Below the listing of actual Elvis sites in Las Vegas is a listing of some of the many wedding chapels in Las Vegas that offer wedding ceremonies with an Elvis theme. Elvis himself wed Priscilla in Las Vegas in May 1967, and each year hundreds, if not thousands, of Elvis fans come here to be married in an atmosphere that reminds them of the King.

University of Nevada–Las Vegas 🎥

4505 South Maryland Parkway
Las Vegas, Nevada
(702) 895-3381

In *Viva Las Vegas*, Rusty Martin, Ann-Margret's character, works both as the pool manager at the Flamingo Hotel and as a dance instructor at the University of Nevada–Las Vegas. In the film, the only dance sequence in which Elvis and Ann-Margret are on stage together was filmed at the University of Nevada gym.

The roads leaving the McCarran International Airport grounds feed into East Tropicana Boulevard, and you turn left on East Tropicana Boulevard to reach Las Vegas Boulevard South. If you turn right on East Tropicana Boulevard, you will soon notice the University of Nevada campus on your left. A left turn at South Maryland Parkway will take you to the main entrance of the university. Maps located on the campus will direct you to the gymnasium.

Tropicana Resort and Casino 🎥

3801 Las Vegas Boulevard
Las Vegas, Nevada 89109
(702) 739-2222
(800) 634-4000

As noted above, the roads leaving the McCarran International Airport grounds feed into East Tropicana Boulevard, the southernmost major east-west street in Las Vegas. If you turn left on East Tropicana Boulevard, the first major intersection will be Las Vegas Boulevard South. The Tropicana Resort will be on your left. The exterior of the Tropicana was featured briefly in *Viva Las Vegas*, and it was at the Tropicana's shooting range that Elvis and Ann-Margret did their skeet-shooting sequence. Today the hotel has 1,913 guest rooms, 120 suites, and 9 restaurants. The total casino area comprises 45,200 square feet.

Hard Rock Hotel and Casino 🏛

4455 Paradise Road
Las Vegas, Nevada 89109
(702) 693-5000
(800) 473-ROCK

Leaving the Tropicana Hotel and driving north, the next intersection will be Harmon Avenue. Turn right on Harmon to Paradise Road. As you near Paradise Road, you'll see the massive four-story guitar that is the marquee of the Hard Rock Hotel and Casino. Billing itself as "the world's first—and only—rock 'n' roll hotel," the plush eleven-story Hard Rock opened three blocks east of the Strip on Paradise Road in the predawn hours of March 9, 1995. A star-studded celebration on March 10 and 11 featured the Eagles and Sheryl Crow, who flew in for the occasion.

While the property did not exist in Elvis's time, it is important to fans both for its rock 'n' roll ambiance and for the important Elvis memorabilia that is on display. As with the Hard Rock Cafes that exist in various cities around the world, the property is filled with hundreds of thousands of dollars' worth of rock-music memorabilia. In addition to guitars once owned by Elvis, the Hard Rock Hotel and Casino displays Pearl Jam's surfboard, James Brown's gold jacket, and guitars owned by Chris

Opened in 1995 under the marquee of a four-story guitar, the Hard Rock Hotel and Casino is "the world's first rock 'n' roll hotel." Elvis never played here, but a great deal of important Elvis memorabilia is on display. (Photo by the author, copyright Bill Yenne.)

Isaak, Tom Petty, and Depeche Mode. There are also glass kiosks that house musical instruments and costumes worn by such stars as "The Artist Formerly Known as Prince."

The centerpiece of the Hard Rock property is the 50,000-square-foot casino, where the color-coded gaming chips carry the image of specific rock performers. For example, the red $5 chips carry a Red Hot Chili Peppers picture, while the purple $25 chips are Jimi Hendrix "Purple Haze" chips. The $100 Tom Petty is the "You Got Lucky" chip. Roulette wheels spin in mock pianos and the blackjack tables are adorned with lyrics from famous rock songs. Harvey's, the firm that owns and operates Harvey's Hotel and Casino in Lake Tahoe, manages the Hard Rock's casino. The Hard Rock has 340 guest rooms, 28 suites, and 2 restaurants.

From the Hard Rock, return on Harmon Avenue to Las Vegas Boulevard South and turn right.

(Former site of the) Aladdin Hotel

3667 Las Vegas Boulevard
Las Vegas, Nevada 89109

On the right, just north of Harmon Avenue, is the former site of the Aladdin Hotel. Originally known as the Tally-Ho, the property became the Aladdin in 1966, and it was demolished in April 1998.

It was here at the Aladdin, at 9:41 A.M. on May 1, 1967, that Elvis Presley married Priscilla Beaulieu in a double-ring ceremony. (Elvis lost his ring at the Circle G Ranch in Mississippi less than a month later, and it has never been found.)

The Aladdin Hotel was the site of Elvis and Priscilla's wedding at 9:41 on the morning of May 1, 1967. Arranged by Colonel Parker, the ceremony lasted eight minutes and took place in the private suite of then-owner of the property, Milton Prell. (Photo by the author, copyright Bill Yenne.)

The wedding was arranged by Elvis's manager, Colonel Parker, and lasted just eight minutes, shorter than a typical Elvis impersonator-themed wedding at a Las Vegas chapel today. The actual ceremony took place in the private suite of then-owner of the property, Milton Prell. Elvis was dressed in a black tuxedo and Priscilla was adorned in a white chiffon gown with a six-foot train, although there was no "Wedding March" to show off the train. Both Elvis's tuxedo and Priscilla's wedding dress are currently on display at Graceland in Memphis, Tennessee.

The couple flew in from Palm Springs, California, in Frank Sinatra's private jet, the *Christina*, and returned promptly thereafter. Though they did not spend their wedding night at the Aladdin, they did host a brief reception, at which they cut their six-tiered wedding cake with its pale pink meringue icing. According to information that we received from the Aladdin's kitchen staff, the cake was designed to serve 500, although fewer people actually attended the reception.

Until it closed in 1998, the Aladdin boasted 1,100 guest rooms, 42 suites, and 6 restaurants. The casino on the property had an area of 42,000 square feet.

Flamingo Hilton 🎥

(formerly the Flamingo Hotel)
3555 Las Vegas Boulevard
Las Vegas, Nevada 89109
(702) 733-3111
(800) 732-2111

Driving north on the Strip from Harmon Avenue, the next major intersection will be Flamingo Avenue. Through this intersection, the Flamingo Hilton will be the second property on the right, the first being the Barbary Coast. In 1963 the Flamingo was one of the only major properties on this part of the Strip, and it was noted for its vast central courtyard, the centerpiece of which was its swimming pool. In *Viva Las Vegas*, Ann-Margret's character, Rusty Martin, is the Flamingo's pool manager, and a great deal of the filming took place around the large swimming pool. At one point, Rusty knocks Elvis's character, Lucky Jackson, into the Flamingo's pool from the high-dive platform.

The Flamingo was opened the day after Christmas in 1946 by noted underworld character Benjamin "Bugsy" Siegel. After Siegel was assassinated in 1947, the Flamingo went through various hands, including those of entrepreneur Kirk Kerkorian, who purchased it in 1967 and sold it to the Hilton hotel chain in 1970. The facility has recently completed a $130 million-plus expansion that includes a sixth tower with 612 rooms, 15 acres of Caribbean-style pool and grounds area, a wildlife habitat featuring

The Flamingo Hotel, now the Flamingo Hilton, was founded in 1946 by noted underworld character Benjamin "Bugsy" Siegel. It was used in 1963 for the poolside scenes in Viva Las Vegas, which featured Ann-Margret and Elvis. (Photo by the author, copyright Bill Yenne.)

live flamingos and African penguins, a wedding chapel surrounded by lush foliage and waterfalls, the 550-seat Paradise Garden Buffet with a wide view of the grounds, and expanded casino, meeting, and retail spaces.

Today the Flamingo Hilton has a total of 3,642 guest rooms, 176 suites, and 8 restaurants. The total casino area comprises 77,000 square feet.

Imperial Palace 🚗

3535 Las Vegas Boulevard
Las Vegas, Nevada 89109
(702) 731-3311
(800) 634-6441

Located on the east side of Las Vegas Boulevard South a few steps from the Flamingo Hilton, the Imperial Palace is an important Las Vegas site for Elvis fans for two reasons. First, there is the world famous, 750-car Imperial Palace Automobile Collection, which includes one of the last cars that Elvis owned. He purchased this pale metallic-blue 1976 Cadillac El Dorado coupe with a white top in Denver on January 14, 1976, for $14,409, and used it during at least one ski vacation to Vail, Colorado. He had a minibar installed in the backseat and a citizen's band radio in the front. The car was acquired by the Imperial Palace in 1988 and is one

of two hundred on display at the property. His trademark TCB ("Taking Care of Business") insignia is engraved on the door.

A second feature of the Imperial Palace repertoire that draws Elvis fans is the nightly *Legends in Concert* show, which includes actors impersonating various stars ranging from Barbra Streisand to Michael Jackson. The Elvis impersonator is always the climax of the extravaganza, which typically concludes with the him leading the other impersonators in a rendition of the title song from *Viva Las Vegas*.

Currently the largest single-proprietor hotel in the world, the Imperial Palace has 2,700 guest rooms, 225 suites, and 10 restaurants. The total casino area comprises 75,000 square feet.

Frontier (formerly New Frontier) Hotel ♫

3120 Las Vegas Boulevard South
Las Vegas, Nevada 89109
(702) 794-8200
(800) 634-6966

About a mile north of the Flamingo and the Imperial Palace, but also on the Strip, is the Frontier Hotel. Originally known as the Last Frontier, this property opened in 1942 and was the second hotel on the Strip after the El Rancho. It was renamed the New Frontier in 1955, and the original building was torn down in 1966. The present Frontier Hotel was opened in 1967 on the same site by Howard Hughes' Summa Corporation.

Elvis made his first Las Vegas appearances at the property in 1956, having been booked by New Frontier manager Sammy Lewis for a four-week run, sharing the bill with the Freddy Martin Orchestra, comedian Shecky Greene, Johnny Cochrane, Dave Leonard, and Bob Hunter, in the Venus Room. Advertised as "the Atomic-Powered Singer" and paid $12,500 a week, Elvis actually appeared only from

Elvis's first concerts in Las Vegas took place in April and May of 1956 at the Last Frontier, which is now known as the Frontier Hotel and Casino. (Photo by the author, copyright Bill Yenne.)

April 23 through May 6 because of the poor response that he received from the Las Vegas audiences, who weren't ready for "Heartbreak Hotel" and "Blue Suede Shoes." The final concert was recorded, and four tracks appeared on the 1980 RCA boxed set *Elvis Aron Presley*, which was released to celebrate the twenty-fifth anniversary of his first recording on RCA.

When the King returned to the Las Vegas stage in 1969, it was to the stage of the Las Vegas Hilton and not to the Frontier. Today the Frontier has 986 guest rooms and 2 restaurants in a 15-story tower, 7-story building, and 3-story wing. The total casino area comprises 41,325 square feet.

Las Vegas Hilton ♪

(known as the International Hotel from 1969 to 1971, and as the Hilton International Hotel from 1971 to 1972)
3000 Paradise Road
Las Vegas, Nevada 89109
(702) 732-5111
(800) 732-7117

Driving north on the Strip from the Frontier, the next major intersection will be Desert Inn Road. Turn right on this street, drive to Paradise Road, and turn left. As you continue north on Paradise Road, the sprawling Las Vegas Convention Center will be on your right. Next on the right will be the grounds of the Las Vegas Hilton, with the massive, thirty-story hotel and casino complex rising from a hill.

Originally owned by Kirk Kerkorian, the property opened as the International Hotel in July 1969. In 1970 Kerkorian sold part of the International to Hilton Hotels, and a year later Hilton purchased the remaining share. It became known as the Las Vegas Hilton in 1972.

The first act that Kerkorian booked into his showroom at the International was Barbra Streisand. The second was Elvis Presley. Fresh from the great success of Elvis, his *Comeback Special* that had aired on NBC television in December 1968, Presley was one of the hottest acts in show business and, as it turned out, he was about to become the most popular act in the history of the Las Vegas stage. His opening night at the International, July 29, 1969, was by invitation only, but the remainder of his twenty-eight-night stand was a sellout. It was his first sustained series of concerts since 1957, and there was a great deal of pent-up demand. Elvis set a Las Vegas attendance record with 101,509 paying customers through August 28 and a gross of $1.5 million.

After his triumphant return to the stage in the summer of 1969, Elvis made the property his home base, and he was to appear on stage at 3000 Paradise Road more often than at any other venue in the world.

When Elvis returned to the International in January 1971, his anxiously awaited stand was an even more in-demand ticket than it had been in the summer of 1969. Elvis made Las Vegas a routine part of his tour schedule. By the time he came back again in January 1972, the International was the Las Vegas Hilton, but Elvis was still the King. He continued to return to Las Vegas through the middle years of the 1970s.

He set a pattern of two- to four-week appearances in the summer and fall of each year through 1975, with a single stand at the end of 1976. He returned to the International Hotel between January 26 and February 23, and from August 10 to September 7, in 1970. It was still the International Hotel when he appeared from January 26 to February 23, 1971, but the name had been changed to the Hilton International Hotel when he returned from August 9 to September 6, 1971, and between January 26 and February 23, 1972.

After the property officially became the Las Vegas Hilton Hotel, Elvis's appearances were from August 4 to September 4, 1972; from January 26 to February 23, 1973; from August 6 to September 3, 1973; from January 26 to February 9, 1974; from August 19 to September 2, 1974; from March 18 to April 1, 1975; from August 18 to 20, 1975; from December 2 to December 15, 1975; and from December 2 through December 12,

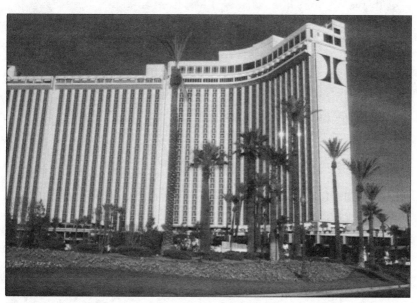

The Las Vegas Hilton was the scene of more Elvis Presley concerts than any other venue. It was still the International Hotel when Elvis first appeared here in July 1969, but it became the Las Vegas Hilton in 1972. He made two several-week appearances here annually through 1975, with a single stand at the end of 1976. (Photo by the author, copyright Bill Yenne.)

1976. His annual return was the most eagerly awaited event in Las Vegas, and every seat at the venue was booked well in advance. As he strode onto the stage in his brilliant white jumpsuit to the strains of Richard Strauss's "Also Sprach Zarathustra" (the theme from *2001: A Space Odyssey*) and launched into "See See Rider," he transformed himself into one of Las Vegas's most lasting legends. Indeed, he came to symbolize the glamour and the vital energy that was, and is, Las Vegas.

While he was in residence at the Las Vegas Hilton, Elvis stayed in a suite that he helped to decorate, one that naturally came to be known as the Elvis Presley Suite. Today it is called the Imperial Suite, as it was when Elvis arrived there. Reportedly suites 446–447 were reserved for Colonel Parker.

Today Elvis fans visiting the Las Vegas Hilton usually make a stop at the plaque commemorating his unprecedented eight years of appearances at the property. An inscription penned by Barron Hilton (the hotel mogul) reads: "Elvis Aaron Presley: Memories of Elvis will always be with us. None of us really, totally, know how great a performer he was. All of us at the Las Vegas Hilton were proud to present Elvis in our showroom. The decorations in the hotel, the banners, the streamers . . . Elvis always created great excitement with his loyal fans and friends. The Las Vegas Hilton was Elvis's home away from home. His attendance records are a legend. We will miss him. Thanks, Elvis, from all of us."

Today, the Las Vegas Hilton has 3,174 guest rooms, 278 suites, and 10 restaurants. The total casino area comprises 165,500 square feet.

Sahara Hotel and Casino 🎥

2535 Las Vegas Boulevard South
Las Vegas, Nevada 89109
(702) 7372111
(800) 6346666

From the Las Vegas Hilton, drive north on Paradise Road to Sahara Avenue and turn left in the direction of the Strip. At the corner of Sahara Avenue and Las Vegas Boulevard South is the Sahara Hotel and Casino, where Elvis stayed between July and September 1963 while he was filming *Viva Las Vegas*. The property was opened in December 1952 by a group of investors including developer Del Webb and Milton Prell, who was the manager at the Aladdin Hotel when Elvis and Priscilla were married there in 1967.

Today the Sahara has 2,033 guest rooms, 76 suites, and 6 restaurants in 15-, 25-, and 27-story towers. The total casino area comprises 26,956 square feet.

Fremont Street Experience 🎥

(Fremont Street between Main Street and Fourth Street)
425 Fremont Street (office and information)
Las Vegas, Nevada 89101
(702) 678-5600 (office and information)

In 1963, when Elvis and Ann-Margret were in Las Vegas to make *Viva Las Vegas*, "Glitter Gulch," the four-block section of Fremont Street between Main Street and Third Street, was still the area of Las Vegas that had the bright lights, big signs, and big casinos that defined the city. Nighttime aerial views of a sparkling Glitter Gulch are used in the opening scenes of *Viva Las Vegas*, and daylight views are used in the race sequences for the "Las Vegas Grand Prix," the imaginary auto race won by Elvis's character.

During the 1980s and early 1990s, as rapid changes were happening on the Strip, the old Las Vegas downtown area around Fremont Street was slipping into decline. In 1994 a major effort began to rejuvenate the area under a project that would create a four-block pedestrian mall. Fremont Street was permanently closed to automobile traffic on September 7, 1994, and it was soon transformed into a towering, ninety-foot-tall, four-block-long "space frame," with 2.1 million lightbulbs and a 540-kilowatt, state-of-the-art sound system. The Fremont Street Experience, the cornerstone for the comprehensive redevelopment of

The historic downtown area of Las Vegas on Fremont Street, between Main Street and Fourth Street, was traditionally known as "Glitter Gulch." The area appeared in scenes from Viva Las Vegas, *and Elvis impersonators still show up here. (Photo by the author, copyright Bill Yenne.)*

downtown Las Vegas, was a private and public partnership between the Fremont Street Experience Company—owned by a group of downtown casino operators—and the city of Las Vegas.

The Flying Elvi

7910 Bermuda Road
Las Vegas, Nevada 89123
(702) 896-9420

Life often imitates art with amazing results. For the finale of the 1992 film *Honeymoon in Vegas*, writer-director Andy Bergman conceived the notion of a group of jumpsuited jumpers skydiving into Las Vegas dressed as Elvis impersonators. For the aircraft interior scenes, he used actual Elvis impersonators, but for the jump scenes he required experienced skydivers, so he solicited the help of a professional skydiving team from Las Vegas. There was no trick photography or special gimmicks used when these ten Elvis impersonators jumped out of an airplane from an altitude of 15,000 feet and landed in a small parking lot lined with thousands of people. With that event, the Flying Elvi were born.

After they performed as Elvis impersonators—known as "The Flying Elvises"—in the movie, this ten-man skydiving team *became* Elvis impersonators, and they now perform as such throughout the world, combining a spine-tingling aerial skydiving performance of smoke trails, flashing lights, and precision maneuvers, with a stage show. Jumping from altitudes of 12,500 to 15,000 feet above the earth, they free-fall for 9,000 to 13,000 feet at speeds ranging from 120 to 160 miles per hour.

They have appeared for numerous events in and around Las Vegas, as well as in Japan on the Fuji Television Network; at the Hard Rock Cafe in Newport Beach, California; at Busch Gardens in Williamsburg, Virginia; at the East-West Shrine Game in Palo Alto, California; at the Jam Against Hunger '95 in Minneapolis, Minnesota; and for the San Diego Padres in San Diego, California.

All of the team members are United States Parachute Association pro-rated skydivers with an average of over 1,500 jumps each. In real life the crew consists of a teacher, a health inspector, a machinist, a free-fall cameraman, a commercial-refrigerator company owner, a newspaper writer, a realtor, a skydiving instructor, a contracting-business owner, and a parachute salesman.

To reach 7910 Bermuda Road from McCarran International Airport, turn left on East Tropicana Boulevard to Las Vegas Boulevard South, then make another left. Drive south for about four miles to East Windmill Lane and turn left, then drive for about two miles to Bermuda Road.

Landmark Pharmacy

252 Convention Center Drive
Las Vegas, Nevada 89109
(702) 731-0044

On the darker side of the Elvis Presley legend is his sad dependency on prescription drugs, a factor that likely had a detrimental effect on his performing ability and his health, and may have played a role in his death. In Memphis he had his Prescription House—across the street from the office of Dr. George Nichopolous—and in Las Vegas he reportedly had his prescriptions filled at the Landmark Pharmacy, whose sign reads "Landmark Drugs." There is no commemorative acknowledgment at this site. Driving north from McCarran International Airport on Las Vegas Boulevard South, turn right on Convention Center Drive, which is just north of Desert Inn Road. Driving north on Paradise Drive, turn left on Convention Center Drive, across from the Las Vegas Convention Center.

Weddings with Elvis 🏠

In the state of Nevada, for persons over the age of eighteen, there is no waiting period or blood test required for a marriage license. For these reasons many people make the trek from neighboring states—or from far away—to get married in Nevada. Indeed, Elvis and Priscilla Beaulieu were married in

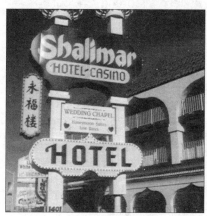

The Shalimar Wedding Chapel at 1401 Las Vegas Boulevard South is one of many chapels offering weddings with an Elvis impersonator theme. (Photo by the author, copyright Bill Yenne.)

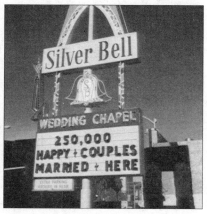

The Silver Bell Wedding Chapel at 607 Las Vegas Boulevard South is another of many chapels offering weddings with an Elvis impersonator theme. (Photo by the author, copyright Bill Yenne.)

Nevada in 1967 to take advantage of this fact and to avoid the crush of publicity that would have befallen them in a state requiring a waiting period.

Because of the liberal marriage-license requirements, wedding chapels have been a sort of cottage industry in Nevada for more than half a century. In recent decades, many of the wedding chapels have been offering "theme" weddings in which couples may get married in costume, and/or with a particular type of music. Naturally, one of the most popular themes for weddings in Las Vegas has been the Elvis Presley theme.

Today many chapels specifically offer Elvis "packages." This might simply mean having an Elvis impersonator sing three or four songs, but it can also include having the Elvis impersonator walk the bride down the aisle, say the vows, and/or pick up the bride or the couple at their hotel in a limousine. In some cases people have hired Elvis impersonators for their receptions as well as for the weddings. Most chapels will include a videotape of the ceremony as part of their package and/or arrange for a professional photographer. A list of several Las Vegas chapels offering Elvis packages is provided below, with addresses and phone numbers. Because specifics and prices may be subject to change without notice, we suggest that you contact them in advance to plan that special moment with Elvis.

Candlelight Wedding Chapel
2855 Las Vegas Boulevard South
Las Vegas, Nevada 89109
(702) 735-4179

Cupid's Wedding Chapel
827 Las Vegas Boulevard South
Las Vegas, Nevada 89101
(702) 598-4444

Graceland Wedding Chapel
619 Las Vegas Boulevard South
Las Vegas, Nevada 89101
(702) 474-6655
(800) 824-5732

Hitching Post Wedding Chapel
1737 Las Vegas Boulevard South
Las Vegas, Nevada 89104
(702) 387-5080
(800) 572-5530 (ask for Marie)

Las Vegas Wedding Chapel
727 South 9th Street
Number C
Las Vegas, Nevada 89101
(702) 383-5909

Riviera Wedding Chapel
2901 Las Vegas Boulevard South
Las Vegas, Nevada 89109
(702) 794-9494

Shalimar Wedding Chapel
1401 Las Vegas Boulevard South
Las Vegas, Nevada 89104
(702) 382-7372

Silver Bell Wedding Chapel
607 Las Vegas Boulevard South
Las Vegas, Nevada 89101
(702) 382-3726
(800) 221-8492

Victoria's Wedding Chapel
2800 West Sahara Avenue
Number 2D
Las Vegas, Nevada 89102
(702) 252-4565

Nevada beyond Las Vegas

There is probably no state that is more closely identified with the myth of striking it rich overnight than Nevada. People do, but many more go home having been struck down, struck dumb by loss, or having simply struck out. For a time—from the mid-1950s through the mid-1970s— the same was true of stage performers. Many careers were made and broken in Las Vegas during those years. For Elvis, Las Vegas represented his career triumph.

Elvis was on stage at the Las Vegas Hilton more times than at any other venue. Indeed, he was in residence there for a total of forty-five weeks during the 1970s. Beyond Las Vegas, however, he appeared in just two venues in the Silver State. His only casino stand outside of Las Vegas was at Lake Tahoe, and he made only one single appearance in Reno, Nevada's second city.

Sahara Tahoe Hotel and Casino ♫

(now Tahoe Horizon Casino Resort)
Highway 50
Stateline, Nevada 89449
(702) 588-6211

Sitting astride the California-Nevada border an hour's drive from Reno, Lake Tahoe is one of the most picturesque sites in either state, and, in terms of scenic beauty, it ranks at or near the top of Nevada's list. It is also the leading ski area for both states. Approximately twenty-two miles long and twelve miles wide, Lake Tahoe boasts seventy-two miles of shoreline. One of the deepest lakes in the world, Lake Tahoe's average depth is placed at 1,000 feet, and its deepest point is 1,645 feet. The average surface elevation is 6,225 feet above sea level, making it the highest lake of its size in the United States. The highest mountain peaks sur-

rounding the lake are Mt. Rose at 10,776 feet and Mt. Tallac at 9,735 feet.

The town of Stateline, located in Nevada on the south shore of Lake Tahoe, is home to several four-star hotels and elegant casinos. Next door in California is South Lake Tahoe, the area's largest residential and business community and the site of the Tahoe area's largest airport.

Among the properties in Stateline, the Sahara Tahoe was once owned by the Del Webb Corporation, an Arizona-based development company that was, for a time, involved in casino operations in Nevada. In the 1980s and early 1990s, the property operated as the High Sierra, before finally becoming the Tahoe Horizon.

During the 1970s, the Sahara Tahoe was one of the most important sites in the Tahoe area for showcasing musical talent, and Elvis was certainly the most important. He made his first appearance for a two week stand between July 20 and August 2, 1971, two years after he had begun his series of appearances in Las Vegas. He did not return in 1972, but he did come back for a twelve day stand between May 4 and May 16, 1973. Elvis performed at the Sahara Tahoe twice in 1974, coming in on May 16 through 27, and October 11 through 14, 1974. His last appearance was between April 30 and May 9 in 1976.

Reno Sparks Convention Center

(Formerly Centennial Coliseum)
4590 South Virginia Street
Reno, Nevada 89502

The only concert that Elvis ever gave in Nevada outside Las Vegas and Lake Tahoe occurred on November 24, 1976 in this desolate crossroads town on Interstate 80. Amazingly, we discovered that few people now associated with what was then known as the Centennial Coliseum, even realize that Elvis once performed here!

The coliseum has been substantially remodeled since Elvis left the building in 1976, so there is truly nothing to see. The Lake Tahoe area (see previous entry) is much more picturesque, and more worthwhile to visit.

Sierra Sid's Auto Truck Plaza

200 North McCarran Boulevard
Sparks, Nevada 89431
(702) 359-0550

The small Great Basin town of Sparks is home to one of the more important Elvis museums in the West. Sierra Sid's Union 76 truck stop displays a dazzling array of the King's jewelry — including tiger eyes and opals — and many watches and other items that were given as presents to Vernon Presley by his son. Sierra Sid acquired these items from Sandy Miller, who was Vernon's fiancée at the time of his death in 1979.

The most important feature of the Sierra Sid collection is, however, two sets of fifty-two Elvis albums that were certified gold, and which were presented to Elvis by RCA Records. They are two of only twenty such sets in existence and were given to Vernon by Elvis, and later willed by Vernon to Sandy Miller.

Aficionados of Elvis's Western movies or of his interest in firearms will be interested in the fact that Sierra Sid's collection also contains three of Elvis' favorite pistols. The .44 magnum Ruger Blackhawk with ivory grip was engraved by Otto Bock and acquired by Elvis when he was in Germany. The gold Smith & Wesson .38 Special has a two inch barrel and is engraved with lions and bears. The the 1897 Colt .38 has the quick-draw holster that was made for Elvis by Alphonse of Hollywood. Elvis used this in *Viva Las Vegas*. However, it is not believed that any of these guns were used by Elvis in the several instances where he fired hand guns into television sets in hotel and motel rooms.

Recipes from the kitchen at the Sierra Sid's Auto Truck Plaza restaurant are featured in The *All-American Truck Stop Cookbook* by Ken Beck, Jim Clark, and Les Kerr, which was published in 2002.

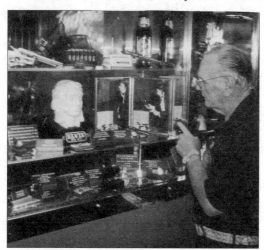

Sid Doan of Sierra Sid's Museum in Sparks, Nevada, which contains a number of important items of Elvis memorabilia; notably the King's favorite hand guns.
(Photo by the author, copyright Bill Yenne.)

Chapter 11

Los Angeles County, California

Chuck Berry's song "Johnny B. Goode" and its sequel, "Bye Bye, Johnny," are largely biographical of Elvis Presley. They tell of a guitar-strumming Southern country boy who becomes so famous that he ultimately leaves the South for the "golden West" to make movies in Hollywood."

Whatever can be said of the movies that Elvis made—and there have been a great many negative comments over the decades—he did make more motion pictures than any other rock star of his era, and possibly any rock star ever. Only Kris Kristofferson, among later rock artists, has had a more prolific Hollywood film career, and it can be argued that Kris is primarily a country singer.

As was the intention of his manager, Colonel Parker, Elvis Presley made the kind of transition from the concert stage to the B-movie screen that had been made earlier by pop singers such as Frank Sinatra and Dean Martin. Excluding concert films and documentaries, the Beatles made only two feature-length motion pictures and the Rolling Stones made none—although Mick Jagger has appeared in a handful of movies.

Elvis appeared in thirty-one feature films between 1956 and 1969, and they reportedly grossed $150 million in theatrical release during his lifetime. Four of these—*Love Me Tender* (1956), *Loving You* (1957), *Jailhouse Rock* (1957), and *King Creole* (1958), arguably his best—were made prior to his being inducted into the U.S. Army in 1958. The remainder were filmed and released between 1960 and 1969, an average of one new movie every nineteen weeks!

When the Colonel decided that Elvis Presley was going to become a film star, he went at it full steam. To facilitate the making of these Hollywood pictures at such a rapid clip, Elvis essentially had to take up residence in southern California.

In the 1956–1958 period, during the filming of the first four, Elvis was still making live concert appearances, so he was in southern

California only when he was on the soundstages. During the production of his first two movies, he stayed—with his parents—at the Hollywood Knickerbocker Hotel. Later he moved to the Beverly Wilshire Hotel. After he was discharged from the U.S. Army in 1960, he began his ten-year, full-time film career. While Graceland in Memphis was the home to which he returned for the holidays, most of his time during the 1960s was spent in the Los Angeles County area.

In May 1969 it was announced that Elvis would take a break from filmmaking to do concerts. It was assumed by all, probably Elvis included, that after a hiatus of a few years, he would return to the screen. A number of screen projects were suggested to Elvis through Colonel Parker, but apparently the only one that earned serious consideration was the male lead opposite Barbra Streisand in the second remake of *A Star Is Born* in 1976. Barbra reportedly wanted Elvis in the part, and, in retrospect, it could have been not only a great role, but it also could have been the assignment that restarted a successful serious film career for Elvis. And it might even have saved his life. However, Colonel Parker is credited with squashing the deal by demanding for Elvis a million dollars and top billing (rather than shared top billing with Barbra). At the time of his death in 1977, Elvis was reportedly considering a non-singing role in the film *Billy Easter*, which he would have financed.

It should be noted that, while he was living in the various locations in Southern California during the 1960s, Elvis almost always shared his homes with members of an entourage of about a dozen men and women, dubbed "the Memphis Mafia" by the media in 1960. This group consisted primarily of men that Elvis Presley had known in Memphis prior to his becoming a major star, and most received modest salaries for tasks that they performed for Elvis. Some members of the Memphis Mafia lived with Elvis for extended periods, most of whom had homes nearby that were purchased for them by the singer. Among the Memphis group were Delbert "Sonny" West and Sonny's cousin, Robert Gene "Red" West. The Wests were notable for being longtime Elvis Presley bodyguards, and Red West was married to Elvis's secretary Pat Boyd. Red also wrote or cowrote a number of songs that were recorded by Elvis and various other artists, and he had speaking parts in ten of Elvis's movies. Charles Franklin "Charlie" Hodge, who also lived with Elvis in Los Angeles County, had met Elvis in 1956 and had served in the U.S. Army with him.

This section is divided into the Elvis Home Tour, the Elvis Studio Tour, and a tour of other selected Elvis sites in southern California. For each of these, we use the Los Angeles International Airport (LAX) as the anchor point when providing directions. The home tour given immediately below is described as a driving tour, leading from point to point within the tour.

The Elvis Home Tour 🏠

While he was residing in Los Angeles County during the 1960s, Elvis lived in five houses, all of them in the hills above Hollywood, north of Sunset Boulevard and east of the San Diego Freeway (Interstate 405). To reach Sunset Boulevard from the Los Angeles International Airport, leave the airport driving east on Century Boulevard. Follow the signs that will direct you to the San Diego Freeway northbound. Take the Sunset Boulevard exit and proceed eastbound on Sunset Boulevard. The Elvis Home Tour begins about a mile east of the freeway with a left turn on Stone Canyon Road.

The two hotels where Elvis stayed during his visits in 1956–1958 and 1960 are located south and east of the sites of his houses, and are listed here with separate directions.

Los Angeles, California: The Elvis Home Tour (hotels)

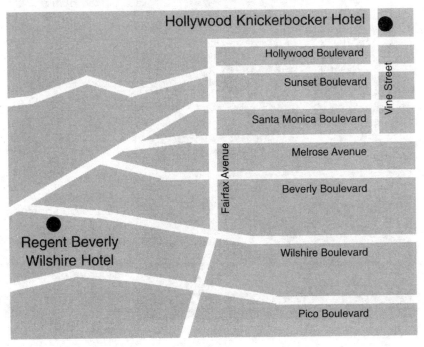

The Hollywood Knickerbocker Hotel

1714 North Ivar Avenue
Los Angeles, California 90028
(323) 462-8202

One of the great hotels from the golden era of Hollywood, the Knickerbocker is located about a half block from Hollywood Boulevard in the Los Angeles district known as Hollywood (Hollywood is not an incorporated city). Completed in 1925, it was the Hollywood hotel during the 1930s and 1940s. Many of Hollywood's greats stayed here and a few even died here. Director D. W. Griffith passed away in the lobby and character actor William Frawley (of *I Love Lucy* fame) died just outside. Magician Harry Houdini's widow held her famous séances here, trying to contact the spirit of her dead husband and insisting that if anyone could escape from the great beyond, it was he. Harry never materialized, but the

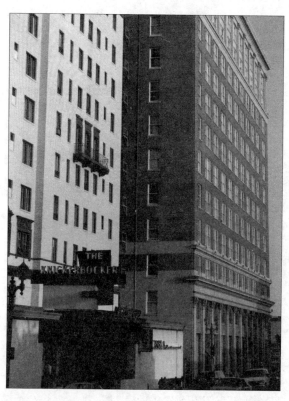

When Elvis came to Hollywood to film his early movies, he stayed at the Hollywood Knickerbocker Hotel. He was here from August to October in 1956, and from January through March of 1957. One of the great hotels from the golden era of Hollywood, the Knickerbocker is said to be haunted by the ghosts of Rudolph Valentino and Marilyn Monroe, but Elvis's ghost has left the building. (Photo by the author, copyright Bill Yenne.)

ghosts of Marilyn Monroe—who honeymooned here with Joe DiMaggio—and Rudolph Valentino are said to be seen here occasionally.

Elvis's ghost has not been seen here—that we know of—but, in life, he was a guest here with his parents several times during the early phase of his filmmaking career. Among his longer stays at the Knickerbocker were those from August to October in 1956, and from January through March of 1957. During his later treks to Los Angeles, Elvis stayed at the Beverly Wilshire Hotel in Beverly Hills.

The story that the Elvis Presley song "Heartbreak Hotel" is based on his experiences at the Hollywood Knickerbocker is not true. The song was written in 1955 by Tommy Durden and Mae Axton, and is based on a suicide that had occurred in Miami. Elvis recorded the song in New York in January 1956, before his first trip to Hollywood in April 1956.

After many years of decline, the Hollywood Knickerbocker is now a residence hotel, occupied primarily by Russian-born senior citizens.

To reach the Hollywood Knickerbocker from the Los Angeles International Airport, take Century Boulevard east to the San Diego Freeway (Interstate 405). Turn north on this freeway, and then east on the Santa Monica Freeway (Interstate 10) to the Harbor Freeway (Interstate 110/California Route 110). Turn north on the Harbor Freeway to the Hollywood Freeway (U.S. Highway 101). Take the Hollywood Freeway north to the Hollywood Boulevard exit. Drive west on Hollywood Boulevard to Ivar Street and turn right, driving for half a block. The Hollywood Knickerbocker is on your right.

The Regent Beverly Wilshire Hotel 🏠

(formerly the Beverly Wilshire Hotel)
9500 Wilshire Boulevard
Beverly Hills, California 90212
(310) 275-5200

Touted then, as now, as "the Beverly Hills spot to see and be seen," the Regent Beverly Wilshire is located between Rodeo Drive and Camino Drive in Beverly Hills' most fashionable shopping district.

Elvis first stayed at the Beverly Wilshire during January, February, and March of 1958, while he was in Hollywood filming *King Creole*. The hotel was, and is, one of the most stylish hotels in Beverly Hills, and it was selected by Colonel Parker as befitting Elvis's newfound fame. Elvis had been drafted by the U.S. Army in December 1957, but, since he was granted an induction deferment to complete the movie, Elvis actually left Hollywood in late March. Discharged two years later, he was back in Hollywood at the end of March 1960 to begin filming *G.I. Blues* (1960) and *Flaming Star* (1960). Both of them would be released before the end

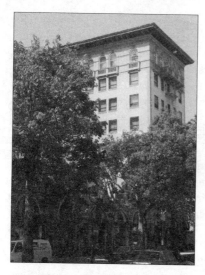

In 1958, when he was in Hollywood filming King Creole, Elvis stayed at the Beverly Wilshire (now the Regent Beverly Wilshire). When he came back in 1960 to begin his decade-long sojourn in Hollywood, he spent his first few months back at the Beverly Wilshire. (Photo by the author, copyright Bill Yenne.)

of 1960, specifically on October 20 and December 20 respectively. It was during this second stay that Elvis and his entourage were asked to leave the hotel because they were being disruptive and bothersome to other guests. It had happened before, and it would happen again.

Today, the Regent Beverly Wilshire has 275 oversized rooms, including sixty-nine suites. One now finds such amenities as an executive business center that is open seven days a week, a 24-hour personal room attendant, an extensive health club with a full-service spa and sauna, an Italian villa-styled pool, a dining room, an elegant lobby lounge, and a "California style" cafe.

To reach the Regent Beverly Wilshire from the Los Angeles International Airport, leave the airport driving east on Century Boulevard. Follow the signs that will direct you to the San Diego Freeway (Interstate 405) northbound.

Take the Santa Monica Boulevard Exit and proceed eastbound on Santa Monica Boulevard to Wilshire Boulevard and turn right for eight blocks. The Regent Beverly Wilshire will be on your right.

The Elvis 1960-1961 and 1963-1965 Home

525 (Sometimes listed as 565) Perugia Way
Los Angeles, California 90077

Located in Bel Air (a district within the City of Los Angeles), this home was rented by Elvis for most of the early sixties, although for just over a year, he lived in the nearby house at 10539 Bellagio Road. His two sojourns on Perugia Way were from September 9, 1960 to October 22,

Los Angeles, California
The Elvis Home Tour (Bel Air and Beverly Hills)

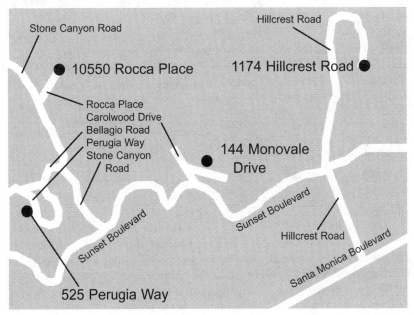

1961 and from January 18, 1963 through the end of 1965. Perugia Way is located on a heavily-wooded hillside overlooking the grounds of the Bel Air Country Club.

Now entirely rebuilt, the original structure on the site that Elvis knew was designed by Frank Lloyd Wright. The story is told that Iran's last shah, Mohammed Reza Pahlavi, owned the house before Elvis.

It was while he was living on Perugia Way that Elvis had his legendary "Summit Conference" with the Beatles. The meeting, the only time that Elvis and the Beatles would ever meet, was arranged between Colonel Parker and Beatles manager Brian Epstein. The Fab Four were at the end of their third United States tour, and were staying in a rented house at 2850 Benedict Canyon Road, about two miles away.

The Summit Conference occurred on the evening (some sources say the afternoon) of August 27, 1965, when the Beatles — out of deference to the respect they held for the King of rock and roll — came to his home. Both Elvis and the Beatles were quite nervous before the meeting, but they got along quite well and spent about three hours together. Reportedly, they played music together and a tape recorder was turned on. However, if such an historically important tape still exists, its whereabouts are unknown. The Beatles made their famous appearances at the Hollywood Bowl on August 28-30, but Elvis did not attend. These concerts were recorded, but their release was delayed for a decade.

To reach Perugia Way from Sunset Boulevard, turn north on Stone Canyon Road for about a quarter of a mile. Turn left on Bellagio Road at the end of the Bel Air Country Club Golf Course and drive for about half a mile. Perugia Way is a two-block street bisected by the 10500 section of Bellagio Road. Perugia Way is intersected by no other street than Bellagio Road. Have your Los Angeles street map handy. Please note that this is a private home and not open to the public. Do not disturb the occupants. Crossing the end of the driveway constitutes trespassing. As with nearly all of the homes in Bel Air, it is protected by a private security company.

The Elvis 1961-1963 Home

10539 Bellagio Road
Los Angeles, California 90077

Located in the Bel Air district, this site was home to Elvis and his entourage from October 22, 1961 to January 18, 1963. The Bellagio address is listed in several sources as 1059 Bellagio, but all the Bellagio Road addresses have five digits, so this is erroneous.

To reach Bellagio Road from Sunset Boulevard, turn north on on Stone Canyon Road. Have your Los Angeles street map handy. Please note that this is a private home and not open to the public. Do not disturb the occupants. As with nearly all of the homes in Bel Air, it is protected by a private security company.

The Elvis 1966-1968 Home

10550 Rocca Place
Los Angeles, California 90077

The lease on Elvis' Perugia Way house expired in the fall of 1965, as he was finishing work on *Paradise, Hawaiian Style*, and he went house-hunting. By this time, 20-year-old Priscilla Beaulieu was living with him (they were married in 1967) and she was especially anxious for privacy.

When they moved in February 1966, Elvis and Priscilla remained in Bel Air, but moved about a mile north in Stone Canyon to 10550 Rocca Place. They would stay in this home until February 1968.

As had been the case with his Perugia Way house, the Rocca home was leased, but it would be the last house that he would lease in the Los Angeles area. Located on the ridge between Stone Canyon and Beverly Glen, this home was probably the most secluded of any Elvis Presley home in California. Rocca Way, which climbs up from Stone Canyon Drive, is an extremely steep street, and there are no roads which cross the ridge all the

way from side to side. Sometimes confused with Rocca Way, Rocca Place is a tiny street that juts off to the left from Rocca Way near the top of the hill as Rocca Way makes a sharp right turn.

It was also while living at the Rocca property that Elvis reportedly made his one and only "trip" on LSD.

To reach Rocca Way and Rocca Place from Sunset Boulevard, turn north on Stone Canyon Road for about a mile. In so doing, you will pass Bellagio Road, which was the turn-off to reach Perugia Way. Rocca Way is a sharp right turn. As noted above, Rocca Place is a short cul-de-sac on the left side of Rocca Way near the top of the hill. Have your Los Angeles street map handy. Please note that this is a private home and not open to the public. Do not disturb the occupants, and do not pass the gate under any circumstances. As with nearly all of the homes in Bel Air, it is protected by a private security company.

The First California Home that was actually owned by Elvis
1174 Hillcrest Road
Beverly Hills, California 90210

Elvis Presley married Priscilla Beaulieu at the Aladdin Hotel in Las Vegas on May 1, 1967. On May 7, he closed escrow on this home in the Trousdale Estates section of Beverly Hills, literally next door to Villa Rosa, the palatial modern mansion owned by entertainer Danny Thomas. The couple did not, however, actually take up residence at the Hillcrest property until February 25, 1968.

Elvis reportedly paid $400,000 for the Hillcrest Road house in 1967, but today it could be worth ten times that sum. Built in 1961, it was the first house in the Los Angeles area that Elvis *owned*. As it was in Beverly Hills, it was one of two of his houses in the Los Angeles area that was not within the Los Angeles city limits. Located high on a steep hillside, it also had the best view of any of his Los Angeles County homes.

Among the friends of Elvis who spent time living in the main house or the guest house on the grounds, while Elvis owned the Hillcrest home were Richard Davis, Joe Esposito and Charlie Hodge, as well as Patsy and Gee Gee Gambill.

Elvis and Priscilla closed on the purchase of their next home at 144 Monovale Drive in Beverly Hills in December 1970, but they remained in the Hillcrest house while the Monovale home was being remodeled. Most of their furniture was moved from Hillcrest to Monovale in September 1971, but they stayed on at Hillcrest for about a month.

After the couple separated in September 1972, Elvis moved back to 1174 Hillcrest Road. He had put the Hillcrest property up for sale for a reported $500,000, but it had not yet sold.

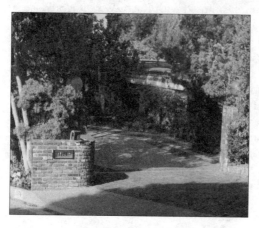

Outwardly, the house at 1174 Hillcrest Road in the Trousdale Estates section of Beverly Hills appears as it did when Elvis closed escrow on the property on May 7, 1967, a week after he married Priscilla. It was the first house that he actually owned in California. (Photo by the author, copyright Bill Yenne.)

Between June 1967 and May 1969, while living at the Hillcrest property, Elvis made his last six feature films, *Stay Away Joe; Speedway; Live a Little, Love a Little; Charro; The Trouble With Girls* and *Change of Habit*. Also during that time, in June 1968, he made a taped-for-TV music special called Elvis, but known universally as "The Comeback Special." Aired in December 1968, it was so popular that it set the stage for a return to regular live concerts, something that Elvis had not done on a regular basis since before going into the US Army (although he made a couple of one-time appearances in the early 1960s).

This era also marked the end of his motion picture career. While there would be a number of concerts filmed in the 1970s, Elvis made no feature films after 1969. With this "change of habit," the center of gravity for Elvis Presley shifted away from southern California, and it never shifted back. Elvis gradually began spending more time back in Memphis, albeit with extended stays in the new capital of his stardom — Las Vegas.

In fact, the center of gravity had really begun to shift back to Memphis even well before Elvis and Priscilla's daughter, Lisa Marie, was born on February 1, 1968 at Baptist Memorial Hospital in Memphis.

To reach 1174 Hillcrest from Sunset Boulevard, turn north on Hillcrest Road, which is about four miles east of the San Diego Freeway. From Sunset Boulevard, Hillcrest Road climbs steadily upward as you drive north. After nearly a mile, Hillcrest makes a sharp right turn and enters a switchback as it continues to climb. Have your Los Angeles street map handy.

You'll now be heading south, with a spectacular view of Beverly Hills and the towers of Century City ahead of you. Hillcrest reaches a dead end about an eighth of a mile from the switchback, with the gates of Villa Rosa directly ahead at 1187 Hillcrest Road, and Elvis' former home at 1174 Hillcrest Road on your right.

Since it is surrounded by trees, the best view of the 1174 Hillcrest property is from across the canyon to the west on Wallace Ridge. As you

are climbing north on Hillcrest Road, Wallace Ridge is the last intersecting road to the left before you enter the switchback. As Wallace Ridge turns to the south, paralleling Hillcrest Road, there will be a long open space on the left. From here, you can look across the canyon at 1174 Hillcrest Road, as well as Villa Rosa, which sits at the end of the ridge.

As you observe the home at 1174 Hillcrest Road, please note that this is a private home and not open to the public. Do not disturb the occupants. As with nearly all of the homes in Beverly Hills and the adjacent communities, it is protected by a private security company.

The Last Elvis Home in California

144 Monovale Drive
Beverly Hills, California 90210

Nestled behind an imposing adobe wall in the Holmby Hills area, the property at 144 Monovale Drive is listed by the US Postal Service as having the famous 90210 zip code of Beverly Hills, while the Southern California Automobile Club maps show it as being about 100 feet within the Los Angeles city limits.

Some "maps to movie stars' homes" list it as being at 144 Carolwood Drive, but this is incorrect. Carolwood Drive is that street intersects Monovale Drive a half block to the west. If there is any doubt, wait fifteen minutes for a tour bus to lumber past.

This was the last house that Elvis Presley owned in the Los Angeles area. He bought the two-story home — with its sprawling two acre grounds and orange trees — in December 1970. He reportedly paid $339,000 for the house, slightly less than he had paid for the Hillcrest Road house.

According to Priscilla, in her 1985 book *Elvis and Me*, she picked the house from an advertisement in *Variety* during the time that Elvis was in Arizona finishing work on *Stay Away Joe*. While the Monovale Drive house

Elvis's last California home was this walled estate in the Holmby Hills area of Beverly Hills. Priscilla actually chose the property and they purchased it at the end of 1970. Priscilla lived here for a time after their 1972 separation. The property was sold in 1975.
(Photo by the author, copyright Bill Yenne.)

is just a block off busy Sunset Boulevard and it does not have the sensational view with which the Hillcrest Road house is blessed, it is the *largest* private home that Elvis occupied in southern California.

The site had once been owned by actor Robert Montgomery, who was the father of actress Elizabeth Montgomery. She is best remembered as the star of the cult television classic *Bewitched*, but she had also once been married to Gig Young, who appeared with Elvis in *Kid Galahad* in 1962.

After purchasing the Monovale property, Elvis and Priscilla would remain at the Hillcrest home for nearly a year while extensive renovations were being done. Elvis reportedly spent his first night in the Monovale house on October 6, 1971.

The 144 Monovale Drive property remained home to Elvis for a relatively short time, although Priscilla continued to use the house after her separation from Elvis in February 1972, and even after their divorce became final on October 9, 1973. Elvis, meanwhile, stayed at the 1174 Hillcrest Road house, which he had listed, but not yet sold.

It was on June 18, 1975 that Elvis and Priscilla finally sold the 144 Monovale Drive house to actor Telly Savalas for a reported $625,000 (some sources say $650,000).

To get to 144 Monovale Drive from Sunset Boulevard, turn north on Carolwood Drive, which is a bit less than a mile east of Stone Canyon Road and about two miles east of the San Diego Freeway. The first right is Monovale Drive, and 144 is on the north side of the street. Monovale Drive is only one block long, and the intersection with Ladera Drive — at the opposite end from Carolwood Drive — marks the Beverly Hills city limits. Have your Los Angeles street map handy.

As with other Elvis homes mentioned in this chapter, the 144 Monovale property is a gated compound that is not open to the public, and can be viewed only from the street. The high walls obscure the view somewhat, but the house can be seen over the gate.

The Monovale Drive location seems to be the Elvis home most sought by tourists, as it appears on most of the "maps to the stars' homes" and it is on the tour bus circuit. One spring afternoon a few years back, we noted two such buses passing the site in a span of less than five minutes. The reason for its being singled out may be that it was Elvis's last home in southern California, or it may be that it is the house most easily accessible from Sunset Boulevard, while the other houses are on steep, winding streets that would be hard for buses to negotiate.

As with other private homes, you are admonished not to disturb the residents, or to intrude on the property. The parade of tour buses must certainly be disturbing enough.

The Elvis Studio Tour 🎥

As noted above, Elvis Presley made a total of thirty-one feature films between 1956 and 1969, with twenty-seven of them being made in the 1960s alone. Much of the filming for most of these movies was done at the soundstages and lots of southern California studios, specifically those of Paramount, Metro-Goldwyn-Mayer, and Twentieth Century-Fox. Since fewer than half of the Elvis Presley films involved any location shooting outside Los Angeles County, the studios are truly the focal points of Elvis's motion-picture career.

Los Angeles, California: The Elvis Studio Tour

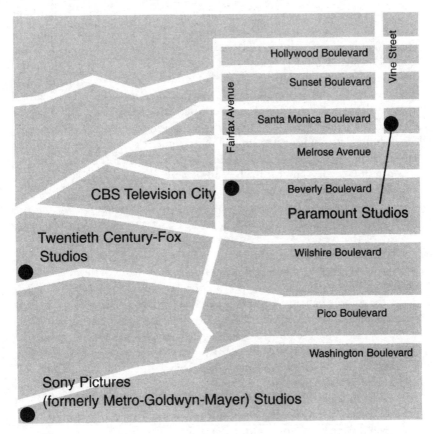

Paramount Studios/
Paramount Pictures Corporation 🎥

5555 Melrose Avenue
Los Angeles, California 90038
Paramount Visitor Center
860 North Gower Street
Los Angeles, California 90038
(323) 956-5000 (main switchboard)
(323) 956-1777 (Guest Relations/studio tours)
(323) 956-5575 (recorded Paramount show information)

Elvis Presley's career in the movies began on April 3, 1956, when he was driven through the big Paramount gate at 5555 Melrose Avenue for his first screen test. The screen test had been arranged through negotiations between Colonel Tom Parker and Hal B. Wallis, the Paramount producer who, more than anyone else, would shape Elvis's movie career. Elvis tested for the role of Jimmy Curry in *The Rainmaker* (1956), a part that ultimately went to Earl Holliman. Nevertheless, on April 6, Paramount signed Elvis to a three-picture, seven-year, $450,000 contract.

Though Paramount had signed an agreement with the popular young singer, it did not immediately have a script for him, so he was loaned to Twentieth Century-Fox for his first film, *Love Me Tender* (1956). His first Hal Wallis production to be made on the Paramount lot would be *Loving You*, in which he played country singer Jimmy Tompkins. *Loving You* was filmed between January 21 and March 8, 1957, and opened in Memphis in July of that year.

The second Hal Wallis/Paramount/Elvis Presley film was actually the fourth Elvis Presley movie, as Paramount had loaned him to Metro-Goldwyn-Mayer for his third production, *Jailhouse Rock* (1957). While *Jailhouse Rock* is valued by many Elvis Presley fans as being his signature film as a singer, his fourth film, *King Creole*, is considered by many critics to be his best. He is seen with much of his youthful energy, which was deliberately toned down for the entries that were made in the 1960s. Filming for *King Creole* took place between January 20 and March 10, 1958, and it opened in July 1958 in nationwide release after Elvis had been inducted into the U.S. Army. With Elvis starring as nightclub singer Danny Fisher, most of the scenes were done on Paramount soundstages, but several were also shot on location in New Orleans.

As Elvis was in the army for two years, his film career was on hold for the duration. Because of its theme, many people assume that *G.I. Blues* was filmed while Elvis was still in the service, but it actually began production on May 20, 1960, two months after his discharge. In this movie,

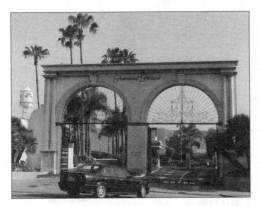

Elvis's film career began beyond the gates of Paramount Pictures in 1956, when he made his first screen test for producer Hal Wallis. Over the next ten years, Elvis would make eight films on the lot and in the sound studios of Paramount. (Photo by the author, copyright Bill Yenne.)

Elvis's fifth, and his third for Hal Wallis at Paramount, he plays a soldier named Tulsa McLean. Though the setting was Germany, where he had served with the army, all of the filming for *G.I. Blues* in which Elvis was involved was done at Paramount.

Elvis would do six more Paramount pictures with Hal Wallis as producer. Of these, three would be shot in part, or almost entirely, at resort locations in Hawaii. With *Blue Hawaii* (1961) having been filmed on the island, the fourth Elvis Presley movie made at the Paramount Studios was *Girls! Girls! Girls!* in which Elvis played a jolly drifter named Ross Carpenter. Most of this Hal Wallis formula picture was made in Hawaii during April and May in 1962, but the interior scenes were shot at Paramount in May of that year.

Between January and March 1963, Hal Wallis sent a film crew to Acapulco to shoot "atmosphere" scenes, keeping Elvis and costar Ursula Andress in Los Angeles and using the Paramount lot to simulate Mexico for the filming of *Fun in Acapulco* (1969). Wallis also employed the Paramount Studios extensively for *Roustabout*, in which Elvis played a carnival worker named Charlie Rogers. Filmed between March 9 and April 20, 1964, *Roustabout* (1964) marked the first time that Paramount Sound Stages 12, 14, and 15 had been opened into one another to form a single massive space. The cast, which included Barbara Stanwyck and Leif Erickson as well as Elvis, was originally to have included Mae West, but she turned down a role in the project.

The penultimate Hal Wallis/Elvis Presley film, Paradise, *Hawaiian Style* (1966), was followed by their final collaboration, *Easy Come, Easy Go*, in which Elvis was cast as a singing naval officer. Six weeks of filming began on September 12, 1966, and included Elvis performing the memorable "Yoga Is as Yoga Does." It would be his twenty-third film, and his sixth and last to be shot at the Paramount Studios.

Paramount Studios is the only major studio from the classic era of filmmaking still located in the Hollywood district of Los Angeles (Hollywood is not an incorporated city). Paramount is also one of only

two major film studios in southern California that give tours to the public. (The other is Universal.) Guided walking tours at Paramount Studios are provided Monday through Friday, but are subject to the needs of the studio to use the facilities for ongoing productions. The tours are available on a first-come, first-served basis through walk-up admission at the Paramount Visitors Center, which is located at 860 North Gower Street.

To reach Paramount Studios from the Los Angeles International Airport, take Century Boulevard east to the San Diego Freeway (Interstate 405). Turn north on this freeway, and then east on the Santa Monica Freeway (Interstate 10) to the Western Avenue exit. Travel north on Western Avenue for just over seven miles to Melrose Avenue and turn left. After six blocks, the Paramount Studios will be on your right. The main gate is located at 5555 Melrose Avenue on the south side of the lot, but for the Visitor Center, continue on Melrose Avenue to North Gower Street, which marks the western perimeter of the lot. Turn north on North Gower Street to number 860.

Twentieth Century-Fox Studios 🎥

10201 West Pico Boulevard
Los Angeles, California 90064
(310) 369-1000

Though Elvis signed his first film contract with Paramount Pictures, he made his first film for Twentieth Century-Fox at their Los Angeles facility. After Elvis signed a three-picture, seven-year, $450,000 contract with Hal Wallis at Paramount in April 1956, the studio didn't have an appropriate script ready for him. But Twentieth Century-Fox did, so Elvis was loaned to them. The first Elvis Presley feature film, *Love Me Tender*, was filmed between August 23 and October 8, 1956, at the Twentieth Century-Fox Studios and it starred Elvis as a handsome young cowboy opposite Debra Paget. The western movie premiered in November 1956.

Twentieth Century-Fox would borrow Elvis from Paramount twice more, for two entries that were shot in rapid succession between September 1960 and January 1961. The first of these was another western, ultimately released as *Flaming Star*, which was based on the book *The Brothers of the Broken Lance*. Originally, the picture was supposed to have been shot in 1958 and star Marlon Brando and Frank Sinatra, but contract negotiations broke down. With Elvis cast as cowboy hero Pacer Burton, filming took place between August 16 and October 4 under the working titles *Black Star* and *Flaming Lance*. It was directed by Don Siegel (who had helmed the original *Invasion of the Body Snatchers* in 1956, and who would direct the original *Dirty Harry* with Clint

While he first signed with Paramount, Elvis was loaned to Twentieth Century-Fox Studios for his first feature film, Love Me Tender, which was filmed here between August 23 and October 8, 1956. He made two further films here at Twentieth Century-Fox, in September 1960 and January 1961. (Photo by the author, copyright Bill Yenne.)

Eastwood in 1971). Released as *Flaming Star* (1960), it was the second film that Elvis made after his discharge from the U.S. Army.

Elvis's next picture, *Wild in the Country*, his third and last for Twentieth Century-Fox, began filming on November 11, 1960, even before *Flaming Star* premiered in Los Angeles on December 20. Shooting was supposed to wrap by the end of the year, but continued to January 19, 1961. In the film, Elvis played a writer, opposite Hope Lange, who was cast as a psychologist. Starlet Tuesday Weld was also featured as a love interest and a foil for Hope Lange. *Wild in the Country* premiered in Memphis, Tennessee, on June 15, 1961.

While most of his Paramount and Metro-Goldwyn-Mayer movies were done at the studio, Twentieth Century-Fox chose to shoot only the interiors for their Elvis entries on their home lot, primarily at Sound Stage 14. As locations for the exterior filming on *Love Me Tender* and *Flaming Star*, Twentieth Century-Fox chose the Conejo Movie Ranch in Thousand Oaks, California, and several other ranches in the San Fernando Valley that were used for westerns during the early 1960s. All of these were later developed for tract housing. For *Wild in the Country*, Twentieth Century-Fox also used several sites in Napa County in northern California.

Unlike Paramount and Universal, which offer tours of their southern California studios to the general public, Twentieth Century-Fox no longer has public tours. The studio can be seen from the street, however, and one can, with a bit of imagination, picture Elvis coming to work here back in the exciting days of 1960.

To reach Twentieth Century-Fox Studios from the Los Angeles International Airport, take Century Boulevard east to the San Diego Freeway (Interstate 405). Turn north on this freeway, and then east on the Santa Monica Freeway (Interstate 10) to the Overland Avenue exit. Travel north on Overland Avenue for about a mile to Pico Boulevard and turn right. After about another mile, the Twentieth Century-Fox Studios will be on your left, and Rancho Park will be on your right.

Sony Pictures (formerly Metro-Goldwyn-Mayer) Studios 🎥

10202 West Washington Boulevard
Culver City, California 90232
(310) 244-3456

While Metro-Goldwyn-Mayer still exists as a company, the physical site of the former Metro-Goldwyn-Mayer Studios in Culver City was sold to the Sony Corporation and it has been Sony Pictures Studios since 1994. Sony in turn owns Columbia and TriStar. The former Metro-Goldwyn-Mayer Culver City facility is well-known for its soundstages ranging from 7,672 square feet to 42,296 square feet. It was on these stages that Elvis Presley filmed more of his movies than at any other site. In addition to thirteen Metro-Goldwyn-Mayer features that were produced here, there were four United Artists pictures and one National General release shot in part or in their entirety at the Metro-Goldwyn-Mayer Culver City studio.

United Artists, which would merge with Metro-Goldwyn-Mayer in 1981, was founded in 1919 by Charlie Chaplin, D. W. Griffith, and Mary Pickford as an "artist-owned" film company. United Artists never actually had a studio of its own, but relied on renting space from other studios on a per-project basis and doing a great deal more location shooting than the other movie companies.

Jailhouse Rock (1957), the first Elvis Presley movie for Metro-Goldwyn-Mayer, was filmed quickly at the Culver City studio between May 13 and June 14, 1957. It features Elvis as Vince Everett, a rock 'n' roll singer who is sent to jail for killing a man in a fight. *Jailhouse Rock* is generally regarded as Elvis's best non-documentary music movie, and the title song remains a genuine rock 'n' roll classic. The prison angle aside, Vince Everett is probably closer to what Elvis was really like at the time than any other character that he ever played in a motion picture. In the movie, Vince winds up going to Hollywood to make movies for Climax Studios. Metro-Goldwyn-Mayer cast its own Culver City studio as the Climax lot.

In 1961 Elvis also made two films for United Artists that were shot primarily on location with minimal use of the Metro-Goldwyn-Mayer Culver City studio for interior scenes. These were *Follow That Dream*, filmed in August 1961, and *Kid Galahad*, for which shooting wrapped in December 1961. Both pictures were released in 1962.

After the two entries for United Artists, Elvis made a series of "location" pictures for Metro-Goldwyn-Mayer that depended heavily on these locales, but which used the Culver City studio for many interior scenes.

It Happened at the World's Fair (1963) was based on—and largely filmed at—the 1962 Seattle World's Fair, but the first days of shooting were between August 27 and September 5 at Culver City. *Kissin' Cousins* (1964)—which featured Elvis in dual roles—used California's Big Bear Lake as a backdrop, but most of the incredibly fast, sixteen-day shoot took place on a Culver City soundstage. The producer of the project was Sam Katzman, who was then known in Hollywood as "the King of the Quickies." The haste apparently didn't matter, as *Kissin' Cousins* did better at the box office than many of the other Metro-Goldwyn-Mayer Elvis features.

Perhaps the most important of all the Elvis "location" movies for MGM was *Viva Las Vegas* (1964), made in the summer of 1963, but even with this film, many interiors were shot at Culver City. *Girl Happy* (1965), filmed the following summer, used Fort Lauderdale, Florida, exteriors. These were less memorable than those of Las Vegas, and, again, the interiors were shot by Metro-Goldwyn-Mayer at the Culver City facility.

By the late 1960s, Metro-Goldwyn-Mayer was in financial difficulties, and was taking drastic steps to control costs. This meant that the studio would utilize the lot that it already owned rather than use locations, where travel expenses for the crews would drive up costs. After its series of location movies with Elvis, Metro-Goldwyn-Mayer produced three films with Elvis between 1965 and 1967 that were made entirely at its Culver City studio, with minimal shooting on two of them in the Los Angeles area. In addition, United Artists produced two movies that were filmed almost entirely at the Metro-Goldwyn-Mayer Culver City lot.

The first of the Metro-Goldwyn-Mayer features during this period was *Harum Scarum* (1965), with Elvis as Johnny Tyrone in a Rudolph Valentino-style role and a "movie within a movie" plot. *Harum Scarum* began shooting on March 15, 1965, at Culver City. No sooner had he finished it than he began making *Frankie and Johnny* (1966) for United Artists on May 25. The remake of a 1936 Republic feature, *Frankie and Johnny* saw Elvis cast as Johnny, a riverboat gambler, opposite Donna Douglas as Frankie, a saloon singer.

Between February 1966—a few weeks after *Frankie and Johnny* premiered in Baton Rouge, Louisiana—and April 1966, Metro-Goldwyn-Mayer filmed *Spinout*, Elvis's twenty-second picture. The event was significant because the Metro-Goldwyn-Mayer publicity department used the November 23, 1966, release of *Spinout* as the keystone of a massive publicity blitz to celebrate Elvis's tenth anniversary in the film world. Paramount, which had released his previous feature, *Paradise, Hawaiian Style*, in July, no doubt also benefited from the MGM publicity effort. *Spinout*, starring Elvis as race-car driver Mike McCoy, was made largely at the Metro-Goldwyn-Mayer Culver City studio, but even the 42,296-square-foot soundstage was too small for the car-racing scenes. MGM

went off-site but stayed within Los Angeles County, using such venues as Dodger Stadium, twenty-two miles to the east.

Filmed entirely at the Culver City studio between June and September 1966—but not released until April 1967—*Double Trouble* spotlighted Elvis as lounge singer Guy Lambert. The settings were Belgium and England, but since the script called mostly for interiors, it was an easy soundstage shoot.

Clambake, which was done at the Metro-Goldwyn-Mayer Culver City studio by United Artists in April 1967, utilized minimal Los Angeles-area exteriors and actual scenes of a Miami, Florida, power-boat race to make it seem like a location film. A few scenes filmed in Miami that appear to feature Elvis were actually filmed with a double. *Clambake* starred Elvis as Scott Hayward in an aquatic version of his role in *Spinout*. *Clambake* was the third and last film that Elvis made in the mid-1960s and had Shelley Fabares as one of his most memorable costars. The film was also the last Elvis Presley feature made for United Artists.

During the last seventeen months of his feature film career—between October 18, 1967, and May 2, 1969—Elvis made an incredible six pictures. Four of these were for Metro-Goldwyn-Mayer, one was a National General release filmed at Metro-Goldwyn-Mayer, and the last one was for Universal. Two of the Metro-Goldwyn-Mayer features were filmed in part at Metro-Goldwyn-Mayer's Culver City studio, and two were produced in their entirety at the Culver City studio. Metro-Goldwyn-Mayer's *Speedway* (1968), which capitalized on the fast-car theme of *Spinout*, began filming in June 1967 at the Charlotte Speedway in Charlotte, North Carolina, but after capturing a ten-camera car race, the crew was back to Culver City for interiors. *Speedway* is notable for being the only film that Elvis made with Nancy Sinatra, who was Elvis's official greeter when he returned to the United States in 1960 upon his discharge from the army. Nancy, the elder daughter of legendary crooner Frank Sinatra, had a brief stay as a pop singer in the 1960s, and *Speedway* was seen as a vehicle for her career.

Metro-Goldwyn-Mayer's *Stay Away, Joe*, filmed in October and November 1967, was shot mostly on location in Arizona, as was National General's *Charro!*, filmed in July and August 1968. However, both would utilize the Metro-Goldwyn-Mayer Culver City facility for interior shots.

Live a Little, Love a Little (1968), filmed by Metro-Goldwyn-Mayer in July 1968, had one scene shot at the newspaper offices of the *Hollywood Citizen-News*, but otherwise it was made entirely at Culver City. It featured Elvis as pinup photographer Greg Nolan, opposite a number of young women chosen for their looks, including models Michelle Carey and Ursula Menzell, as well as beauty-contest winners Susan Henning and Celeste Yarnell. Trivia buffs will recall that this was the first film in which Elvis was seen sporting the long sideburns that would remain his trademark for the rest of his life.

The penultimate Elvis Presley feature film, and his last non-documentary for Metro-Goldwyn-Mayer, was *The Trouble with Girls (And How to Get Into It)* (1969). It was set in Radford Center, Iowa in 1927, but made entirely at the Culver City lot between October 28 and December 16, 1968. It starred Elvis as sweet-talking Walter Hale, a role that was originally intended for Dick Van Dyke.

Another Elvis film produced and distributed by Metro-Goldwyn-Mayer was *Elvis on Tour* (1972). A concert documentary rather than a feature film, it was shot entirely during his fifteen-city concert tour in April 1972, a tour that began in Buffalo, New York, and ended in Albuquerque, New Mexico.

As noted above, the former Metro-Goldwyn-Mayer lot in Culver City is now owned by Sony Pictures. Like Twentieth Century-Fox, and unlike Paramount and Universal, the Sony Pictures Studios offer no tours for the general public. They do, however, host an open house on three consecutive Saturdays each spring, but these are open only to residents of Culver City. As with Twentieth Century-Fox, the studios can be seen from the street, and non–Culver City residents can view the exterior of the great soundstages where such milestone films as *Kissin' Cousins*, *Double Trouble*, *Girl Happy*, and *The Trouble with Girls* came to life.

To reach the Sony Pictures Studios from the Los Angeles International Airport, take Century Boulevard east to the San Diego Freeway (Interstate 405). Turn north on this freeway, and then take the Venice Boulevard exit. Travel east on Venice Boulevard to Overland Avenue and turn right. In one block, you will be at the northwest corner of the Sony Pictures Studios lot.

Universal Studios Hollywood 🎥

100 Universal Center Drive
Universal City, California 91608
(818) 622-3771
(818) 622-3801 (studio tour information)

Excepting the documentaries, the last Elvis Presley film was *Change of Habit* (1969), his only project for Universal. It was filmed mostly on Stage D at Universal Studios between March and May 1969, with minimal location shooting, using downtown Los Angeles to simulate New York City. *Change of Habit* starred Elvis as Dr. John Carpenter opposite Mary Tyler Moore as Sister Michelle Gallagher. Ed Asner, who played a prominent role in Mary Tyler Moore's subsequent television series, also was featured as a police lieutenant.

When Elvis left the *Change of Habit* set on May 2, 1969, the door closed forever on the thirty-one-film Hollywood career of Elvis Presley.

Most people in Hollywood assumed he would be back. However, it was not to be. Over the next eight years, a number of movie projects were suggested to Elvis through his manager Colonel Parker, but *Change of Habit* proved to be the end of an era.

Universal Studios Hollywood are actually located in Universal City, about eight miles north of the Los Angeles neighborhood known as Hollywood. Today this location is home to the world's largest film-and-television studio, having evolved from the studio started in the early twentieth century by Bavarian immigrant Carl Laemmle, who bought a chicken farm in the Hollywood Hills and began building stages and movie sets. Just in case his film venture didn't work out, Laemmle kept the chickens and continued to sell eggs. On March 15, 1915, Universal City became the first incorporated city to consist entirely of a film studio, and during its first year more than 250 short, silent films were shot at Universal. Success came quickly and, by the 1920s, the studio was releasing such prestige movies as *The Hunchback of Notre Dame* and *The Phantom of the Opera.*

Meanwhile, Universal had begun its practice of allowing the public to watch movies being made. Visitors paid twenty-five cents for admission and a box lunch. In recent years, such films as *Jaws* (1975), *E.T.: The Extra-terrestrial* (1982), *Back to the Future* (1985), *Fried Green Tomatoes* (1991), and *Backdraft* (1991) have been filmed on Universal's 422-acre facility, and visitor tours have evolved into a full-fledged theme park that is one of southern California's top tourist attractions. Tours are offered 363 days a year and there are numerous tourist facilities, from shopping to dining, in addition to the studio tours and the amusement-park rides.

To drive to Universal Studios from the Los Angeles International Airport, take Century Boulevard east to the San Diego Freeway (Interstate 405). Turn north on this freeway, and then east on the Santa Monica Freeway (Interstate 10) to the Harbor Freeway (Interstate 110/California Route 110). Turn north on the Harbor Freeway to the Hollywood Freeway (U.S. Highway 101). Take the Hollywood Freeway north to the San Fernando Valley, take the Lankershim Boulevard exit, and follow the many signs. Universal Studios will be on your right.

Other Los Angeles County Elvis Sites

In addition to the places where Elvis Presley lived and the studios where he made his motion pictures, there are a number of other sites where fans can go to evoke his memory.

The Elvis Presley Star

Hollywood Walk of Fame
In the 7000 block of Hollywood Boulevard, near La Brea Avenue
Los Angeles, California 90028

When fans of Hollywood stars make their pilgrimages to that Los Angeles district known as Hollywood (Hollywood is not an incorporated city), one of their first stops is often at the Hollywood Walk of Fame. The Walk of Fame is actually the sidewalks (on both sides of the street) of Hollywood Boulevard between Orange Drive and Vine Street, as well as the sidewalks on the west side of Vine Street immediately adjacent to Hollywood Boulevard. On these sidewalks there are more than 1,800 two-foot, brass-trimmed stars imbedded in the sidewalk that contain the names of actors, producers, directors, and singers who have made their mark in the entertainment industry in Hollywood and beyond. For many years, Elvis Presley's star was located in the 6700 block of Hollywood Boulevard, near Highland Avenue, but it has been relocated to the 7000 block of Hollywood Boulevard near that of the Beatles.

To reach the Walk of Fame from the Los Angeles International Airport, take Century Boulevard east to the San Diego Freeway (Interstate 405). Turn north on this freeway, and then east on the Santa Monica Freeway (Interstate 10) to the Harbor Freeway (Interstate 110/California Route 110). Turn north on the Harbor Freeway to the Hollywood Freeway (U.S. Highway 101). Take the Hollywood Freeway north to the Hollywood Boulevard exit. Drive west on Hollywood Boulevard to La Brea Avenue.

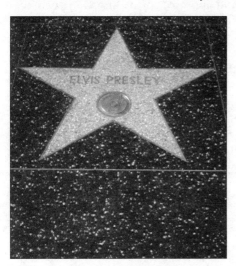

Elvis's star on the Hollywood Walk of Fame is a favorite shrine visited by Elvis fans who come to Los Angeles. For many years it was located near Highland Avenue, but it has been moved nearer to the corner of Hollywood Boulevard and La Brea Avenue. (Photo by the author, copyright Bill Yenne.)

CBS Television City 🎥

7800 Beverly Boulevard
Los Angeles, California 90036
(323) 852-2345 (main switchboard)
(323) 852-2000 (Guest Relations)

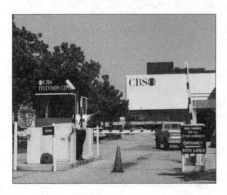

Elvis's first appearance on The Ed Sullivan Show *on September 9, 1956, took place not in New York City, but in Los Angeles. Because he was in California working on his first film, CBS arranged to do a remote feed from Studio 33 at CBS Television City on Beverly Boulevard. (Photo by the author, copyright Bill Yenne.)*

While Elvis was in Los Angeles making his first film, *Love Me Tender*, for Twentieth Century-Fox, he was scheduled to appear on CBS-TV's *The Ed Sullivan Show* on September 9, 1956. To facilitate this without his having to travel to New York City, CBS arranged for him to perform in Studio 33 at Television City, and his segment was fed live into *The Ed Sullivan Show* originating in New York. During the 1950s and 1960s, CBS Television City was used primarily for variety shows, and it was here that Judy Garland appeared in the first CBS color special. Today the facility is used for the taping of daytime television, including *The Price Is Right* and soap operas such as *The Young and the Restless*. Tours of the CBS Television City facility are not currently available to the general public, but that does not preclude their being added in the future, so call ahead.

To reach CBS Television City from the Los Angeles International Airport, leave the airport driving east on Century Boulevard. Take the San Diego Freeway (Interstate 405) northbound to the Santa Monica Boulevard exit. Drive east on Santa Monica Boulevard to Beverly Boulevard and turn right for four miles. CBS Television City will be on your right at Fairfax Avenue.

(Former site of the) Pan Pacific Auditorium 🎵

7600 Beverly Boulevard
Los Angeles, California 90036

Amazingly, for all the time that he spent in southern California, Elvis made only two live concert appearances within the Los Angeles city limits. On June 8, 1956, he played the Shrine Auditorium, and on October 28–29, 1957, he played two shows at the old art-deco Pan Pacific Auditorium. The building burned down during the 1980s, and, at present, the site remains a vast vacant lot. While there is nothing left to see, the site is worth noting because of its historical significance. It is two blocks west of CBS Television City.

To reach the site of the Pan Pacific Auditorium from the Los Angeles International Airport, leave the airport driving east on Century Boulevard. Take the San Diego Freeway (Interstate 405) northbound to the Santa Monica Boulevard exit. Drive east on Santa Monica Boulevard to Beverly Boulevard and turn right for four miles. The site of the Pan Pacific Auditorium is several blocks east of CBS Television City on the south side of Beverly Boulevard.

Studio 56 *(formerly Radio Recorders)* 🎵

7000 Santa Monica Boulevard
Los Angeles, California 90038
(323) 464-7747

For many years, and especially during the 1950s, Radio Recorders was one of the top music recording studios in Los Angeles. Charlie Parker recorded here, as did Nelson Riddle, André Previn, Spike Jones and the City Slickers, Jack Benny, Connie Francis, and Stan Freeberg. Also many episodes of *The CBS Mystery Theater* were recorded here, and the Radio Recorders music and sound-effects libraries were legendary. Elvis recorded all of the songs for the soundtracks for *Love Me Tender, Loving You, Jailhouse*

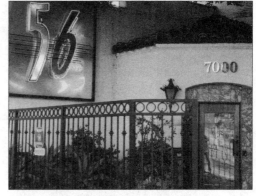

In 1957, when Elvis first recorded in Los Angeles, the top studio in town was Radio Recorders on Santa Monica Boulevard. Elvis recorded "Jailhouse Rock" and most of his movie soundtracks here. The facility is now Studio 56. (Photo by the author, copyright Bill Yenne.)

Rock, and *King Creole* here, including the song "Jailhouse Rock," which was recorded on April 30, 1957.

In 1963 the studio was acquired by Educational, Musical, and Cultural Recordings Corporation (EMC), which operated at 7000 Santa Monica Boulevard until 1977.

To reach the site of Radio Recorders from the Los Angeles International Airport, leave the airport driving east on Century Boulevard. Take the San Diego Freeway (Interstate 405) northbound to the Santa Monica Boulevard exit. Drive east on Santa Monica Boulevard for fifteen miles. The nearest major cross street is La Brea Boulevard.

Dodger Stadium 🎥

1000 Elysian Park Avenue
Los Angeles, California 90012
(323) 224-1500

The home of the Los Angeles Dodgers, of Major League Baseball's National League, Dodger Stadium was the site of the filming for many of the car-race scenes in the 1966 movie *Spinout*, which starred Elvis as race-car driver Mike McCoy. Shooting at Dodger Stadium took place in March 1966, four years after the stadium was opened, and involved twenty-eight actors with speaking parts, two hundred extras, and sixty-two cars, including twelve custom race cars. The stadium itself has a seating capacity of 56,000.

To reach Dodger Stadium from the Los Angeles International Airport, take Century Boulevard east to the San Diego Freeway (Interstate 405). Turn north on this freeway, and then east on the Santa Monica Freeway (Interstate 10) to the Harbor Freeway (Interstate 110/California Route 110). Turn north on the Harbor Freeway and watch for the signs directing you to Dodger Stadium.

NBC Studios 🎥

3000 West Alameda Avenue
Burbank, California 91523
(818) 840-3537 (tickets)
(818) 840-4404 (scheduling)

By 1968 Elvis Presley had been absent from the concert circuit for more than a decade, and he had not appeared before a live audience for more than seven years. It was obviously an event of immense importance when it was announced that he would tape a television special for

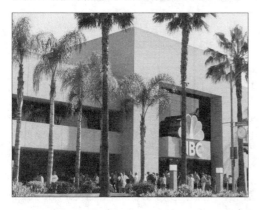

The legendary 1968 Comeback Special—Elvis's first appearance before a live audience for most of the 1960s — took place at NBC Studios in Burbank. Today, fans line up here to see Jay Leno. (Photo by the author, copyright Bill Yenne.)

broadcast on NBC and that portions of the show would be before a live audience.

The venue chosen was Studio 4 at the NBC complex in Burbank. After three days of rehearsals, Elvis recorded four complete shows, at 6:00 P.M. and 8:00 P.M. on June 29 and June 30, 1968. There were production numbers with the Claude Thompson Dancers in which Elvis lip-synched to tracks that he prerecorded on June 21 and June 22, but the most memorable portion of the show was the songs that he performed live with backup musicians Scotty Moore, D. J. Fontana, and Charlie Hodge.

The final television special was edited from the four performances and was aired on December 3, 1968, under the title *Elvis*, although it is universally remembered as *The Comeback Special* or the *Elvis Comeback Special* because of the way that it relaunched Elvis's singing career.

Today the NBC Studios in Burbank are used by NBC News and for much of NBC's live television programs, especially *The Tonight Show with Jay Leno*, which is the biggest draw on the studio tour.

To reach the NBC Studios from the Los Angeles International Airport, take Century Boulevard east to the San Diego Freeway (Interstate 405). Turn north on this freeway, and then east on the Santa Monica Freeway (Interstate 10) to the Harbor Freeway (Interstate 110/California Route 110). Turn north on the Harbor Freeway to the Hollywood Freeway (U.S. Highway 101). Take the Hollywood Freeway north to the San Fernando Valley and turn east on the Ventura Freeway (California Route 134). (This intersection is a little tricky, in that you have to exit the Hollywood Freeway at Vineland Avenue before the two freeways cross. You continue north on Vineland for a few blocks to Riverside Drive, where you turn right. The entrance to the Ventura Freeway will be the very next left turn off Riverside. Watch for the signs for the freeway.) Continue on the Ventura Freeway, and take the Olive Avenue exit. The NBC Studios will be visible on your right as you exit on Olive Avenue, and West Alameda Avenue is the first major intersection you will encounter.

(Former site of) Nudie's Rodeo Tailors

5015 North Lankershim Boulevard
North Hollywood, California 91601

Located on this site in North Hollywood until 1995, Nudie's Rodeo Tailors held a special place in the early history of Elvis Presley as a performer, as it was here that Elvis purchased his legendary $10,000 gold lamé tuxedo. Rodeo Tailors was founded by a New Yorker named Nudie Cohen, who got his start—and earned his nickname—designing rhinestone costumes for women working in strip clubs. About 1947, he made the transition to tailoring outlandish suits for rodeo stars, singers—earning a special niche with country-and-western performers—and movie stars. Among the notables who wore Nudie-tailored suits were John Wayne and Roy Rogers, as well as the legendary Hank Williams. By 1957 his reputation was well-known to many in the entertainment industry, including Colonel Tom Parker, who commissioned the famous tuxedo for Elvis. Reportedly, Elvis did not like the suit because it was too heavy and too hot to wear on stage, but he wore it for publicity photographs and is seen wearing it on his 1959 "greatest hits" album, *50,000,000 Elvis Fans Can't Be Wrong*. The gold suit was a perfect counterpoint to the gold records on the album.

The publicity from the Elvis tuxedo gave Nudie a popularity that kept him busy for the rest of his life. Rock stars streamed in, all wanting suits made by the man who had clothed Elvis, and rock stars had money. It didn't hurt that Nudie always kept a replica of the Elvis tuxedo on display at his North Hollywood shop. Through the years, Nudie tailored suits for Elton John, John Lennon, Eric Clapton, George Harrison, and Ricky Nelson. He, too, became a Hollywood celebrity—a man hard to miss in his own rhinestone suit or driving his silver dollar-covered convertible with the steer horns on the prow. When Nudie died in May 1984, his wife, Bobbie, kept the business going for a time, but Nudie's finally closed forever in 1995. All that is left is the original building, presently a discount furniture store.

To visit the former site of Nudie's Rodeo Tailors, from the Los Angeles International Airport take Century Boulevard east to the San Diego Freeway (Interstate 405). Turn north on this freeway, and then east on the Santa Monica Freeway (Interstate 10) to the Harbor Freeway (Interstate 110/California Route 110). Turn north on the Harbor Freeway to the Hollywood Freeway (U.S. Highway 101). Take the Hollywood Freeway north to the San Fernando Valley, to the North Lankershim Boulevard exit. Turn right onto Lankershim and continue driving north on Lankershim to number 5015 on your left, north of Camarillo Street, which crosses Lankershim.

Mayfield Senior School 🎥

500 Bellefontaine Street
Pasadena, California 91105
(626) 799-9121

In Universal's *Change of Habit* (1969)—which was a fictionalized account of the work of Sister Mary Olivia Gibson in Syracuse, New York—Dr. John Carpenter (Elvis Presley) and Sister Michelle Gallagher (Mary Tyler Moore) are seen working with autistic and disabled children. Because an actual school was needed, director William Graham used Pasadena's Mayfield Senior School for location shooting during March and April of 1969.

This was the first use of Mayfield Senior School as a movie set, but in the 1990s it was rediscovered and used for shooting an impressive list of feature films. These included *The Cutting Edge* (1992), *Sneakers* (1992), *The Shadow* (1994), *Devil in a Blue Dress* (1995), *Matilda* (1996), *The Nutty Professor* (1996), and *The Lost World: Jurassic Park* (1997). It was also utilized as a location for the 1991 made-for-TV movie *Murder 101*.

Founded in 1931, Mayfield Senior School is a girls' arts- and religious-studies college-preparatory day-school affiliated with the Roman Catholic Church. There are roughly 265 students on an eight-acre campus.

To reach Mayfield Senior School from the Los Angeles International Airport, take Century Boulevard east to the San Diego Freeway (Interstate 405). Turn north on this freeway, and then east on the Santa Monica Freeway (Interstate 10), driving past downtown Los Angeles on your left to the Golden State Freeway (Interstate 5). Turn north onto the Golden State Freeway, driving past Dodger Stadium and Griffith Park to the Ventura Freeway (California Route 134). Exit onto the Ventura Freeway, going east through Glendale to Pasadena. Exit the Ventura Freeway at Orange Grove Boulevard in Pasadena and drive south to Bellefontaine Street.

Chapter 12

California beyond Los Angeles County

E lvis called California his second home from 1960 until his divorce from Priscilla Presley in 1973. During that time, he maintained two homes outside Los Angeles County and made one movie at a location north of Los Angeles County. The two homes were in Palm Springs, which is one hundred miles east of central Los Angeles on Interstate 10. A popular wintering spot for celebrities in the entertainment industry, Palm Springs boasts many homes of the rich and famous, surrounded by acres and acres of lawns and golf courses green with vegetation that couldn't survive in the harsh desert climate without extensive irrigation efforts. Elvis's visits to other parts of the state were few, even on his various concert tours in the 1950s and 1970s.

Elvis lived in Memphis and traveled to many locations in Tennessee beyond Memphis. In contrast, he maintained a home in Los Angeles County for nearly a decade but made very few forays into other parts of the Golden State, especially those north of the Los Angeles County line. Even when he was involved in his series of exhaustive tours in the 1970s, he performed few California playdates. Interestingly, he played only four concerts in San Francisco, a city that revolutionized rock music in the 1960s and continued to be an important center during the 1970s. One can only imagine what might have happened if Elvis had decided to make an appearance at the Fillmore Auditorium at the time of his *1968 Comeback Special.*

California Elvis Sites and Movie Locations

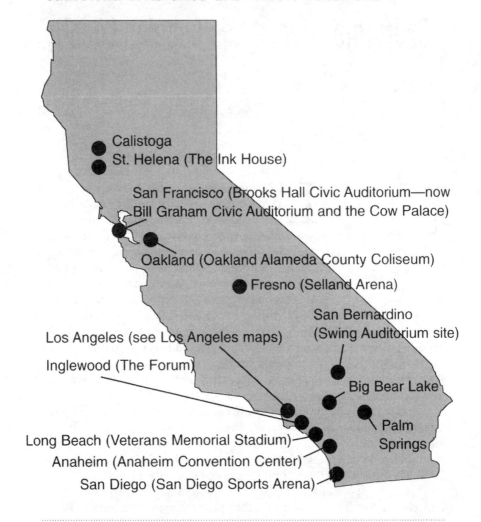

Calistoga
St. Helena (The Ink House)

San Francisco (Brooks Hall Civic Auditorium—now Bill Graham Civic Auditorium and the Cow Palace)

Oakland (Oakland Alameda County Coliseum)

Fresno (Selland Arena)

San Bernardino (Swing Auditorium site)

Los Angeles (see Los Angeles maps)

Inglewood (The Forum)

Big Bear Lake

Palm Springs

Long Beach (Veterans Memorial Stadium)
Anaheim (Anaheim Convention Center)
San Diego (San Diego Sports Arena)

The Palm Springs House that Elvis Built 🏠

845 Chino Canyon Road West
Palm Springs, California 92262

Of all the homes in which Elvis lived—from Tennessee to Texas to California—there was only one house that Elvis built. He did not, of course, build it with his own hands, but he did have it custom-built for him, and he approved the design and the plans. It is a fifteen-room, single-story stucco structure built in the style known in California real-estate parlance as "Spanish." It was constructed in 1965 on two fenced acres at a

cost of $85,000. It had recording facilities on the premises, which Elvis used to record the songs "Are You Sincere?" and "I Miss You." Elvis and Priscilla were staying at this house in 1967 at the time Elvis decided they should fly to Las Vegas to be married.

When Elvis died in 1977, the house was inherited by his daughter, Lisa Marie, but it was sold two years later to singer Frankie Valli for $385,000.

Please note that this is a private home and not open to the public. View it from the street and please do not disturb the occupants, as this behavior reflects badly on the fans who come to remember respectfully the life and times of Elvis Presley.

The Palm Springs House that Elvis Leased 🏠

1350 Ladera Circle
Palm Springs, California 92262

In April 1970, while he still owned the Chino Canyon home, Elvis briefly leased this house. Please note that this is a private home and not open to the public. View it from the street and please do not disturb the occupants, as this behavior reflects badly on the fans who come to remember respectfully the life and times of Elvis Presley.

Colonel Parker's Palm Springs Home 🏠

1166 Vista Vespero Drive North
Palm Springs, California 92262

When Elvis went to Hollywood to spend the 1960s making movies, of course Colonel Tom Parker went, too. As the highly compensated manager of one of the hottest superstars of the day, the Colonel moved in much more posh circles than he had when he was taking his dancing chickens to carnival sideshows on the back roads of the South two decades before. Befitting his new station in life, Colonel Parker did what most rich Hollywood celebrities did when they reached the comfortable point in their lives when they didn't actually have to work every day: he bought a home in Palm Springs.

Though the Colonel died in 1997 at the age of eighty-seven, his Palm Springs house is still there and intact.

Please note that this is a private home and not open to the public. View it from the street and please do not disturb the occupants, as this

behavior reflects badly on the fans who come to remember the life and times of the man born Andreas van Kuijk, who became an honorary colonel and the famed manager to the King of Rock and Roll.

Big Bear Lake 🎥

Big Bear Lake Tourist Bureau
P.O. Box 2817
Big Bear Lake, California 92315
(909) 866-5753 (Big Bear Lake Tourist Bureau)
(909) 878-3040 (City of Big Bear Lake Film Office)

Located in the San Bernardino National Forest, less than two hours from the Sony (formerly Metro-Goldwyn-Mayer) Culver City studio, Big Bear Lake has been the site of numerous Hollywood productions, including the location filming for Elvis's *Kissin' Cousins* (1964). Curiously, Big Bear Lake was chosen to replicate Elvis's home state of Tennessee, a state in which no location filming for an Elvis feature film ever took place.

The nearby Big Bear Lake location has always provided more than proximity to Hollywood. It affords some of the most beautiful mountain scenery in southern California, with alpine lakes, rugged wilderness areas, high desert terrain, and mountain vistas. Indeed, the terrain is a good deal more rugged than much of Tennessee. So important is the motion picture industry to Big Bear Lake that there now is a Big Bear Lake Film Office to provide free location scouting assistance; liaison services with the community and various municipal and governmental agencies; information on lodging, restaurants, support services and local crews; maps and weather information; production resource guides; and photos from a location library.

Known as "the King of the Quickies," producer Sam Katzman and director Gene Nelson brought the *Kissin' Cousins* cast and crew to Big Bear Lake in October 1963 for the beginning of what would be just sixteen days of shooting. In fact, most of the filming would take place back on the Culver City lot, so Elvis saw little of the San Bernardino mountain country. Elvis played both Josh and Jodie Tatum—a pair of cousins—opposite Pam Austin as Selena Tatum, and Yvonne Craig as Azalea Tatum. Ronald Reagan's daughter Maureen also had a small role in the movie.

To reach Big Bear Lake from Los Angeles, take Interstate 10 (the San Bernardino Freeway) east from downtown Los Angeles to the town of San Bernardino (about sixty miles). Stay on Interstate 10 five miles past the Interstate 215 freeway until you come to California Route 30, "the Highland 30." Take Route 30 to California Route 330 (the Running Springs Freeway). Take the 330 Freeway north to the town of Running

Springs. In the town of Running Springs, Route 330 will end and you will be on Route 18, which leads into Big Bear Lake.

The Ink House 🎥

1575 St. Helena Highway
St. Helena, California 94574
(707) 963-3890

For Elvis's third film after his discharge from the army, producer Jerry Wald and director Philip Dunne chose what would be the only northern California location for an Elvis film. The title for this 1961 Twentieth Century-Fox feature was *Wild in the Country*. However, the "country" chosen was the Napa County wine country, probably the least "wild" and most urbane nonurban area in the Golden State. Many exteriors were shot in Napa County, including the streets of the village of Calistoga, but the principal location was the Ink House in St. Helena.

Now a popular bed-and-breakfast establishment, the Ink House was built in 1884 by pioneer businessman Theron H. Ink, at the center of his Helios Ranch. Today it still boasts two first-floor parlors, with a concert grand piano, a fireplace, a circa-1870 pump organ, crystal chandeliers, and original stained glass, all of which Elvis saw when he was here and which can be seen in *Wild in the Country*. He probably even tickled the ivories of the piano. At the top of the house, high above the treetops, is a glass-enclosed observatory perched fifty feet above the valley floor.

Filming in Napa County began on November 11, 1960, with Elvis cast as Glenn Tyler opposite Hope Lange as Irene Sperry and Tuesday Weld as Noreen. Location shooting wrapped before Christmas, and the crew moved back to Los Angeles for interiors that would be accomplished on the Twentieth Century-Fox home lot in January 1961.

To reach Napa County from San Francisco, cross the Golden Gate Bridge on U.S. Highway 101 and drive north twenty miles to California Route 37. Drive east for eight miles to California Route 121. Turn north and drive twenty-five miles to California Route 29. Take Route 29 north through the city of Napa. St. Helena is about twenty miles north of Napa, and Calistoga is about ten miles north of St. Helena on Route 29.

Elvis Concert Venues in California ♪

Within this state the venues of Elvis concerts are arranged in chronological order by the date of the first concert given in a particular place, then followed, chronologically, by the rest of the concerts given in that place. This is done to give readers the cities in the order that Elvis first experienced them.

TV Broadcast from the USS *Hancock*
Naval Station San Diego
San Diego, California 92136
(619) 556-1011
(April 3, 1956)

San Diego Sports Arena
3500 Sports Arena Boulevard
San Diego, California 92110
(619) 244-4176
(November 15, 1970; April 26, 1973; April 24, 1976)
(Elvis also performed at the old San Diego Arena on April 4–5, 1956, and June 6, 1956.)

★

Auditorium Arena
Oakland, California
(This venue was not found to be listed under this name, nor was it found to be listed under another name.)
(June 3, 1956; October 27, 1957)

Oakland Alameda County Coliseum
7000 Coliseum Way
Oakland, California 94621
(510) 569-2121
(November 10, 1970; November 11, 1972)

★

Municipal Auditorium
Long Beach, California
(This venue was not found to be listed under this name, nor was it found to be listed under another name.)
(June 7, 1956)

Long Beach Veterans Memorial Stadium
5000 Lew Davis Street
Long Beach, California 90805
(562) 938-4018
(November 14–15, 1972; April 25, 1976)

★

Shrine Auditorium
649 West Jefferson Boulevard
Los Angeles, California 90007
(213) 748-5116
(June 8, 1956)

CBS Television City
(The Ed Sullivan Show)
7800 Beverly Boulevard
Los Angeles, California 90036
(323) 852-2345 (main switchboard)
(323) 852-2000 (Guest Relations)
(September 9, 1956)

Pan Pacific Auditorium
7600 Beverly Boulevard
Los Angeles, California 90036
(The building was later destroyed by fire.)
(October 28–29, 1957)

★

Brooks Hall Civic Auditorium
(now Bill Graham Civic
Auditorium)
99 Grove Street
San Francisco, California 94102
(415) 974-4060
(October 26, 1957)

Cow Palace
Geneva Avenue at Santos
San Francisco, California 94134
(415) 469-6065
(November 13, 1970; November
28–29, 1976)

★

The Forum
3900 West Manchester Boulevard
Inglewood, California 90305
(310) 673-1300
(November 14, 1970; May 11,
1974)

★

Swing Auditorium
689 South E Street
San Bernardino, California
92408
(The auditorium was torn down
after an airplane crashed into it
on September 11, 1981, damag-
ing it beyond repair.)
(November 12–13, 1972; May
10, 1974; May 13, 1974)

★

Anaheim Convention Center
800 West Katella Avenue
Anaheim, California 92802
(714) 999-8911
(April 23–24, 1973; November
30, 1976)

★

Selland Arena
Fresno, California 93706
(April 25, 1973; May 12, 1974)

Chapter 13

The Northwest

Back when Elvis was growing up in the 1930s and 1940s, in the days before jetliners and instantaneous electronic communication, the Northwest was far from the South, both literally and figuratively. When Elvis, Scotty Moore, and Bill Black were playing the small towns of Louisiana, Arkansas, and Texas in 1955, they had probably never heard of Pasco, Kennewick, or Bend. Two years later, they made one foray into the Northwest, reaching as far inland as Spokane, Washington, but this would be the only time that Elvis would get a sense of the lay of the land outside the cities. The largest block of time that Elvis would spend in the Northwest came in 1962, when he was in Seattle, Washington, filming *It Happened at the World's Fair* (1963).

By the time that Elvis took his show on the road again in the 1970s, only cities like Seattle and Portland, Oregon, had the large-capacity coliseums that could hold his audiences, although he did make one stopover at the University of Oregon in Eugene. In this chapter, the concert venues for each state are grouped together, with the entries being in chronological order by the date of the first concert given in a particular locale.

Seattle Center 🎥

(site of the 1962 World's Fair)
Seattle Center
305 Harrison Street
Seattle, Washington 98109
(206) 684-7202
(206) 684-8582 (recorded events-line)

The early 1960s were an era of excitement and promise, with a view of the future that saw no limit to the wonders of technology. Against this

backdrop, the United States hosted its last two major fairs to actually be called world's fairs. One would open in New York City in 1964, after the one hosted by Seattle in 1962. The Washington event—known officially as "Century 21"—was a defining moment in Seattle's image of itself, and it attracted a great deal of notice from around the country. It even caught the eye of producer Ted Richmond at Metro-Goldwyn-Mayer, who decided to use it as the centerpiece of an Elvis Presley movie. The nation's attention was on Seattle in the summer of 1962, and when the public looked, MGM wanted Elvis in their field of view.

Along with the Southeast, Las Vegas, and Hawaii, Seattle was one of just a handful of settings for Elvis films where the location was really a key part of the story. Filming for *It Happened at the World's Fair* began on August 27, 1962, at Metro-Goldwyn-Mayer's Culver City, California, studio, and location work commenced in Seattle on September 5. Most of the shooting took place on the seventy-acre fairgrounds near downtown Seattle. Elvis starred as private pilot Mike Edwards, opposite former country singer Joan O'Brien as Dianne Warren. Among the supporting cast was Asian-American child actress Vicky Tiu, who received good reviews but no career boost; Yvonne Craig, whom Elvis dated and who, later, was television's Batgirl on the mid-1960s *Batman* series; and child actor Kurt Russell, who went on to a bigger and better film career than Elvis would ever enjoy.

Ted Richmond and director Norman Taurog seemed to have gone overboard in showcasing the Seattle fairgrounds. Location shooting for *It Happened at the World's Fair* began on September 5 with scenes of Elvis and Vicky Tiu on the then-futuristic monorail. The first full-scale commercial monorail in the United States, Seattle's was built to provide a link between the fairgrounds and downtown, a mile away. It was sold to the city in 1965 for $600,000. With a top speed of fifty miles per hour, it is still the fastest full-sized monorail system operating in the United States.

Other scenes for the movie took place in the "World of Tomorrow" section, especially the United States Science Pavilion. This building housed the Bell Telephone Exhibit which Elvis visited, as well as the million-dollar UNIVAC "electronic brain" that had computing power equivalent to a calculator that you can buy today at a drugstore—a fact that could not have been imagined by those who planned the exhibit and predicted this "World of Tomorrow." It was just outside the United States Science Pavilion that young Kurt Russell kicked Elvis on-camera in their now-famous screen scene together.

The principal "show off the World's Fair" sequence in *It Happened at the World's Fair* occurs when Elvis takes Joan O'Brien to dinner at the top of the 605-foot Space Needle. Now somewhat dwarfed by Seattle's 1990s-vintage skyline, the Space Needle was, in 1962, the tallest structure in the Northwest and the highest restaurant in a major city anywhere in the

West. Of all the places that Elvis dined in his movies, it probably had the best view.

After the fair closed, the fairgrounds became the Seattle Center, and the United States Science Pavilion became the Pacific Science Center. The Century 21 Coliseum became the Seattle Center Coliseum, to which Elvis returned for concerts on November 12, 1970; April 29, 1973; and April 26, 1976.

Today Seattle Center still attracts nine million visitors annually to its twenty acres of landscaped areas. The 17,000-seat Seattle Center Coliseum—currently called the Key Arena—and 6,000-seat Mercer Arena are now the home of the four major performing-arts organizations in Seattle: the Seattle Symphony, the Seattle Opera, the Pacific Northwest Ballet, and the Seattle Repertory Theater. Meanwhile, these Seattle Center venues are also home to the Seattle Super Sonics basketball team (NBA), the Seattle Reign professional women's basketball team (ABL), the Seattle Thunderbirds hockey team (WHL), and the Seattle SeaDogs (CISL). And yes, the Space Needle still has its restaurant with its unparalleled view of Seattle and Puget Sound, and yes, you can sit where Elvis and Joan O'Brien sat. Any window seat might be thought of as where they sat, because it is a revolving restaurant. For reservations, phone (206) 433-2100 or (800) 937-9582.

The New Washington Hotel 🏠

(now Theodora House)
6559 35th Avenue Northeast
Seattle, Washington 98115
(206) 523-3565

In 1962, while he was in Seattle filming *It Happened at the World's Fair*, Elvis and his entourage lived on the fourteenth floor at the New Washington. The building now houses a nonprofit boardinghouse.

The 24-Hour Church of Elvis 🏛

720 Southwest Ankeny
Portland, Oregon 97205
(503) 226-3671

The idolatry involved in treating Elvis as a religious deity would certainly send tremors into his Baptist roots. Idolatry never played well in rural Mississippi and it does not to this day, but at the 24-Hour Church

of Elvis, he is less a deity than an icon, and Elvis is just as much an icon in Tupelo as he is in Portland, Oregon.

The 24-Hour Church of Elvis is located in a late-nineteenth- or early-twentieth-century brick storefront building on a narrow street near downtown Portland, only minutes from the Burnside exit off the Interstate 5 freeway. A mannequin leg juts from a lampshade, and there is the obligatory rack of 24-Hour Church of Elvis T-shirts on prominent display. It looks more like a gallery of conceptual art than a church, so we might call this a conceptual church or a gallery of iconography, but such descriptions would not distinguish it from many other "legitimate" churches.

The centerpiece of "worship" at the 24-Hour Church of Elvis is "The Mystery of the Spinning Elvi." When a quarter is deposited, spinning magic Elvis images summon the King's spirit, who will then perform a service such as a marriage, a blessing, or fortune-telling.

The 24-Hour Church of Elvis differs from the Greater Las Vegas Church of Elvis in that its believers spread the word of "Our King Elvis" to prepare the world for his return, the Second Concert. A similarity exists in the mission statement that the Greater Las Vegas Church of Elvis "exists not to convert others to the way of the King, but rather to bring about acceptance of his unavoidable influence, and to spread the message of the King throughout the world." In this, the two have a like doctrine.

The "pastor" of the 24-Hour Church of Elvis is Stephanie G. Pierce, whose résumé lists her as an "Artist to the Stars," a celebrity spokesmodel/minister and the "world-renowned" author of such works as *Healing Through Glitter*, *Psychic Gardening*, and *6000 Handbook*. The latter is described as the riveting account of her life inside a combination biosphere, diet center, and breast-enlargement clinic.

Pastor Pierce describes the 24-Hour Church of Elvis as "a church that operates like a bank machine...the World's First 24 Hour Coin Operated Art Gallery...The Church of Elvis offers a wide variety of services, all priced moderately from one to four quarters, including weddings, confessions, catechisms, sermons, and photo opportunities with the King."

For twenty quarters, the 24-Hour Church of Elvis offers a "Cheap Not Legal" wedding. An especially economical experience for couples wishing to both invoke and evoke the spirit of the King, the "Cheap Not Legal" wedding includes rings, a marriage certificate, the use of a bridal veil and—perhaps best of all—a trip around the block with a Just Married sign and cans trailing the car. A Polaroid photo to commemorate the special day is available for $2.50 extra.

For those who are not content with a cheap but not legal wedding, the 24-Hour Church of Elvis also offers a fully legal wedding—performed by Celebrity Spokesmodel/Minister Pierce—with packages beginning at $25. (The Oregon state marriage license fee is an additional $60.) The legal wedding includes a wedding march, "fashion twirl," testimo-

nial, inspirational message, a touching legalization of the vows, a first dance, and the 24-Hour Church's traditional sidewalk parade. For an additional $25, an Elvis impersonator will sing at your wedding.

In was in 1994 that the 24-Hour Church of Elvis went mainstream as it co-sponsored—in cooperation with the Bank of America and the *Portland Business Journal*—the Portland Dead Elvis Parade. Other corporate sponsors included Wonder Bread and Chiquita, who donated the ingredients for the fried peanut-butter-and-banana sandwiches. In the parade, reminiscent of Mexican Day of the Dead parades, an Elvis impersonator is ceremonially "killed" and ceremonially "rises" from the dead.

As prices are subject to change, please call ahead for information.

Elvis Concert Venues in Oregon ♫

Within this state the venues of Elvis concerts are arranged in chronological order by the date of the first concert given in a particular place, then followed, chronologically, by the rest of the concerts given in that place. This is done to give readers the cities in the order that Elvis first experienced them.

Multnomah Stadium
(now Portland Civic Stadium)
1844 Southwest Morrison Street
Portland, Oregon 97205
(503) 248-4345
(September 2, 1957)

Portland Memorial Coliseum
One Center Court
Portland, Oregon 97227
(503) 235-8771
(November 11, 1970; April 27,
1973; November 26, 1976)

MacArthur Court
University of Oregon
1585 East 13th Street
Eugene, Oregon 97403
(541) 346-5470
(November 25–27, 1976)

★

Elvis Concert Venues in Washington

Within this state the venues of Elvis concerts are arranged in chronological order by the date of the first concert given in a particular place, then followed, chronologically, by the rest of the concerts given in that place. This is done to give readers the cities in the order that Elvis first experienced them.

Memorial Stadium
Spokane, Washington 99001
(This venue was not found to be listed under this name, nor was it found to be listed under another name.)
(August 30, 1957)

Spokane Coliseum
(now Spokane Arena)
720 West Mallon Avenue
Spokane, Washington 99201
(509) 324-7000
(April 28, 1973)

Lincoln Bowl
Tacoma, Washington 98301
(This venue was not found to be listed under this name, nor was it found to be listed under another name.)
(September 1, 1957 matinee)

★

Sick's Stadium
(former home of the Seattle Rainiers of the Pacific Coast Baseball League)
2700 Rainier Avenue South at McClellan Street South
Seattle, Washington 98144
(The stadium was demolished in February 1979 and today Eagle Hardware and Garden occupies the site.)
(September 1, 1957 evening)

Seattle Center Coliseum
(now Key Arena)
305 Harrison Street
Seattle, Washington 98109
(206) 684-7202
(206) 684-7200
(206) 684-8582 (recorded events-line)
(November 12, 1970; April 26, 1976)

Seattle Center Arena
(now Mercer Arena)
305 Harrison Street
Seattle, Washington 98109
(206) 684-7202
(206) 684-7200
(206) 684-8582 (recorded events-line)
(April 29, 1973)

Chapter 14

The Islands of Hawaii

The name of Elvis Presley will always be associated with Hawaii because of the three movies he made there and the concerts he gave there. The latter included his famous benefit concert for the USS *Arizona* Memorial in 1961 and his legendary *Aloha from Hawaii* TV special in 1973, which was broadcast to the largest audience to have watched a single live-television program up to that time.

The trio of films that he made in Hawaii were *Blue Hawaii* (1961) and *Paradise, Hawaiian Style* (1966)—which were filmed almost entirely in the Islands—as well as *Girls! Girls! Girls!* (1962), for which the major exterior scenes were shot in the tropical paradise. All three of these screen projects were Hal Wallis productions, released by Paramount Pictures.

To this day, the song "Blue Hawaii" ranks among the most popular wherever Hawaiian music is played in the islands. It is virtually impossible to stroll past the hotels on Waikiki Beach at sunset and not hear a band somewhere playing "Blue Hawaii" for the happy-hour cocktail crowd. The song ranks with "The Hawaiian Wedding Song" and Don Ho's "Tiny Bubbles" as being the tune most requested of Hawaiian bands in tourist areas. Elvis never sang "Tiny Bubbles," but Don Ho has done "Blue Hawaii" on many occasions.

Elvis did, however, feature "The Hawaiian Wedding Song" at the climax of *Blue Hawaii*. At the Coco Palms Resort on Kauai it would not be unusual to see a couple actually getting married in a full-scale reenactment of the wedding scene from *Blue Hawaii*.

Most of the principal Elvis Presley sites in Hawaii are on the island of Oahu, which constitutes the city and county of Honolulu. While the entire island is technically within the Honolulu city limits, in practice, the city of Honolulu is defined as the metropolitan area on the eastern half of the southern coast of the island (between the Koolau Mountains and the Pacific Ocean), and from the Pearl Harbor Naval Base and the Honolulu

The Island of Oahu

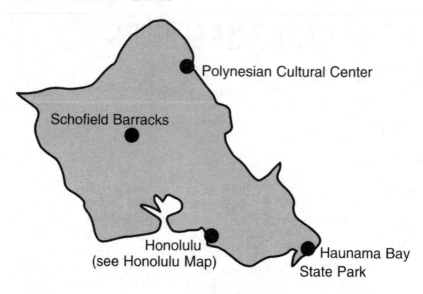

Polynesian Cultural Center

Schofield Barracks

Honolulu
(see Honolulu Map)

Haunama Bay
State Park

International Airport west to Makapuu Beach. When referring to Honolulu in this book, we define it as this section of Oahu.

Elvis performed all of his Hawaii concerts on Oahu, and some shooting for all three films took place here. However, both *Blue Hawaii* and *Paradise, Hawaiian Style* also involved a great deal of shooting on the isle of Kauai, and *Paradise, Hawaiian Style* included filming on the islands of Maui and Hawaii as well. This chapter is divided into three sections: "Concert Sites," "Oahu Movie Locations," and "Outer-Island Movie Locations." For the first two, we use the Honolulu International Airport as the anchor point when providing directions, and for the outer-island sites, we use their respective major airports.

Concert Sites

Old Stadium Park ♫

(formerly the site of Honolulu Stadium)
2237 South King Street
Honolulu, Hawaii 96826

(There is no telephone at the park, but historical walking tours of the area can be arranged by phoning (808) 943-0371.)

Honolulu, Hawaii

1 Bloch Arena
2 USS *Arizona* Memorial
3 Honolulu Police Department
4 Neal S. Blaisdell Center
5 Old Stadium Park
6 Ala Moana Park

7 Ala Wai Yacht Harbor
8 Hilton Hawaiian Village
9 Ilikai Hotel Nikko Waikiki
10 Waikiki Beach
11 Punchbowl Cemetery
12 Makiki Districtl Park

Elvis's introduction to Hawaii—and vice versa—came in November 1957, when he flew there from Los Angeles for three concerts near the conclusion of his fall tour. The first two concerts were held back-to-back on the evening of November 10 at Honolulu Stadium, which no longer exists, although the site is preserved as Stadium Park.

Built in 1926 and demolished in 1976, old Honolulu Stadium was known to several generations of Honolulu residents as the site of local club baseball games and high school football games. During World War II, major-league baseball players who were in the armed services often staged exhibition games here. Eventually the venerable old wooden bleachers came to be known as "termite place." The 9.17-acre city park now has children's play apparatus and thirty-three parking stalls.

To reach Old Stadium Park from the Honolulu International Airport, drive east on the H1 Freeway in the direction of downtown Honolulu. Take Exit 21A and drive south on Bishop Street to King Street. Turn left and drive east to the 2200-block of South King Street at the corner of Isenberg Street.

Schofield Barracks ♫

U.S. Army Twenty-fifth Infantry Division
Schofield Barracks, Hawaii 96857
(808) 471-7110

Elvis's third concert in Hawaii had him entertaining United States troops on Veterans Day at the U.S. Army's Schofield Barracks in central Oahu. Within four months, Elvis himself would be a member of the U.S. Army. The concert took place on November 11, 1957, the evening following his two concerts at Honolulu Stadium.

To reach Schofield Barracks from the Honolulu International Airport, drive west on the H1 Freeway in the direction of Pearl City and Ewa. When the H1 Freeway intersects the H2 Freeway, take the H2 north to where it ends at Exit 9. From there, take Hawaii Route 99 north for about one mile and watch for the main gate of Schofield Barracks.

Because Schofield Barracks is an active U.S. Army post, access is at the discretion of the base commander and may not be possible. This site, among all those in Hawaii, is probably the one that is least accessible to the public.

Bloch Arena ♫

Building 161
Naval Base Pearl Harbor
Pearl Harbor, Hawaii 96860
(808) 474-6156

The attack by the Imperial Japanese Navy on the U.S. Navy Base at Pearl Harbor on December 7, 1941, brought the United States into World War II, and the battleship USS *Arizona* (BB-39), which was sunk in the attack, became a symbol of American determination to win the war. Of all the ships sunk in the Pearl Harbor attack, the USS *Arizona* was the only one deemed unsalvageable and the only one for which there was no attempt made to raise it. The USS *Arizona* remained on the bottom, and her hull—which was only a few feet beneath the surface—was

designated as the final resting place of the 1,102 crewmen who went down with their ship.

The night before the attack on Pearl Harbor, ships' bands from the various vessels anchored at the base had participated in a competition held in Bloch Arena, which was—and is—part of the naval base.

After World War II, there was a great deal of indecision about whether and how to create a permanent USS *Arizona* memorial. Finally, in 1958, the United States Congress authorized such a memorial on the site at Pearl Harbor, but the majority of the funding for the memorial—which would cost a half million dollars to construct—fell to a private group known as the Pacific War Memorial Committee.

When the fund-raising for the USS *Arizona* Memorial bogged down, well short of the goal, Elvis—who was then in town filming *Blue Hawaii*—was enlisted to perform a benefit concert at Pearl Harbor. One of only four concerts that Elvis gave between 1957 and 1969, the USS *Arizona* Memorial benefit was originally scheduled for March 26, 1961, but because that was Palm Sunday, Elvis asked that it be moved back a day to March 25.

The concert at the 4,000-seat Bloch Arena on the grounds of the Pearl Harbor Naval Base raised $62,000 and provided the publicity that led to the Pacific War Memorial Committee meeting their goal, with $250,000 in public donations.

Bloch Arena (Building 161) is still used for concerts, but it also houses many recreational facilities for U.S. naval personnel. There is an aerobics center, a fitness center, and a recreational equipment facility, as well as an information, tours, and ticket office.

To reach Naval Base Pearl Harbor from the Honolulu International Airport, drive west on the H1 Freeway and take Exit 15A, the USS *Arizona*/Stadium exit. Because Pearl Harbor is an active U.S. Navy base, access to certain parts of it may not be possible. You are permitted access to the USS *Arizona* Memorial (see below) via Hawaii Route 99 (Kamehameha Highway).

The USS Arizona Memorial 🏛

1 Arizona Memorial Place
Honolulu, Hawaii 96818
(808) 422-0561 (general information)
(808) 422-2771 (administration)

Though it is not an Elvis concert site, and not a shrine exclusive to Elvis, the USS *Arizona* Memorial is the net result of a project for which Elvis is responsible more than any other single person, and it rounds out

the story that is told in part by the above description of the nearby Bloch Arena.

The memorial straddles the sunken hull of the battleship USS *Arizona* and commemorates the December 7, 1941, Japanese attack on Pearl Harbor. The memorial was dedicated in 1962 and became a National Park Service area in 1980. Annual visitation is approximately 1.5 million persons. It is open Sunday through Saturday, 7:30 A.M. until 5:00 P.M. Interpretive programs, including a documentary film about the attack and the boat trip to the USS *Arizona* Memorial, begin at 8:00 A.M. (7:45 A.M. in summer). The final program each day begins at 3:00 P.M. The USS *Arizona* Memorial is free. There is no entrance fee or activity fee. Free tickets for the program are issued on a first-come, first-served basis at the front desk in the Visitors Center.

To drive to the USS *Arizona* Memorial from the Honolulu International Airport, drive west on the H1 Freeway and take Exit 15A, the USS *Arizona*/Stadium exit. The USS *Arizona* Memorial Visitor Center is located on the shoreline overlooking Pearl Harbor, directly off Hawaii Route 99 (Kamehameha Highway).

Neal S. Blaisdell Center ♪

(formerly Honolulu International Center)
777 Ward Avenue
Honolulu, Hawaii 96814
(808) 527-5400

After his return to the concert stage in 1969, Elvis Presley made four concert appearances in Hawaii, all of them at the Honolulu International Arena at the Honolulu International Center, now the Neal S. Blaisdell Center. These concerts took place between November 1972 and January 1973, when he was at the peak of his post-"comeback" performing prowess. The first two concerts took place on the nights of November 17 and 18, 1972, and the next two were on January 12 and January 14, 1973. In the intervening two months, he made no live concert appearances anywhere.

The January 12, 1973, appearance at the Honolulu International Center was, in effect, a full dress-rehearsal for the January 14 show, which was broadcast worldwide as the *Elvis: Aloha from Hawaii* television special. Both concerts were taped and released as albums. The January 14 concert was released immediately after the event as *Elvis: Aloha from Hawaii*, and it became Elvis's last number-one album. The January 12 concert was released in 1988 as *The Alternate Aloha*.

The January 14 show took place at half past midnight, Hawaii time, so it could be broadcast live in prime time throughout most of the world.

An estimated one billion people saw the concert live, more than had tuned in to any other live television broadcast in history, including the *Apollo 11* first lunar landing in July 1969! It was rebroadcast the following day in Europe, and aired on NBC television in the United States on April 4 and November 14, 1973. It has been rebroadcast hundreds of times since.

The reason that Elvis undertook such a broadcast rather than actually touring Europe, Australia, or the Far East was that Colonel Parker was afraid to leave the United States. Parker, whose real name was Andreas van Kuijk, was a Dutch citizen who had entered the United States illegally in 1929. As such, he had no passport, and if he had applied for one, his illegal status would have been discovered and he most likely would have been deported.

The Neal S. Blaisdell Arena, the largest building at the Center, is located in the heart of downtown Honolulu, five minutes from Waikiki Beach. It has a maximum seating capacity of 8,805, including 5,451 fixed, upholstered, theater-type chairs. Its circular design—with no posts to block sight lines—provides an unobstructed view from every seat, and a flexible venue for many types of events from conventions and trade shows to community and sporting events. In recent years it has accommodated ice shows and concerts ranging from Luciano Pavarotti and *Lord of the Dance*, to Van Halen and Celine Dion. The facility is owned by the city and county of Honolulu, and is managed by the Department of Auditoriums.

To reach the Neal S. Blaisdell Center from the Honolulu International Airport, drive east on the H1 Freeway in the direction of downtown Honolulu. Take the Ward Avenue exit from the H1 Freeway and drive south to South King Street. The Neal S. Blaisdell Center will be on your left, between South King Street and Kapiolani Boulevard. There are three gates. The Kapiolani Gate is open two hours prior to the start of all major events scheduled in the central areas and remains open until the completion of the last event. It is closed when there are no events scheduled. The King Street Gate is the main entrance to the Blaisdell parking lot. The Ward Avenue Gate is a service entrance and is closed to the general public.

Oahu Movie Locations 🎥

Under the direction of Norman Taurog—who helmed many of Elvis's Paramount movies—location filming for *Blue Hawaii* took place on Oahu, from March 17 through the first week of April in 1961. The crews then moved over to the island of Kauai, where the shooting wrapped on April 17. While on Oahu, Elvis made his March 25 appearance at Bloch Arena on behalf of the USS *Arizona* Memorial project.

Among those present on the sets were Joan Blackman, who played Maile Duval, Elvis's love interest; veteran actress Angela Lansbury, cast as Sarah Lee Gates, the mother of Elvis's character; and Roland Winters (best remembered for playing Charlie Chan on screen in the late 1940s), who was seen as Fred Gates. Longtime Honolulu entertainer Hilo Hattie had a small part in the film as Waihila.

Norman Taurog once again was in the director's chair when Elvis returned to Hawaii on April 9, 1962, for the location filming for *Girls! Girls! Girls!* (The working title, *A Girl in Every Port*, summarized the plot.) Stella Stevens was cast as Robin Gantner opposite Elvis's Ross Carpenter. For *Girls! Girls! Girls!* all of the location work was done on Oahu and wrapped by the end of April.

The last of Elvis's Hawaii location films, *Paradise, Hawaiian Style*, was initially announced in 1964 under the working title *Polynesian Paradise,* but ultimately Paramount decided to capitalize on the "Hawaii" connection, because the recently-added fiftieth state was an increasingly popular tourist destination. Once again, the project was a Hal Wallis production for Paramount, but this time the director was D. Michael Moore, a veteran assistant director—and former child actor—who was making his debut in the top slot. British actress Suzanna Leigh starred as Judy "Friday" Hudson opposite Elvis's helicopter jockeying Greg "Rick" Richards. Many people regard the movie as a precursor to the 1980s Hawaii-set television series *Magnum P.I.*

Filming for *Paradise, Hawaiian Style* began on August 7, 1965, with the famous and dramatic helicopter rescue scene at Hanauma Bay at the southeastern tip of Oahu, and continued with location work on three other islands.

Because they are all nearby, this group of sites is listed as a tour. Rather than give directions for each from the Honolulu International Airport, we give directions to each site from the previous site. For this tour, we will begin at the Honolulu International Airport and work our way counterclockwise around the island of Oahu. Obviously, if you are beginning from a Honolulu or Waikiki hotel, there will be some backtracking, but we'll do it this way for the fans who can't wait to get started.

To begin, drive east from the Honolulu International Airport on the H1 Freeway in the direction of downtown Honolulu. Take Exit 21A and drive south on Bishop Street to Ala Moana Boulevard (Hawaii Route 92), turn left, and drive east. Alternatively, you can pick up Hawaii Route 92 just outside the airport and drive east. Highway 92 is known as the Nimitz Highway out near the airport, but is renamed Ala Moana Boulevard when it enters the heart of Honolulu.

From Bishop Street, as you drive east on Ala Moana Boulevard for approximately a half-mile, you will notice Ala Moana Park on your right, between Ala Moana Boulevard and the Pacific Ocean.

Ala Moana Park 🎥

1201 Ala Moana Boulevard
Honolulu, Hawaii 96814
(808) 592-7031 (Ala Moana Park Tennis Club)
(808) 527-6343 (City and County of Honolulu Department of Parks and
Recreation)

Hal Wallis and Norman Taurog used Ala Moana Park as one of the many location settings for *Blue Hawaii*. As a Honolulu city park, it is open to the public, and you can stand where Elvis stood anytime you wish. The famous Ala Moana Shopping Center is across the street at the eastern end of the park.

After a stop at Ala Moana Park, continue east on Ala Moana Boulevard for about one-half mile to Ali Wai Boulevard. At this point Ala Moana Boulevard crosses the narrow Ala Wai Canal. On your right will be the Ala Wai Yacht Harbor.

Ala Wai Yacht Harbor 🎥

1651 Ala Moana Boulevard
Honolulu, Hawaii 96851
(808) 946-4213 (offices of Ala Wai Marine, Ltd.)

The largest yacht harbor on Oahu, the Ala Wai was featured as a backdrop for both *Blue Hawaii* and *Girls! Girls! Girls!* It is located at the mouth of the Ala Wai Canal immediately adjacent to Ala Moana Boulevard. The Hilton Hawaiian Village is literally next door to the Ala Wai Yacht Harbor on Kalia Road, just off Ala Moana Boulevard.

Hilton Hawaiian Village 🎥

2005 Kalia Road
Honolulu, Hawaii 96815
(808) 949-4321

Originally built as the Hawaiian Village Hotel, this massive complex was acquired by the Hilton Hotel Corporation in 1961, the year that Elvis was in town filming *Blue Hawaii*. Elvis stayed at the Hilton Hawaiian Village in April 1962 while shooting *Girls! Girls! Girls!* and it appears in the background in various scenes from all three of his Hawaii location films. In *Blue Hawaii*, it was here that he met Miss Prentice—

played by Nancy Walters—and her tour group. Filming was done at the covered, open-air main entrance and at the open-air bar overlooking Waikiki Beach.

On January 9, 1973, when Elvis arrived in Hawaii for his famous *Aloha from Hawaii* concerts, he was filmed landing in a helicopter on the grounds of the Hilton Hawaiian Village. He had traveled to the Hilton Hawaiian Village by helicopter from the Honolulu International Airport. If you wish to replicate such an arrival for yourself, look in the Honolulu yellow pages under Helicopter Tours and make the appropriate arrangements with the Hilton Hawaiian Village management. Scenes of Elvis's arrival at the Hilton Hawaiian Village were used to open the 1973 television special.

The Hilton Hawaiian Village is situated on twenty lush acres of botanical gardens—with waterfalls and wildlife—directly on Waikiki Beach, eight miles from the Honolulu International Airport. Four high-rise towers house 2,545 guest rooms, which are advertised as being soundproof, with air-conditioning control, phone-message alert, computer jacks, and color television. The four high-rise towers are the fifteen-story Alii, the seventeen-story Diamond Head, the thirty-one-story Rainbow, and the thirty-five-story Tapa. Of the rooms, 400 have a wet bar, 380 have a conversation area, 348 have use of the whirlpool and weight room, and 31 rooms are equipped for the disabled. The complex has 19 restaurants, including the award-winning Bali-by-the-Sea and Golden Dragon, Rainbow Lanai, Village Steak and Seafood, and Tapa Café. There are 9 bars and lounges, including Paradise Lounge, Hau Tree Bar, Shell Bar, Tapa Bar, and Tropics Surf Club.

The Ilikai Hotel Nikko Waikiki

(formerly the Ilikai Hotel)
1777 Ala Moana Boulevard
Honolulu, Hawaii 96815
(808) 949-3811

Adjacent to the Hilton Hawaiian Village is the Japanese-owned Ilikai Hotel Nikko Waikiki, the former Ilikai Hotel, where Elvis stayed in August 1965 while he was filming *Paradise, Hawaiian Style*. He was a guest in suite 2225, which has been remodeled at least once since he was there. There are still people on the staff who remember his visit.

From the Ilikai, take Ala Moana Boulevard to Kalakaua Avenue, the major street linking downtown Honolulu with the Waikiki Beach district, and turn right.

Waikiki Beach 🎥

Roughly from the Ala Wai Yacht Harbor to Kapahulu Avenue (south of Kalakaua Avenue).
Honolulu, Hawaii 96815

The most popular venue for tourists on Oahu, and indeed, the most popular place anywhere in Hawaii, Waikiki Beach is an exceptional strip of sandy beach that was the site of Hawaii's two original luxury resort hotels, the Ala Moana and the distinctive pink, Moorish-style Royal Hawaiian. Today there is an unbroken wall of hotels between Kalakaua Avenue and the beach, but the beach remains one of the world's best. The view looking east from the water's edge near the foot of Kaiolu Street is Hawaii's most photographed, with swaying palm trees and the distinctive profile of the Diamond Head crater in the background. Naturally, this view figures in *Blue Hawaii* as Elvis's character walks these golden sands. In the film, he and costar Joan Blackman sit on Waikiki Beach as he is deciding to start his travel business.

From Waikiki, retrace your route, traveling west on Kalakaua Avenue. At Ala Moana Boulevard, as Kalakaua Avenue turns north into downtown Honolulu, follow it to South Beretania Street and turn left.

Honolulu Police Department 🎥

801 South Beretania Street
Honolulu, Hawaii 96813
(808) 529-3111 (administrative offices)

A scene in *Blue Hawaii*, where Elvis's character is arrested after a fight at the luau, is supposed to have taken place here at the Honolulu Police Department. However, the interiors were done on a Paramount soundstage. Only brief exterior scenes were actually shot here, and they were accomplished without Elvis's presence. Please note that this is a working police headquarters and do not disturb their activities. After you leave the Honolulu Police Department, drive north on Queen Emma Street or Ward Avenue, passing under or over the H1 Freeway. At Ionalai Avenue, turn left to Puowaina Drive.

National Memorial Cemetery of the Pacific— "The Punchbowl Cemetery" 🎥

Department of Veterans Affairs
2177 Puowaina Drive
Honolulu, Hawaii 96813
(808) 566-1430

Makiki District Park 🎥

1527 Keeaumoku Street
Honolulu, Hawaii 96822
(808) 522-7082

In *Blue Hawaii*, the picnic sequence was shot high on the slopes of Mount Tantalus because of its truly spectacular view of Honolulu. The opening scenes of Joan Blackman's character driving a sports car were done on the road that leads down the mountain. Many of the other exterior scenes were filmed in the incredibly beautiful settings around the Punchbowl, a long-extinct volcanic crater that is the site of the National Memorial Cemetery of the Pacific—a military cemetery maintained by the United States Department of Veterans Affairs and known locally as "the Punchbowl Cemetery." The Punchbowl itself does not appear in the film.

From the Punchbowl, one can look up Makiki Valley into the rugged Koolau Mountains. Part of these slopes has been set aside as the Makiki District Park. Tantalus Drive is a torturously twisting road that leads up the valley almost to the 2,013-foot summit of Mount Tantalus. The view is definitely worth the drive, and after all, Elvis came up here during the filming for *Blue Hawaii* to have a picnic. He and Joan Blackman didn't finish theirs (in the movie), but you can finish yours.

From the Punchbowl area, drive south to the H1 Freeway and take it east until it ends as a freeway and becomes the Kalanianaole Highway (Hawaii Route 72). Continue on this road for seven miles to the turnoff for Hanauma Bay.

Hanauma Bay State Underwater Park 🎥

7455 Kalanianaole Highway
Honolulu, Hawaii 96825
(808) 396-4229

It was here, at one of Oahu's most visually impressive locations, that the spectacular helicopter rescue scene at the beginning of *Paradise, Hawaiian Style* was filmed. In the movie, Elvis—as Rick Richards—rescued James Shigeta and Donna Butterworth, who portrayed Danny Kohana and Jan Kohana in the film.

It was also here that Elvis has his "shack" in *Blue Hawaii*, and where he and Joan Blackman take their swim on the day that he arrives from the mainland. Some of the scenes for the beach party in *Blue Hawaii* also take place here.

As you turn off the Kalanianaole Highway, your first view of Hanauma Bay is from the cliffs several hundred feet above the deep turquoise waters of this former volcanic crater that is now a finger of the Pacific Ocean. Currently under the protection of the State of Hawaii, the 101-acre Hanauma Bay State Underwater Park offers some of the best snorkeling on the island of Oahu, with the opportunity to get an excellent close-up view of reef fishes and corals. Scuba-diving and swimming are also possible, and the adjoining land area is a city and county of the Honolulu beach park.

Hanauma Bay State Underwater Park is not nearly as deserted as it was in *Blue Hawaii*, but it is still as beautiful, and it is still a good place to swim.

From Hanauma Bay, continue east, and eventually north, on Kalanianaole Highway (Hawaii Route 72). It was here that Elvis and Joan Blackman were filmed supposedly driving to Hanauma Bay. The ocean was on their right, so they were actually driving north and away from Hanauma Bay.

At Olomana, fourteen miles from Hanauma Bay, Kalanianaole Highway ends. At this point, take Kahekili Highway (Hawaii Route 83) as it continues to wind north along the northeast coastline of Oahu, becoming the Kamehameha Highway at Kahaluu, ten miles north of the junction with Route 72.

Polynesian Cultural Center 🎥

55-220 Kamehameha Highway
Laie, Hawaii 96762
(808) 293-3333
(800) 367-7060 (toll-free reservations)

The Kamehameha Highway (Hawaii Route 83) is a narrow and slow, albeit visually interesting, road that leads eventually to the northernmost tip of Oahu. The Polynesian Cultural Center is located at the town of Laie, forty-two long miles from Hanauma Bay and nearly at this northern tip. It was here that some of the most important scenes for *Paradise, Hawaiian Style* were filmed.

The Polynesian Cultural Center, Hawaii's top visitor attraction since 1977 (according to annual state government surveys) was created by the Church of Jesus Christ of Latter-Day Saints (the Mormons) as "a non-profit, stand-alone entity dedicated to helping preserve the cultural heritage of Polynesia while providing jobs and scholarships for hundreds of students at the adjoining Brigham Young University–Hawaii campus."

The Polynesian Cultural Center features seven sections—each one replicating a different Polynesian island culture—in a beautifully landscaped, forty-two-acre complex. The islands represented include Samoa, New Zealand (Aotearoa), Fiji, Hawaii, Tahiti, the Marquesas, and Tonga. A man-made freshwater lagoon winds throughout the center. An evening show, now called *Horizons! A Celebration of Polynesian Discovery* is the highlight of the Polynesian Cultural Center experience, and this show was incorporated into *Paradise, Hawaiian Style* with Elvis's memorable sequences as he joined the dancers and drummers on stage. The show is still presented in the Center's 2,770-seat Pacific Theater and features the fiery volcanoes, brilliant fountains, multilevel stages, and numerous special effects that we recall from *Paradise, Hawaiian Style*. The experience is a perfect conclusion to a day of imagining yourself in the scenes from Elvis's Oahu locations.

Central Oahu

Driving back to Honolulu from the Polynesian Cultural Center, take the Kamehameha Highway north to continue your counterclockwise loop around the eastern side of Oahu. At Haleiwa on the north shore, the Kamehameha Highway becomes Hawaii Route 99, which runs south through central Oahu, returning to the Honolulu International Airport and metropolitan Honolulu. About eight miles south of Haleiwa are the pineapple fields that were used by Elvis for his field trip in *Blue Hawaii*. It is still possible to stop at a roadside stand here to buy a snack, just as Elvis did.

Kauai and Other Outer-Island Movie Locations 🎥

The Island of Kauai

As noted above, producer Hal Wallis chose Oahu for location shooting for all three of Elvis's Hawaii location films. The spectacular settings at the Punchbowl and Hanauma Bay notwithstanding, this decision was almost certainly one of convenience. Of all the Hawaiian Islands, only Oahu had the infrastructure to support a Hollywood film crew, and in the 1960s, only Oahu had an airport that could be reached by commercial jetliners flying from the United States—or any other part of the world for that matter.

Despite the convenience of Oahu, the scenic beauty of Kauai has always afforded unparalleled natural settings. Joshua Logan had come here in 1957 to shoot the film version of Rodgers and Hammerstein's *South Pacific* (1958) and, more recently, Steven Spielberg used the island's precipitous cliffs and mile-high waterfalls as a backdrop for filming *Jurassic Park* (1993). With the success of *South Pacific* a recent memory, is there any wonder that director Norman Taurog put Kauai on the shooting schedule for April 1961 for *Blue Hawaii*?

While *Girls! Girls! Girls!* was filmed entirely on Oahu—for the sake of convenience and budget—Hal Wallis and director D. Michael Moore decided that *Paradise, Hawaiian Style*, which began shooting on August 7, 1965, on Oahu, would also utilize Kauai, as well as brief vignettes on the island of Maui and the "Big Island" of Hawaii.

Again, because they are all close together, this group of sites is listed as a tour. Rather than give directions for each from the airport, we give directions to each site from the previous one. For this tour, we will begin at the airport and work our way north along the east shore of Kauai. The one-each sites on Maui and Hawaii are noted last, with directions from their respective nearest airports.

In discussing sites on Kauai, it should be noted that, while the appearance of man-made structures on Kauai stayed relatively unchanged for the twenty years following Elvis's first visit in 1961, almost nothing of this remains today, thanks to a pair of disastrous hurricanes that occurred in 1982 and 1992. The former, Hurricane Iwa, with its 80-mph winds, caused $286 million worth of damage to Kauai, particularly to the south shore of the island. A decade later Hurricane Iniki cut through the center of Kauai, ravaging the entire island, rendering a third of the population temporarily homeless, and making 7,000 of the island's 8,202 hotel and condominium rooms unusable. Sustained winds of 160 mph, with gusts of 200 mph, were accompanied by thirty-foot waves. With $1.6 billion worth of damage, Iniki became the third-most-costly hurricane in the history of the United States. More important was the level of destruction that was visited upon the people of Kauai. A third of all buildings on the island was destroyed, and much of what remained was severely damaged.

Our tour of Kauai begins at the Kauai Airport on the edge of the town of Lihue. When Elvis arrived here in 1961 to film *Blue Hawaii*, it was just a runway and a line of low buildings, and these figured in scenes from the picture. When he left after filming *Paradise, Hawaiian Style*, Kauai Airport was still just a runway and a line of low buildings, and Kauai was a relatively untouched corner of Hawaii. Today, after more than a third of a century of tourism and two hurricanes, the airport has a vast, crowded terminal, and the ambiance that Elvis and the crew enjoyed is just a fading memory.

To begin the tour of Elvis sites on Kauai, leave the airport and drive north on the Kuhio Highway (Hawaii Route 56) into what is known locally as "the Coconut Coast" because of the many coconut plantations that once existed here.

Wailua River State Park/ Lydgate State Park 🎥

Kuhio Road at Maalo Road
Wailua, Hawaii 96791

For information, contact:
State of Hawaii
Department of Land and Natural Resources
Kauai District
3060 Eiwa Street, Number 306
Lihue, Hawaii 96766
(808) 274-3444

Many of the most spectacular sights on the eastern side of Kauai are near or within Wailua River State Park, and many of these—especially the waterfalls—were used as backgrounds for Elvis when he filmed *Blue Hawaii*. The horseback-riding scenes were shot on the east side of Kuhio Road and inland on the hillside above the north side of the Wailua River.

From the Kuhio Highway, there are three turnoffs to the left that will take you to a viewing point for one of Wailua River State Park's waterfalls. Take Maalo Road (Hawaii Route 583) for four miles to view Wailua Falls, take Kuamoo Road (Hawaii Route 580) for two miles to view Opaekaa Falls, and continue for another three miles on Kuamoo Road to see Koholalele Falls.

Along the banks of the Wailua River near Kuhio Highway, boat excursions such as Elvis took on-camera, are offered at a marina on the south bank. These cruises include the Fern Grotto, an unusual fern-clothed cave set in a tropical garden, as well as scenic vistas of the attractive waterfalls and Wailua River Valley. Also within the park are the Wailua Complex at the Heiau National Historic Landmark with its remains of heiau (places of worship), puuhonua (places of refuge), birthstones, and a bellstone.

Nearby Lydgate State Park, which also figured in the making of *Blue Hawaii*, contains a coconut grove that once served as a place of refuge for the ancient Hawaiians. Those who could reach the boundaries of the refuge before being caught were spared punishment or even death for breaking a kapu (law).

The phone number and street address given above are for the Kauai office of the State of Hawaii's Department of Land and Natural Resources. This office is located seven miles south of the park and is given as a contact point for further information. The official park entrance is on

Kuhio Road at Maalo Road, where the Wailua River runs into the Pacific Ocean, and about a half-mile south of the town of Wailua.

Coco Palms Resort

4241 Kuhio Highway
Kapaa, Hawaii 96746
(808) 822-4921

From Wailua, drive north for three miles to Kapaa. This area was once the center of coconut plantation activity on Kauai, and despite an end to this industry on the island, and the devastating hurricanes over recent decades, many of the actual coconut palms—laid out in neat rows—still remain. This area of the Coconut Coast has also become one of the most populous parts of Kauai.

The Coco Palms Resort, on the left side of Kuhio Highway as you enter Kapaa, was the setting for the elaborate Hawaiian wedding scene at the finale of *Blue Hawaii*, but it was more than that for Elvis. Indeed, the Coco Palms was the epicenter of Elvis's activities on Kauai. He also stayed here—in cottage 56—during the filming of *Blue Hawaii* and *Paradise, Hawaiian Style*, and he stayed here—in cottage 56—on several occasions when he returned to Kauai as a tourist.

Badly damaged during Hurricane Iniki in 1992, the Coco Palms Resort has remained closed because of an ongoing insurance dispute. Nevertheless, a staff of groundskeepers and caretakers continue to maintain the property. The phone is still connected, and if you call ahead, you can arrange a tour of the grounds with a look at the lagoon where the wedding scene in the finale of *Blue Hawaii* was set. The double-hulled canoe that was used by Elvis and costar Joan Blackman in the story line is also still there. Of course, you can also make a visit to cottage 56. Also worth a look is the resort's old dining room. Elvis's favorite spot was in the southwest corner, but because the furniture has been moved so many times—and was removed entirely after Hurricane Iniki—there is no knowing which actual table was his. It is still there, but it is among many others.

Coco Palms is perhaps the most popular Elvis site in Hawaii, with fans—and often entire fan clubs—coming here on an almost daily basis. As mentioned above, several times every month couples arrange to be married on the lagoon in a full-scale replica of the *Blue Hawaii* wedding scene.

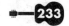
Hawaii Movie Tours 🎥

356 Kuhio Highway
Kapaa, Hawaii 96746
(800) 628-8432
(808) 822-1192

Worth a call, if you are expecting to visit Kauai, is Hawaii Movie Tours, which offer tours of all the important movie locations on Kauai. The *Blue Hawaii* sites are included, of course, as are the locations for *South Pacific* (1958), *Raiders of the Lost Ark* (1981), *Honeymoon in Vegas* (1992), *Jurassic Park* (1993), *The Lost World: Jurassic Park* (1997), and *Six Days, Seven Nights* (1998), as well as the authentic village used in *Outbreak* (1995). Hawaii Movie Tours also offers a helicopter tour to Jurassic Falls and the stunning beach used in *The Lost World: Jurassic Park*, as well as the falls used in every *Fantasy Island* television episode.

The Village on Anahola 🎥

Anahola, Hawaii 96703

Driving north on the Kuhio Highway, you pass through the small town of Anahola. About six miles from Kapaa, Anahola has much of the same feel that it had in 1961 when Elvis used it for the car-chase scene in *Blue Hawaii*. With the Anahola Mountains, Makaleha Mountains, and Nounou Mountain (the Sleeping Giant) surrounding the plateau, Anahola provided another of those settings that made Elvis's Hawaii movie locations so memorable. For *Blue Hawaii*, this was as far north as the film crews ventured, but in *Paradise, Hawaiian Style*, the Hanalei Bay Area on the north shore was used.

Hanalei Bay Area 🎥

Hanalei, Hawaii 96714

The town of Hanalei, overlooking Hanalei Bay, is located on the north shore of Kauai, twenty-three miles north of Kapaa on the narrowest part of the Kuhio Highway. Once one of the most remote corners of Kauai served by a paved road, Hanalei is now a favorite tourist destination, although it is still just far enough off the beaten track to retain a bit of the feel of a small, sleepy village. *South Pacific* was filmed at Hanalei Bay, as was a portion of *Paradise, Hawaiian Style*. The Hanalei Plantation

Resort, where Elvis filmed, is long gone and the area near Hawaii Route 560 has been developed for homes.

Sheraton Maui

2605 Kaanapali Parkway
Lahaina, Hawaii 96761
(808) 661-0031

In August 1965 Elvis flew to Maui and landed at the private airstrip adjacent to the development that later became the Royal Lahaina Resort. In seeing this scene in *Paradise, Hawaiian Style*, we are led to believe that Elvis actually piloted the airplane, but in fact, he was a passenger. As Elvis stepped out on the black asphalt tarmac, he was met by Rocky Rocana, a bellman at the Sheraton Maui, who drove Elvis the short distance to the Sheraton in an electric golf cart. Rocky, who was an actual bellman, retired as the Sheraton's bell captain more than three decades later.

In 1965 the Sheraton was the only hotel on what was then a fairly remote island. Today, however, there are dozens of hotels and resorts. Maui has become the second-busiest tourist destination in Hawaii, after the Honolulu area on Oahu. At the Sheraton, though, they still remember Elvis's visit. After this brief moviemaking scene, Elvis left Maui.

To reach Lahaina from Maui's Kahului Airport, take the Kuihelani Highway (Hawaii Route 380) seven miles south to the point where it intersects the Hanoapilani Highway (Hawaii Route 30). Follow the Hanoapilani Highway sixteen miles west to Lahaina and turn on Kaanapali Parkway to number 2605.

The Kona Coast

In the vicinity of Kailua-Kona, Hawaii 96740.

Only brief use was made of this popular coast of the "Big Island" of Hawaii in the making of *Paradise, Hawaiian Style*. As noted above, most of the location filming took place on Oahu and Kauai. As with Elvis's brief visit to Maui, the Kona scenes were used in the film primarily in an effort to include something of each of the four largest islands. In May 1966 Paramount released a short subject about the making of *Paradise, Hawaiian Style*. It was really just a travelogue—starring Elvis Presley—that promoted the scenic wonders of Hawaii as well as the movie. During the late 1960s, the short film was in wide circulation among television stations and travel agencies.

Chapter 15

Beyond the United States

Throughout his career, especially in the 1970s when he was touring constantly, Elvis was offered enormous sums of money to undertake concert tours in Europe, Australia, and the Far East. The fact that he never accepted these offers remained an unexplained mystery until after his death. Only then was it was revealed that he couldn't tour outside the United States because his manager couldn't get a passport for himself!

Elvis's manager, Colonel Tom Parker, was actually Andreas van Kuijk, an illegal alien from the Netherlands. Born in Breda, van Kuijk ran away to sea and jumped ship in the United States in 1929 . He was never really a colonel—although he served in the U.S. Army from 1929 to 1932— and he was not West Virginia–born Thomas Andrew Parker. And so it was that the rest of the world was cheated of concert visits by the King of Rock and Roll.

Elvis's only extended overseas trip was the eighteen months that he spent in Germany with the U.S. Army. Though several of his films were set overseas, he made no films abroad. *Fun in Acapulco* (1963) contained scenes that were shot in Acapulco, but Elvis wasn't there for the filming. All his scenes were shot at the Paramount home lot in Los Angeles. The scenes of Germany that producer Hal Wallis used in *G.I. Blues* were shot in 1959 without Elvis being present, although he was in Germany at the time. The only concerts that Elvis played off United States soil were three shows that he performed in Canada in 1957. He didn't play Canada during the 1970s when he performed several times in a number of border cities, such as Detroit.

Elvis Concert Venues in Canada ♫

As noted above, Elvis played only three concerts in Canada. These were the only performances that he ever gave outside the borders of the United States, and they all took place in 1957.

Maple Leaf Gardens
60 Carlton Street
Toronto, Ontario M5B 1L1
(416) 977-1641
(April 2, 1957)

★

Auditorium
Ottawa, Ontario
(This venue could not be traced to its full name in 1957, or to its exact location.)
(April 3, 1957)

Empire Stadium
Vancouver, British Columbia
(This venue was constructed in 1954 for the British Empire Games and torn down in 1996.)
(August 31, 1957)

★

Elvis in Germany 🎚

Elvis arrived in Germany aboard the USS *General Randall* at the port of Bremerhaven on October 1, 1958, and was taken to the U.S. Army base at Friedberg, about twenty miles north of Frankfurt, by train. The area around this base, the home of the U.S. Army's Ninety-seventh Infantry Division—and the overseas home of Elvis's Second Armored Division—would remain his home base for his entire tour of duty. He was originally assigned to bed 13 in barracks 3707 at the base, but on October 8 was granted permission to live off-base. He would live in the town of Bad Nauheim, a few miles north of the base, for the next eighteen months, until he flew home to the United States from the U.S. Air Force base adjacent to Rhein-Main Airport at Frankfurt on March 2, 1960.

For virtually the entire time he was in Germany, Elvis lived with his father, Vernon Presley, his grandmother, Minnie Mae Presley, and members of his Memphis entourage—mainly Red West and Lamar Fike.

Elvis's extended time away from this area included two vacation trips and Second Armored Division maneuvers near the Czechoslovak border in Bavaria that took place from November 2 through December 20, 1958. The two vacation outings were virtually identical. In 1959 he was in Munich from June 17 through 20, and then he traveled on to Paris, where he stayed until June 25. In 1960 he was in Munich from January 9 though 11, and then he again went to Paris, where he stayed until January

19. Notable other stops included a brief visit to Mannheim, Germany, on October 29, 1958, to attend a Bill Haley concert, and the brief stopover that his plane made in Prestwick, Scotland, during his return flight to the United States in March 1960.

Hilburts Park Hotel 🏠

2–4 Kurstrasse
61231 Bad Nauheim, Germany
(No telephone number was found listed for this hotel.)

Elvis spent the nights of October 8–11, 1958, at this hotel after being given permission to live off-base. His entourage, including friends and family who traveled to Germany to be near him, had already checked into the hotel. Colonel Parker was, of course, *not* among them.

Hotel Gruenewald 🏠

10 Terrrassenstrasse
61231 Bad Nauheim, Germany
49-6032-2230

After four nights at the Hilburts Park Hotel, Elvis moved himself and his entourage to the Hotel Gruenewald, located at the edge of the city's central park about a half-mile west of the train station. Elvis and his entourage would remain there from October 12, 1958, through February 2, 1959. They were evicted because of excessive noise and property damage. It was while living here that Elvis's father, Vernon, met Davada "Dee" Stanley, who became his second wife on July 3, 1960.

To reach the Hotel Gruenewald from the Bad Nauheim train station, drive west on Bahnhofs Allee for two blocks to Ludwigstrasse. Turn left for two blocks. As Ludwigstrasse curves to the right, it becomes Parkstrasse. Follow Parkstrasse to the end of the park and turn right. The hotel is one-and-a-half blocks north.

Elvis's Home in Germany 🏠

14 Goethestrasse
61231 Bad Nauheim, Germany

When Elvis, his father, his grandmother, and his boisterous entourage were asked to leave the Hotel Gruenewald, Elvis rented this three-story

gray house with its typical red-tile roof, on a quiet street, for the equivalent of $800 per month. The house was located on the south side of central Bad Nauheim, across the city's central park from the Hotel Gruenewald, and about a fifteen-minute walk away from the train station. Elvis, his family, and his entourage remained here from February 3, 1959, to March 2, 1960, when Elvis returned to the United States. Elvis often greeted fans from the narrow, fenced front yard.

It was at this house, on September 13, 1959, that Elvis first met fourteen-year-old Priscilla Beaulieu, who would live at Graceland starting in 1961, and who would become his wife on May 1, 1967. Priscilla was brought to Elvis's house by Currie Grant, a mutual acquaintance who managed the Eagle's Club, a U.S. serviceman's club in Wiesbaden, the town nearest the base where Priscilla's stepfather was stationed with the U.S. Air Force.

To reach this house from the Bad Nauheim train station, drive west on Bahnhofs Allee for one block to Frankfurterstrasse. Turn left and drive through three major intersections. Then turn right at the fourth intersection, Eleonoren Ring. Drive west for approximately three blocks to Goethestrasse, and turn right to number 14.

Elvis in Paris

The following are the places where Elvis stayed or cavorted while he was visiting Paris, France, from June 21–25, 1959 and January 12–19, 1960. In most cases, the original businesses are in the original buildings at the original addresses.

Hotel Prince de Galles 🏠

33 Avenue George V
Paris, 8e, France
33-1-53-23-77-77 (when dialing from the U.S.)
01-53-23-77-77 (when dialing from within France)
53-23-77-77 (when dialing from within Paris)

(This is where Elvis and his entourage stayed for the entirety of both the 1959 and 1960 visits. The hotel has since moved location, but the telephone numbers given are current.)

American Bar Café

91 Avenue de Champs-Élysées
Paris, 8e, France

Elvis visited in 1959. The bar at this location is no longer called the American Bar Café.)

Lido

116 Avenue de Champs-Élysées
Paris, 8e, France
33-1-40-76-56-10 (when dialing from the U.S.)
01-40-76-56-10 (when dialing from within France)
40-76-56-10 (when dialing from within Paris)

(Elvis visited in 1959 and 1960.)

Casino de Paris

19 Rue de Clichy
Paris, 9e, France
33-1-49-95-99-99 (when dialing from the U.S.)
01-49-95-99-99 (when dialing from within France)
49-95-99-99 (when dialing from within Paris)

(Elvis visited in 1959 and 1960.)

Folies-Bérgère

32 Rue Richer
Paris, 9e, France
33-1-44-79-98-98 (when dialing from the U.S.)
01-44-79-98-98 (when dialing from within France)
44-79-98-98 (when dialing from within Paris)

(Elvis visited in 1960.)

Moulin Rouge

82 Boulevard de Clichy
Paris, 18e, France
33-1-46-06-00-19 (when dialing from the U.S.)
01-46-06-00-19 (when dialing from within France)
46-06-00-19 (when dialing from within Paris)

(Elvis visited in 1960.)

Elvis beyond Europe

The Hound Dog Hole ✕

United States Embassy
Almaty, Kazakhstan
c/o United States Department of State
2201 C Street Northwest
Washington, D.C. 20520

While Elvis was in the army in West Germany, he bought an extensive kitchen to prepare meals in the field for himself and his entire regiment. When he left Europe in 1960, the kitchen—complete with solid stainless-steel counters, refrigerators, ovens, utensils, and a 1959 Coca-Cola machine—stayed in Germany, forgotten by the King.

When his former base at Friedberg was demobilized in 1994 after the Cold War, the United States government packed up the kitchen and moved it to the embassy in—of all places—Kazakhstan, for use in a café on the embassy compound. To everybody's surprise, everything worked. Jim Oliver, the proprietor of the café, thought at first, "What a load of junk to send here [but] I just had to plug it in and gas up the fridges. . . . It's a bit ironic, a Scotsman winding up with Elvis's kitchen in the middle of Kazakhstan. Kind of blows your mind a bit."

Now in Almaty, the kitchen is still in use at the embassy café, which is now known informally as "the Hound Dog Hole." However, there is no Elvis memorabilia and no Elvis plates or silverware.

Because the kitchen was designed to feed an entire regiment, less than a quarter of the original gear is at "the Hound Dog Hole." The rest was donated to Almaty's German theater, which was devoted to the folklore of Kazakhstan's ethnic German minority. However, when the theater moved to the Ukraine, the rest of the King's kitchen moved on to the United States Embassy in Bishkek, Kyrgyzstan.

Chapter 16
Elvis on the World Wide Web

E LVIS MAY HAVE "LEFT THE BUILDING," but he is alive and well in cyberspace. It is a place name he never heard in his lifetime, and a place he could never dreamed of being *in*, but he probably would have liked to know that so many people care. Since we produced the first edition of this book in 1999, the World Wide Web has grown and expanded beyond anything that even *we* might have imagined at that time. In the first edition, we said that there were "thousands of Elvis websites on the Internet," but today, there are easily tens of thousands.

As we did in the earlier edition, we provide a list of the sites from around the world that we believe offer the most, both in terms of content and in terms of links to other sites. We have also included some favorites that our readers have shared with us over the past several years.

The sites that are listed range from informational sites to sites that are virtual shrines, each with its own particular — or peculiar — point of view about Elvis, his life and his times. All of these sites were up and running at press time, but we cannot guarantee that they will all stay in business as presently configured.

Official Sites:

Elvis Presley's Official Website
http://www.elvis.com/
Graceland Official Website (With links to other Memphis sites)
http://www.elvis.com/graceland/
Graceland Live Webcam
http://www.elvis.com/graceland/vtour/gracecam.asp
Lisa Marie Presley's Official Website
http://www.lisapresley.com/
Official Jordanaires Website
http://www.jordanaires.net/
Official Memphis Mafia Website
http://www.blacksheep.com/portfolio/memphismafia/
Official Sun Studio Website
http://www.sunstudio.com/
Elvis Presley Memorial Trauma Center
http://www.the-med.org/ (click Centers of Excellence/Trauma Center)
Metro-Goldwyn-Mayer Studios (Elvis films)
http://www.mgm.com/elvis/

Informational Sites:

Elvis Presley Search Engine & Site Directory
http://www.elvisfind.com/
Elvis Presley Virtual Database
http://www.epvd.tk/
Complete Discography (Singles, albums, EPs and CDs)
http://epvd.freeservers.com/page4_1.htm
Elvis Presley Diary (Year by year chronology)
http://www.geocities.com/Nashville/8605/to1954.html
Elvis Song Lyrics
http://www.geocities.com/SunsetStrip/Balcony/1441/eplyrics.html
Elvis Song Lyrics (Over 300 pages in a zipped text file)
http://www.elvis.org/lyric/lyric.html
Elvis Filmography (at Internet Movie Database, imdb.com)
http://www.imdb.com/name/nm0000062/
Solid Gold Elvis (Links to a large database)
http://www.solid-gold-elvis.com/
Elvis the King at elvis.org (Links to a very extensive database)
http://www.elvis.org/
The *Memphis Commercial Appeal* Elvis Archive
http://www.gomemphis.com/mca/elvis_presley/
Elvis Aron Presley, the site for every Elvis fan
http://elvis-aron-presley.nl/
When Richard Nixon met Elvis at the White House (1970)
(From the United States National Archives)
http://www.archives.gov/exhibit_hall/when_nixon_met_elvis/
Elvis Presley Virtual Database
http://www.epvd.tk/
Elvis Presley www Virtual Library
http://www.geocities.com/ep_www_vl/mainindex.html
Elvis Pics (Much more than just pictures)
http://elvispics.tripod.com/
The Priscilla Presley Archives
http://cillapix.com/me.html
The "Portal to Elvis Presley on the Internet"
http://www.elvisstartpage.com/
Elvis News Groups (A Thousand Points of Elvis)
http://www.nwlink.com/~timelvis/elvis_news.html
World Wide Elvis
http://www.worldwideelvis.com/
Follow That Dream (Formerly the Elvis Presley Theme Page)
http://www.followthatdream.com/
The Art of Elvis (or Elvis Art)
http://www.nwlink.com/~timelvis/elvis_art.html

Online Elvis Shrines and Tributes:

The Original Unofficial Elvis Home Page
http://www.ibiblio.org/elvis/elvishom.html

Elvis News
http://www.elvisnews.com/

First Presleyterian Church of Elvis the Divine (Now in Australia)
http://www.geocities.com/presleyterian_church/

Elvis Links: "Places with a high Elvis coefficient"
http://www.ibiblio.org/elvis/elvlinks.html

Won't you wear my TCB ring (The Original Elvis Presley Webring)
http://b.webring.com/hub?sid=&ring=tcbring&id=&hub

The Flying Elvi (The Original Las Vegas Troupe)
http://www.flyingelvi.com/

Elvis Presley Pictures Pictures Pictures
http://geocities.com/SunsetStrip/Stadium/6508/index.html

Disgraceland: A Tim-Elvis Experience
http://www.nwlink.com/~timelvis/

Focus on Elvis
http://home.online.no/~ov-egela/indexep.html

Elvis Information Network
http://www.elvis.com.au/

Elvis Mania
http://www.elvismania.tk/

The Elvis Express
http://www.elvis-express.com/

Official site of John Wilkinson (rhythm guitar player for Elvis)
http://home2.pi.be/verbrugp/

ElvisNet (TCEO) Taking Care of Elvis Online
www.elvisnet.com

Elvis' Women (In the Movies, that is)
http://greggers.granitecity.com/elvis/women/

Eddie Fadal's Elvis Museum
http://waco3.calpha.com/~janice/

Aw Shucks Elvis Links
http://www.shucks.net/shucks/HOMEPAGE/elvis.htm

Judy's Elvis Presley Blvd
http://www.geocities.com/Hollywood/Studio/4382/

Touched By Elvis Fan Club
http://www.touchedbyelvis.com/

Elvis Presley Museum (at Pigeon Forge)
http://www.elvispresleymuseum.com

The Girls' Guide to Elvis
http://www.girlsguidetoelvis.com/

The Next Edition

W E'D LIKE TO TAKE THIS OPPORTUNITY to say "Thank you very much," to all the Elvis fans from around the world who have written to us with updates to our previous edition and to tell us about new shrine sites. As in the earlier edition, we have made every effort to be comprehensive and accurate in this volume of *The Field Guide to Elvis Shrines,* but we do realize that phone numbers and website address-es change, businesses close, businesses open, and venerable old auditoriums are torn down. We also recognize that, despite our extensive fieldwork, we may have missed an important Elvis site or shrine. With this in mind, we'd like to continue to hear from you, so that we can take care of business (TCB) and update the next edition of this book.

For your convenience, we have now added our new email hotline. You may contact us at shrineproject@netscape.net or continue sending in your tips and information via snail mail to our usual post office box.

The Elvis Shrines Project
PO Box 460313
San Francisco, California 94146

shrineproject@netscape.net

Index

Notes:

1. Since this book is about Elvis Presley and he is referenced on every page, there is no entry for "Presley, Elvis." Places named for him are named "Elvis Presley..." or "Elvis..." and are indexed under the letter "E."

2. Auditoriums, arenas, and such that have the same name as the cities in which they are/were located are not indexed, but they can be found by referring to the corresponding city names.

3. The homes occupied by Elvis Presley are indexed under "Homes of Elvis Presley."